Digital Photography Digital Field Guide

Harold Davis

WILEY

Wiley Publishing, Inc.

Digital Photography Digital Field Guide

Published by
Wiley Publishing, Inc.
111 River Street
Hoboken, N.J. 07030
www.wiley.com

Copyright © 2005 by Wiley Publishing, Inc., Indianapolis, Indiana

Published simultaneously in Canada

Library of Congress Cataloging Control Number: 2005925608

ISBN-13: 978-0-7645-9785-5

ISBN-10: 0-7645-9785-X

Manufactured in the United States of America

10 9 8 7 6 5 4 3 2 1

1K/RZ/QZ/QV/IN

For general information on our other products and services or to obtain technical support, please contact our Customer Care Department within the U.S. at (800) 762-2974, outside the U.S. at (317) 572-3993 or fax (317) 572-4002.

Wiley also publishes its books in a variety of electronic formats. Some content that appears in print may not be available in electronic books.

WILEY

About the Author

Harold Davis is a strategic technology consultant, hands-on computer programmer, photographer, and the author of more than twenty books including *Building Research Tools with Google For Dummies*. Harold writes the Googleplex Blog and Photoblog 2.0.

In addition to his work as a writer, Harold has been a technology company executive, enterprise consultant, software developer, and a professional photographer. He maintained a photography studio in New York City for over ten years. His photographs are published, exhibited, and widely collected.

Credits

Acquisitions Editor
Michael Roney

Project Editor
Cricket Krengel

Technical Editor
Michael Dennis

Copy Editor
Scott Tullis

Editorial Manager
Robyn Siesky

Vice President & Group Executive Publisher
Richard Swadley

Vice President & Publisher
Barry Pruett

Project Coordinator
Maridee Ennis

Graphics and Production Specialists
Jennifer Heleine
Lynsey Osborn

Quality Control Technician
Charles Spencer

Proofreading
Linda Quigley

Indexing
Johnna VanHoose

For Julian, Nicholas, and Mathew

Acknowledgments

Special thanks to Phyllis Davis, Cricket Krengel, Michael Roney, and Matt Wagner without all of whom this book would not have been possible.

Contents at a Glance

Contents

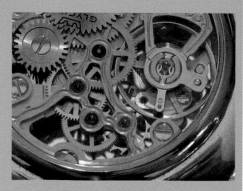

Part II: Creating Great Photos with Your Digital Camera 43

Chapter 3: Photography Basics 45

Chapter 4: Lighting Your Photos 71

Chapter 5: Using Accessories and Filters 87

Chapter 6: Recipes for Great Photos 101

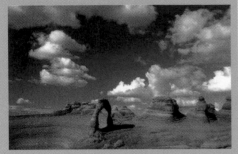

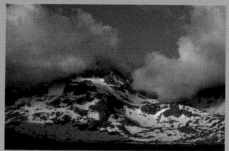

Introduction

Both words in the phrase *digital photography* denote an activity that is important, magical, and powerful.

In the early days, about 150 years ago, photographs were created using now-arcane chemical techniques such as the daguerreotype, albumen, and wet collodion processes. Photography was a worldwide sensation: you could create lifelike images without drawing or painting by hand. The word *photography,* which comes from Greek and literally means to paint with light, reflects this early perception of the magic and miracle of photography.

As the twentieth century progressed, black-and-white photography was dominated by silver halide chemistry. Photographers made exposures on film, and worked in darkrooms lit by soulful red lights to expose film negatives to the silver halide grains in photographic paper.

Eventually the color photographic film chemistries and technologies we are familiar with today emerged. But whatever the processes, one thing did not change: Photography is the dominant way we learn about and perceive our world, our history, and ourselves.

The magic is still there. With digital photography, it is more magical, and more fun, than ever.

Technologic innovation continued. Silver halide was not the end of the line. The industrial age turned to the digital age, and the twentieth century faded. Computers came of age. No longer a chicken in every pot, satisfaction was guaranteed by a PC, a MAC, an IPod, and, yes, a digital camera in every home.

Make no mistake, access to a computer and the ability to manipulate the bits that are at the root of every rendition of reality is a new miracle every bit as compelling as the invention of chemical photography.

We can create images from reality, without drawing, painting, or using film, with digital cameras — which are really special-purpose, powerful computers. We can save those images as photographs using the same kind of storage media used by any computer, and transfer digital photographs from one computer to another. Digital manipulation software can be used to enhance the photographs. The photographs can then be printed from your computer, uploaded to the Web, and used in photo Web logs, also called *photo blogs*.

In other words, the miracle of photography is compounded with a second miracle: Digital technology. Together, the two have changed the world and how we perceive it — and will continue to do so.

Welcome to the world of digital photography!

Getting the most from this book

Although I suppose it would be a nice thing if you read this book from cover to cover, I don't suppose you will do so — nor do I think you necessarily should.

This book can be used as you would a cookbook to look up a recipe. You can look up a specific, common photographic situation and easily see:

✦ Recommended camera settings

✦ Information about lights

✦ Tips, tricks, and alternate techniques

This book can also be used as a source of ideas for digital field photography. If you look at a photograph or a description of a photographic technique in *Digital Photography Digital Field Guide*, maybe you will be inspired to take photographs in the field. Your photos may be similar to the examples in this book, using the techniques described — or you may use the examples and information in this book as a springboard for your own work.

You should know that this book has a companion Web site, www.digitalfield guide.com. There you'll find tools, tips, techniques, and information that complement this book.

Who this book is for

I assume that you are interested in digital photography, and curious about it — otherwise why would you have picked up this book?

You don't need to know much about photography, or about digital technology, to get something from this book. But it will help if you already have a digital camera and enjoy taking pictures.

If your camera is a bit more advanced than the basic point-and-shoot variety, you will be able to take full advantage of the tips, tools, and techniques included in this book. In other words, you don't need to have a digital SLR. In real life, digital cameras that use an LCD viewfinder actually have some advantages over the more expensive digital SLRs (in addition to being far less expensive). But your camera should be able to set exposure and focus manually when you need to.

I don't know about you, but I don't much like to read camera manuals. They are densely packed with information, printed on incredibly thin paper, full of incomprehensible icons, and read like they've been translated from Japanese to some other language and then into English — in each case by someone who doesn't speak the language like a native. Worst of all, manuals don't tell you what you most need to understand: the implications of specific settings of the camera controls.

Don't throw away your camera manual yet! It is a fact of life that a digital camera has many complex controls that are specific to each camera model. The manual is the best (perhaps the only) way to learn about these settings. But this book is intended to provide the information that is absent from the manual, or not put clearly in the manual, so you can learn *why* you set the camera one way or another.

If this book inspires you to take your digital camera along and use it in the field and helps you a bit along the way, then it has done its job. Go have some fun, and happy digital photographing! This book is your invitation to join the digital photography revolution.

Quick Tour: Shooting Your First Digital Photo

It's really exciting to buy a new digital camera.

If you're like me, what you *want* to do right away is go out and take some pictures.

What you may *not* want to do is to stop and read a manual — particularly a manual that is complex and written in English that treads not-too-delicately around the edges of incomprehensibility. (The manual probably reads like it has been translated through several languages, in no case by a native speaker.)

If you've never used a digital camera before — or even if you have — the steps you need to take to prepare your new camera may seem baffling. In addition, if you are not a photography pro, the meaning and implications of the camera's settings may not be readily apparent, nor may it be clear from the camera manual how much of this stuff you really need to know before you can just start taking pictures.

This chapter tells what you need to know to get a quick start taking pictures with your new digital camera.

Figure QT.1 shows you an overview diagram of the steps involved in preparing your camera, taking your first photo, and printing it or saving it for the Web.

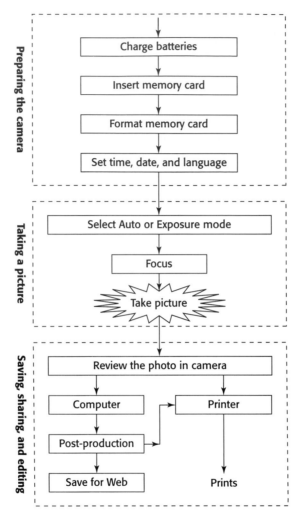

QT.1 Preparing a digital camera, taking a photo, and printing or saving a photo (flowchart schematic).

Before You Can Take Any Pictures...

Before you use your camera for the first time, there are a few things that you need to address. Most likely, you will be prompted to set date, time, and language the first time you turn on the camera. These settings are made using the menus that are displayed on your camera's LCD screen. You also need to make sure that your batteries are charged and that the memory card is formatted and correctly placed in the camera. Attach your lens, if you are using an SLR. Finally, if the camera's strap is not attached, you should probably attach the strap before you get started. After you've done all these things, *then* you are ready to shoot some pictures. Consult the manual that came with your camera to learn more about these items.

Selecting Exposure Mode

There's nothing wrong with automatic exposure. The majority of the time, automatic exposure on a digital camera does a good job of setting an acceptable exposure; so the path of least resistance when you take your first pictures with your digital camera is to select automatic exposure.

Automatic exposure is usually chosen using an exposure mode dial, and is indicated by the word *Auto*.

Cross-Reference *In the due fullness of time you will probably want to use aperture-preferred and shutter-preferred metering for special situations (and you will certainly want to understand the ramifications of the exposure settings selected by the camera). For more details, see Chapter 3.*

Many, if not most, digital cameras have exposure modes you can select in addition to Auto. When these exposure modes are used, the camera still automatically selects the exposure. However, the camera knows it's supposed to optimize its selection of exposures for certain kinds of situations.

If you know right off the bat that you are photographing in one of these situations, you should select one of the automatic exposure modes shown in Table QT.1 rather than just plain vanilla automatic (assuming, of course, that the exposure mode is available on your camera).

Note *The names of these modes differ slightly with different camera brands, but the idea is the same no matter what the mode is called.*

Table QT.1
Automatic Exposure Modes

If You Are Photographing...	Select This Mode	What It Does
Close to objects such as flowers	Close-up	Selects small aperture and exposes for central object
Vistas of cities or mountains	Landscape	Turns off flash; exposes for wide areas and contrast
People	Portrait	Flash set to red-eye reduction; exposure best for skin tones
Fast action	Sports	High shutter speed used

Focusing and Choosing Focus Mode

To activate a digital camera's autofocus, use the viewfinder to point the camera at the primary area that should be in focus, and partially depress the button (the *shutter release*) used to take the photograph.

With the shutter release partially depressed, the camera will autofocus, using one of the two focus modes shown in Table QT.2.

Previewing Depth of Field

Depth of field, the range of distances within a photograph that are in focus, makes a big difference in the end results of your photography (see Chapter 3 for more details). You should get in the habit of reviewing depth of field before taking a picture.

To view the effects of depth of field on the actual photograph you take with a digital SLR, hold down the depth of field preview button, which is usually located on the front of the camera near where the lens is mounted.

With a non-SLR digital camera, you can usually see the impact of depth of field using the simulated view in the LCD screen of the image.

> **Note** *The optical viewfinder of a non-SLR camera will not display depth of field.*

Selecting Image Format

You should decide what format to save your photographs in: JPEG, RAW, or both. You may also have to choose an image size and compression ratio if you select JPEG as your format. Make sure to select a format and size that is appropriate for your purposes before you take the picture.

> **Cross-Reference** *For more details on choosing a file type and size for your pictures, see Chapter 2.*

Table QS.2
Auto Focus Modes

If You Want to...	Choose	When to Use
Lock the focus and then move the camera	Single-servo mode	You want to focus and then recompose without changing the focus
Let the focus change as needed	Variable-servo mode (sometimes called continuous mode)	When you are tracking something that moves, like an active person

Taking the Picture

The camera is prepared, an exposure mode selected, and you have focused. It's time to take the picture. With the camera turned on, depress the shutter release button.

Hold the camera steady as you depress the button. Congratulations! You've taken a digital photograph.

Reviewing the Image

It's easy to display the image you just exposed on the LCD screen of your digital camera. With an SLR, the screen is used primarily for this purpose (and also to allow menu selections). With a non-SLR, the LCD screen is also used as a viewfinder to compose pictures.

In either case, there will be special button controls near the LCD screen that allow you to view the image and to cycle through all the images on the memory card.

You can also delete images that don't live up to your expectations directly in the camera by pressing a delete button near the LCD viewer. Normally, this button is marked with a trash can icon, and you have to confirm by pressing twice to delete the image.

Note *Some cameras use menus and the LCD screen rather than buttons to display and delete images.*

Tip *Don't be too hasty about deleting images based on the in-camera display. It can be awfully hard to see images on the LCD viewer, especially in bright light conditions.*

Printing Your Photographs

With your photographs saved on the memory card in your digital camera, you can print the images in a number of ways. You can

✦ Use cabling to connect directly to an at-home photo printer.

✦ Remove the memory card from your camera and insert it in your at-home photo printer.

Cross-Reference *For a more detailed look at printing your images, read Chapter 7.*

✦ Remove the memory card from your camera and bring the card to a kiosk in a store to print your pictures.

✦ Use cabling — either attached directly to the camera or to a separate card reader — to download the pictures to your computer, and then print them from your computer.

✦ Download the pictures to your computer and upload them via the Internet to make prints using online services.

Tip *Downloading photographs to your computer has the advantage that you can digitally enhance the images before printing them (see Chapter 7 for more information).*

Most of the time, a USB cable is used to connect your computer to your camera. The cable should be connected to the computer with the camera turned off. After it is connected, you can turn the camera on.

You can elect to use the software provided by the digital camera manufacturer to download pictures to your computer (and manage the catalog of pictures on your computer). In this case, you should have the software installed before you connect your camera. The software automatically launches when the camera is connected to the computer and turned on. This software will help you copy photographs to your computer and delete them from the camera so you can reuse the camera's memory card.

Alternatively, you don't need to use the manufacturer's software, particularly if you are using third-party software such as Photoshop, Photoshop Elements, or Picasa that can catalog and manage your photographs.

Cross-Reference *For more on specific photo-editing software, see Chapter 7.*

With your camera connected to your computer and turned on, the memory card in your camera will be seen simply as another storage device (a *drive*). You can use software such as Windows Explorer (or iPhoto

on the Mac) to drag and drop photographic files from the camera to your computer, and then delete them from the camera.

Once a photo has been saved on your computer, you print it just as you would any other file — by dragging and dropping it on the icon representing your photo printer or by selecting Print from the menu (make sure to select your photo printer).

You can send a photo along with an e-mail by attaching the photo file to the e-mail message. Depending on the e-mail program you are using, most likely you can attach a file to the message by selecting Attach from the File menu, or clicking an Attach button.

You can upload a photograph saved on your computer to an online photo sharing service such as Shutterfly (www.shutterfly.com) or Flickr (www.flickr.com). Many online services also have software you can use to upload to photos and make basic edits. There are many other photo sharing services on the Web if you don't find either of these to your liking.

Using Your Digital Camera

Exploring the Digital Camera

Welcome to the *Digital Photography Digital Field Guide*. This book will help you get the most out of your digital camera in field conditions. Digital cameras are used in field conditions for applications that range from action photography through architectural and nature photography. You'll also find information and tips about using your digital camera in a studio setting, as well as enhancing your digital photographs on the computer, but that's not what this book is primarily about. My goal is to help you get the most out of your digital camera when you take it somewhere outside — in the field — whether you are photographing clouds, flowers, rainbows, buildings, people, or anything else that grabs your attention.

If you are like me, you probably don't find the instruction manual that came with your camera very easy to read (or useful!). But you do need to know something about how your camera works before you bring it with you in the field. One of the biggest secrets to taking great pictures is preparation. This chapter helps you get prepared for your digital photography fieldwork by providing a quick and fun tour of digital camera anatomy.

Suitability to Tasks

Each kind of digital camera is more suitable for specific tasks than others. Table 1.1 looks at some specific kinds of photography and the kind of digital camera that is most likely to give you good results.

Table 1.1
Choosing the Right Camera for the Job

Task	Best Type of Digital Camera to Use
Easy access and accessibility virtually anywhere	Mobile phone cameras and compact point-and-shoot models
Portraits	Advanced non-reflex cameras; SLRs
Sports and other action photography	Point-and-shoot models with manually adjustable shutter speeds or the availability of a high shutter speed and SLRs
Landscapes	Almost any digital camera provided the lens is good enough
Close-ups	SLRs; some point-and-shoot models with a good enough lens

Typical Non-SLR Controls

Where the actual controls are on your camera, how they work, and what various settings are named depends on the brand and model of your camera. Almost any advanced non-reflex digital camera (a non-reflex camera is one where you don't view the picture through the lens used to take the picture) provides controls and settings appropriate for serious photography like those shown in figure 1.1, including

✦ An optical viewfinder. This, however, does not give an exact image that is comparable to the one seen through the camera lens — although some models provide electronic viewfinders that do view through the lens but present the image on a tiny TV tube.

✦ An LCD electronic viewfinder that provides an accurate rendition of the picture being composed.

✦ Automatic exposure and focus capabilities.

✦ Mode settings, for optimizing the camera's settings for specific kinds of pictures.

✦ A mechanism for enabling specific exposure modes, such as aperture preferred or shutter preferred. With a camera in aperture preferred, for example, you pick the camera aperture, and the camera automatically chooses the shutter speed that corresponds to control the exposure.

✦ Manual override controls for focusing and exposure, so that the camera can be used in a completely manual mode.

✦ A mechanism for playing back photographs on the LCD screen, so they can be reviewed, deleted, and enhanced in minor ways.

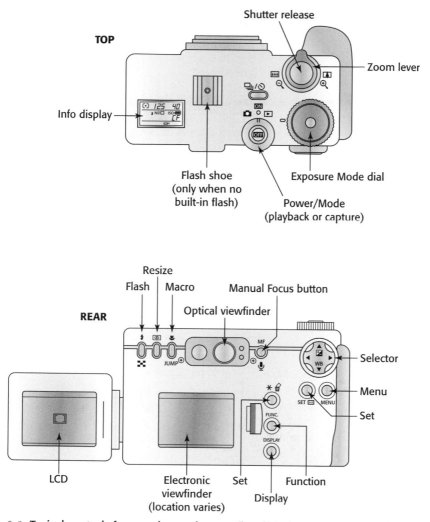

1.1 Typical controls for an advanced non-reflex digital camera (selected controls shown).

In addition to these controls, the camera provides a slot for the memory card and a digital connector for attaching the camera to a computer. In some cases, you recharge the batteries by taking them out of the camera and using an external charger. If the camera batteries are recharged while still in the camera, a connector plug for this purpose will also be provided.

Adding Useful Accessories

The most useful accessories in the field for your digital camera are a tripod, a good waterproof case, and a lens shade.

The tripod lets you take long exposures without shaking the camera, resulting in sharper images than those taken without a tripod, provided your subject is not moving. In addition, with the camera on a tripod you can use longer shutter speeds. This means that the exposure can be set with a correspondingly small aperture (such as f/22), increasing depth of field in the final result. A tripod is an extremely important accessory for photographers interested in photographing nature in the field for a number of reasons, including

✦ A great deal of field photography happens at sunrise or sunset when light conditions are low

✦ Many landscape photographs require a great deal of depth of field

✦ Close-ups tend to require exposures that are too long to be handheld

A good waterproof case helps keep your camera dry and snuggly no matter what the weather is. It's always important to keep you camera dry.

Your camera may have come with an accessory lens shade (if not, you can easily buy one). A lens shade helps protect the lens when you are using it. More importantly, it helps to keep extraneous light out of the lens so you don't get optical flares in your photos.

Typical SLR Controls

A digital SLR camera generally provides automatic, semiautomatic, and manual settings for both exposure and focus.

However, the process of viewing and composing a picture before you take it works differently in a digital SLR than it does in an advanced non-reflex (and will feel very familiar to users of traditional 35mm film SLRs). Depending on the camera model, an optical or electronic viewfinder is used to preview the photograph. A system of mirrors sends the image to the viewfinder (rather than to the media used to capture the image). When the photo is actually taken, the mirrors are repositioned so the image is sent to the capture media for the duration of the exposure rather than to

the viewfinder. The LCD in a true digital SLR cannot be used to compose photos because the mirror blocks exposure to the image capture device until the moment of exposure.

An electronic viewfinder (EVF) camera has many features similar to an SLR (but is not a true SLR). That is, you view through the lens, but you are seeing an electronic image in the viewfinder. EVF cameras do not let you change lenses.

Typical digital SLR controls are shown in figure 1.2.

After a photograph has been taken, it can be viewed in the LCD screen for review, minor editing, or possible deletion. What can be done depends on your camera's capabilities.

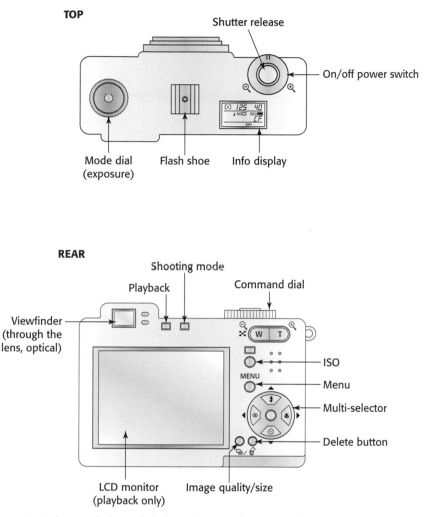

1.2 Typical controls for a digital SLR (selected controls shown).

Understanding Zoom Lenses

Advanced non-reflex digital cameras and digital SLRs usually come equipped with a zoom lens. Some digital SLR cameras are sold without a lens — so you aren't necessarily stuck with the standard lens that comes with the camera. You can buy another one if you prefer, but make sure it is compatible with your specific camera. In contrast, the zoom lens is an integrated part of an advanced non-reflex camera, so what you buy is what you get, which is not necessarily a bad thing if it is a good lens.

Note *To say a lens is good means that it has good optical qualities — a hard thing to know without taking pictures using the lens. However, if you stick to a lens made by major camera manufacturers, particularly if you can find positive reviews of the lens in photography magazines or online, you probably won't go wrong.*

By the way, the term digital zoom is a misnomer because a digital zoom does not accomplish its effect optically — the program inside the camera simply crops an image to produce a zoom-like effect.

How close or far away a subject appears in a photograph depends on several factors, including

✦ How far the camera (and photographer) is from the subject.

✦ The focal length of the lens used on the camera.

The *focal length* of a lens is the length from the front piece of glass on the lens to the image capture device in the camera.

A zoom lens is a lens with a continuous series of focal lengths, for example, 18mm–70mm. In this example, 18mm represents a wide-angle lens, meaning the subject matter looks farther away than it really is. 70mm represents a telephoto lens, meaning the subject matter is brought closer than it really is. The zoom lens provides a ring on its barrel that allows you to continuously shift to any focal length between these two extremes.

Zoom lenses come in a great number of varieties. Some zoom lenses, such as the 18mm–70mm variety, provide more wide-angle focal lengths. In contrast, other zoom lenses emphasize telephoto focal lengths.

What gets a little complicated is that the apparent closeness of the subject to the camera is controlled not just by the focal length of the lens, but by the *ratio* of the focal length of the lens to the size of the image capture mechanism. This did not present a problem in 35mm film photography. For every 35mm film camera, the image capture size was the same: a frame of 35mm film. So the degree to which a lens was wide angle or telephoto could always be determined by the focal length of the lens.

Roughly speaking, in 35mm film photography, a lens with a 50mm focal length is considered normal, meaning no magnification or reduction of a subject occurs. Anything less than 50mm, such as 28mm, is wide angle, which results in subjects that appear farther away. Anything greater than 50mm, such as 135mm, means that subjects are magnified and appear closer.

In digital photography, the actual sensors are smaller than in 35mm photography, and they are also non-standardized; that is, one digital camera may have a different image capture size from another (even within the same brand). Without knowing the dimensions of the sensor, the focal length of a zoom lens is just a number: It doesn't provide the information you need. Digital camera manufacturers provide 35mm film equivalent focal length information, which is an estimate of what the range of focal

lengths provided by the zoom lens would have been if the lens were on a 35mm film camera rather than a digital camera. For example, the 7.2mm–28.88mm zoom lens that ships with models of the Canon PowerShot camera has a 35mm film equivalence of 35mm (moderate wide angle) to 140 mm (moderate telephoto).

> **Note** You should know that focal lengths for digital cameras tend to be less than the 35mm equivalents (because digital image capture sensors are smaller than a piece of 35mm film). Also, there aren't very many extreme wide angles for digital cameras for technical reasons related to optical properties and the smaller image capture size.

Knowing the 35mm film equivalence of your zoom lens lets you get a ballpark feeling for how close or far away your subjects will be, and lets you compare your zoom lens to other digital cameras equipped with zoom lenses (as illustrated in figures 1.3 through 1.5).

> **Tip** Whether a lens is wide angle or telephoto impacts the optical properties of a photograph as well as its apparent distance from objects. You may have noticed curvature and distortion that occur with wide-angle lenses. Another effect that is a little less obvious is the compression of apparent depth that occurs when you use a zoom lens in its telephoto mode. These optical properties of the focal length of your zoom lens can be used in the field to create more interesting photographs.

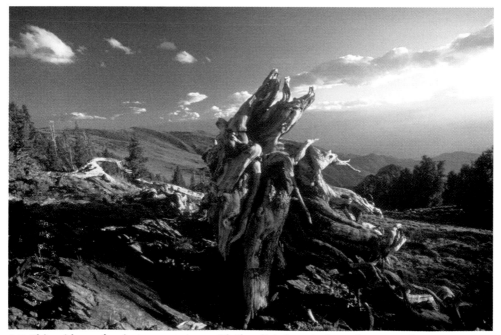

1.3 This wide-angle photo was taken with the digital equivalent of a 35mm lens.

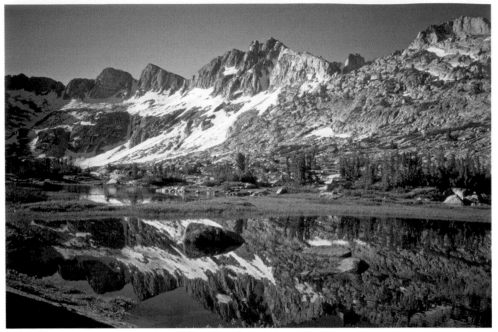

1.4 When you use a normal focal length, things appear neither farther away nor closer than they do in real life (50mm equivalence).

1.5 A telephoto lens brings objects closer and compresses perspective (135mm equivalence).

It's important to understand that the actual focal length on a digital camera depends on the camera model and the size of the sensor (and may not correspond to the actual focal length numbers shown in figures 1.3, 1.4, and 1.5 through 1.9, which are from a Canon PowerShot advanced non-reflex camera). In particular, digital SLRs are likely to have larger sensors (and be capable of capturing images with correspondingly greater resolution). This is reflected in larger focal lengths for lenses; for example, the Nikon AF-S ED 18–70mm zoom lens, intended primarily for use with the Nikon D70 digital SLR, is roughly equivalent to the Canon PowerShot zoom lens.

You may also encounter the distinction between optical and digital zoom lenses. An optical zoom lens is a true zoom lens in the sense that it uses optics, which are usually glass, to provide a range of focal lengths. In contrast, a digital zoom simply edits a captured image by zooming into the desired parts. Although this is done in the camera, it is in theory no different than editing your images by cropping them on your computer, and produces images without the full resolution of optical zooms.

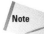 **Note** *Using a digital zoom provides exactly equivalent results to cropping with your computer a picture taken optically. There are no resolution advantages or disadvantages to the digital zoom. So if your optical zoom doesn't bring you close enough to a subject, consider cropping and using the portion of the photo that you want using digital editing.*

Understanding your zoom lens doesn't have to be too complex. The zoom lens on your digital camera will most likely allow you to select from moderate wide angle through moderate telephoto and everywhere in between.

Depth of Field

Put simply, *depth of field* means how much of a photo is in focus. If all the things in a photo are in focus — particularly if their distance from the camera varies, as with a flower in the foreground and a landscape behind — then the photo is said to have high depth of field. If only one element in the photo is in focus — for example, the flower in the foreground of figure 1.6 but not the foliage behind — then the photo is said to have shallow depth of field.

1.6 The flower is emphasized in this picture because the rest of the photo is out of focus due to shallow depth of field.

Although not entirely the same thing as *sharpness* (photos that appear crisp and defined are said to be sharp), images with wide depth of field tend to appear sharper than images with shallow depth of field. However, using shallow depth of field can also be a wonderful digital field technique: If your photo is only concerned with a flower, and shallow depth of field is used to make the flower the only element in focus, then the flower will look like the only thing that matters in the photo because the rest of the photo is blurred and unfocused.

If you are going to use depth of field with control in your photos, you need to understand the simple relationship between aperture and depth of field. *Aperture* is the opening in the lens. The smaller the aperture, the greater the depth of field.

Both wide and shallow depth of field can be useful techniques when the subject matter that you care about in a photo (for example, a flower or a face) is sharp and in focus, and everything else in the photo is blurred. Shallow depth of field can be used in this way as a powerful photographic technique. So there's no good or bad with depth of field, only levels of in-focus subject matter. Figure 1.7 shows an attractive landscape image that uses wide depth of field to bring all elements within it in focus, and figure 1.8 shows a shallow-depth-of-field flower image that also works because the central object of the photograph is the only thing in it that appears sharp.

As mentioned, the smaller the aperture of the lens, the greater the depth of field. Somewhat confusingly, smaller lens aper-

1.7 Everything seems sharp in this landscape image due to high depth of field.

tures are indicated by larger *f-stop* numbers; so a photo taken with the camera lens set to f/32 (a small aperture) will have wider depth of field than a photo taken with the camera lens set to f/2.0 (a large aperture). Table 1.2 gives you some idea of what to expect with aperture settings and depth of field.

With your digital camera operating in automatic mode, you have no control over the aperture setting of the lens and the resulting depth of field (or lack thereof). To control the depth of field, you have to take your digital camera off Auto mode and set the aperture yourself:

✦ Manually set the exposure.

✦ Select an aperture-preferred exposure mode, in which you pre-select the aperture and the camera chooses the rest of the settings to match. Different digital camera manufacturers have different designations for this exposure mode. For example, Canon calls it AV (Aperture Value), and Nikon calls it A (Aperture preferred).

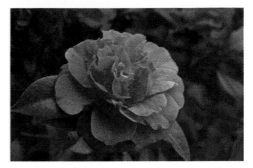

1.8 Only the flower is sharp in this image that uses shallow depth of field.

You should also know that (generally more expensive) digital SLRs that employ true through-the-lens viewing do so with the lens aperture wide open. This is because there would not be enough light to see by if the lens were *stopped down* (meaning the aperture is adjusted to a higher f-number) to the actual small apertures (such as f/32) used for many photos. But it does mean that with these cameras you are not viewing the actual depth of field that will appear in the photo. (35mm film SLR users encounter the same problem.) Note that this is not an issue with LCD viewfinders or with high-end EVF cameras.

Table 1.2
Aperture, Depth of Field, and Photo Appearance

Size of Lens Aperture	f-stop	Depth of Field	Photo Appearance
Large	f/2.0	Extremely shallow	Only one plane appears in focus
Medium	f/4.0 to f/5.6	Medium	Objects close together in their distance from the camera are in focus
Small	f/8.0 to f/11	Wide	Most planes in the photo are in focus
Very Small	f/16 and greater	Very wide	All the objects in the photo appear to be in focus and sharp

Digital SLRs with optical through-the-lens viewing provide a facility called *depth-of-field preview.* Depth-of-field preview is usually activated by pressing a small button near the base of the lens mount on the camera. With depth-of-field preview activated, you see the photo as it will actually appear (at really small apertures, there may be so little light coming through that it may be hard to view the results).

Understanding ISO

ISO is short for International Standards Organization, an organization that defines standards. *ISO speed* is a term for expressing the light sensitivity of a digital camera. Although it is not exactly the same thing, you can think of ISO speed as corresponding to film speed in an old-fashioned film camera; the higher the ISO speed, the dimmer the light in which you can take pictures.

Of course, nothing in life is free or without trade-offs. By increasing ISO speed so that you can capture images in dimmer light, you will also increase image *noise* or graininess, essentially lowering image quality.

Increasing the ISO you use with your digital camera is like replacing a fine-grained but low-speed film in a film camera with high-speed but grainy film — you can take pictures in low light conditions, but the pictures aren't as crisp.

| Note | *Sometimes crispness isn't everything. To a photojournalist, capturing a once-in-a-lifetime photo is worth the introduction of some grain or noise. And some photographers add noise, either by boosting the ISO or by using Photoshop post-production, on purpose as a creative effect.* |

The normal ISO speed used by most digital cameras is either 100 or 200. Some digital cameras automatically adjust the ISO speed to changing conditions (you can usually override this). In addition, you can manually set ISO speed to a greater number. Depending on the digital camera, you can select ISO speeds as high as 1600, but beware of image degradation at higher ISO speeds.

With some digital cameras, particularly digital SLRs, the default mode does not automatically adjust ISO speeds to conditions. However, you can change this default so the camera does adjust ISO speeds (although not in all exposure modes).

Of course, sometimes you can boost ISO speed intentionally to create the effect of an image with noise (see figure 1.9).

Table 1.3 should give you an idea of when it might make sense to use a higher ISO speed.

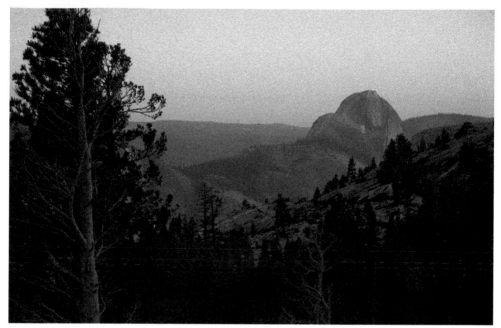

1.9 Images taken with a high ISO appear grainy.

Table 1.3	
ISO and Applications	
ISO	*Best Used For*
100–200	Landscapes, general photography
400–1600	Nighttime or dim interiors where flash is not an option and image quality isn't paramount

Exposure Modes

Advanced non-reflex and SLR digital cameras can be operated in automatic exposure mode, in a variety of semiautomatic modes, or manually. The next few sections should help you better understand what your camera is capable of in these modes.

Automatic exposure

Automatic exposure mode works well for the most part. The digital camera's light meter reads the light and processes it using a set of preformulated instructions to set the camera's aperture and shutter speeds. But, if you take an image, view it, and aren't happy with the results, you'll want to use a semiautomatic exposure mode or manual exposure mode instead.

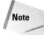 **Note** *Some cameras have both Automatic and Programmed modes. Programmed mode tries to combine the highest shutter speed with the smallest f-stop, depending on the lighting in the scene. In many cameras the user can choose a program that looks for either higher speeds or wider f-stops. Also Programmed mode allows the user to make some adjustments that Automatic mode does not.*

Most digital SLRs provide histogram information about the exposure values in a photo after you take the picture. The *histogram* shows the distribution of tones in a photo. The horizontal axis in a histogram corresponds to pixel brightness (dark tones are to the left and bright tones are to the right). The vertical axis displays the number of pixels at each level of brightness.

This sounds complex, and in fact a histogram needs to be evaluated depending on what you want to accomplish in your photo, but it's pretty simple to get the key information out of a histogram. For example, if the histogram is shaped like a mountain on the left with nothing on the right, the image is probably underexposed, as shown in figure 1.10. In contrast, a histogram showing mountains on the right and nothing on the left is probably overexposed, as shown in figure 1.11.

It's important to understand the area that the light meter in your digital camera is using to calculate its exposure. Most advanced non-reflex and SLR digital cameras have several metering modes, including

✦ Full screen, sometimes called *evaluative* or *matrix* metering (usually this metering mode is the default).

✦ Center-weighted, which gives more exposure emphasis to subjects in the center of the image.

✦ Spot, which only measures the light hitting a small spot in the center of the image.

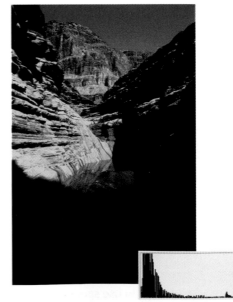

1.10 You can tell from the histogram that this image is underexposed.

If your camera has these different modes, full screen is usually the default; however, you can switch between them. Spot metering can be particularly useful if the portion of the image you really care about has very different exposure values than the rest of the picture, like the image in figure 1.12.

Tip

Note that pressing the shutter release button on the camera halfway down locks the exposure; so you can compose a picture, determine the exposure, and then shift the camera viewpoint while still maintaining the exposure. Some digital cameras also have an Exposure Lock button, which does the same thing and also may allow the first measured exposure to be used in multiple photos in a series.

1.11 You can tell from the histogram that this image is overexposed.

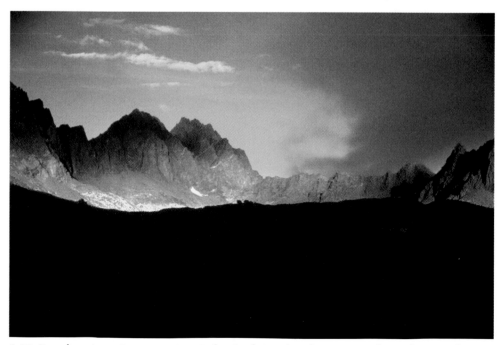

1.12 It makes sense to use spot metering to determine the exposure for an image when the image is not evenly lit.

Semiautomatic exposure

There are two kinds of semiautomatic exposure modes:

✦ Those in which the camera adjusts automatically for a particular kind of image, like a portrait or a close-up.

✦ Those where you set either the aperture or the shutter speed and the camera automatically adjusts the remaining settings.

The name given to each mode varies depending on the digital camera brand, but typical names include the following:

✦ Portrait

✦ Landscape

✦ Close-up

✦ Sports and action

✦ Night

Choosing one of these modes tells the exposure program to make the choices that best optimize results for that type of subject matter. For example, when you choose Portrait, the exposure is optimized for mid-range skin tones, and a wide f/stop is selected to throw the background out of focus. In Landscape mode, the camera's integrated flash will not go off, no matter how dark it is, such as in figure 1.13. In Sports mode, a high shutter speed that stops the action is automatically selected.

With shutter-preferred exposure, you can set the shutter speed high to freeze motion or to create special effects, such as blurring moving objects, as shown in figure 1.14. Remember that when you raise the shutter speed, the f-stop will be wider, and conversely when you lower the shutter speed, the f-stop will be smaller.

1.13 In Landscape mode, the camera does not use the flash even in low light conditions.

The primary reason for using aperture-preferred exposure is to control depth of field. For example, you might want to be sure that everything in a close-up photo is in focus as in figure 1.15.

Manual exposure

By setting the camera exposure manually, you are taking complete control of the exposure settings of your digital camera. It certainly makes sense to experiment from time to time because, unlike film cameras, a digital camera doesn't waste anything if your experimental image doesn't come out; you can simply erase the image and begin again.

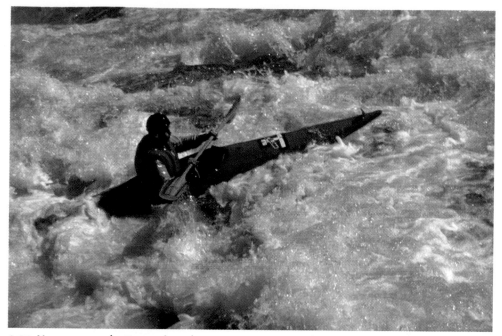

1.14 You can use shutter-preferred exposure to stop motion.

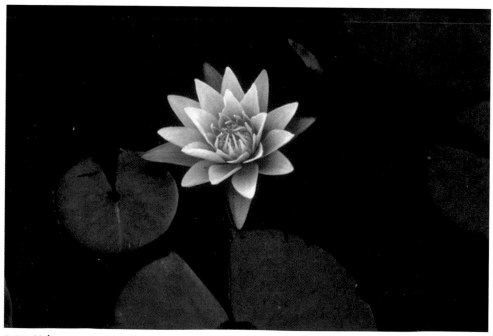

1.15 Using aperture-preferred exposure, you can control depth of field.

To get good pictures in the field using manual exposure, you need to use an external light meter, or have a good feeling for what shutter speed and aperture combinations create the right exposure at a given ISO.

There are a couple of special situations in which you'd probably want to use fully manual exposure control. One is for very long exposures, sometimes called *bulb* exposures. In a bulb exposure, the shutter is kept open as long as the shutter release button is depressed (as in figure 1.16).

 Note *It's called a bulb exposure because a long time ago a bulb (it looked roughly like the end of a kitchen turkey baster), was used, rather than a button, to hold the shutter of a camera open. The bulb was attached to a length of hose attached to an air-operated shutter.*

The other situation in which manual exposure is mandatory is when you use old lenses with an interchangeable-lens digital SLR. This is because typically you cannot use automatic exposure modes with lenses that predate the digital era.

Using Automatic Focusing

Almost all digital cameras provide an automatic focusing mechanism. The camera focuses when the shutter release button is pressed halfway down.

Automatic focus works very well most of the time, but you should be careful to point the camera at the object you want in focus when you depress the shutter release. You can then move the camera with the shutter partially depressed to better compose the picture.

You should also remember to monitor the depth of field of the photo you are making. Depending on the aperture you select, more or less of your photo may be in focus than you planned.

1.16 This extreme macro shot with a Canon PowerShot G3 required a long bulb time exposure.

 Note *Unless you are trying for an experimental or shaky effect, you should have the camera mounted on a tripod when you take any long exposure.*

Overriding Automatic Focus

Sometimes automatic focus just doesn't work. (For example, highly reflective metal or glass surfaces tend to fool automatic focus devices.) If automatic focus is not working, you should manually focus your digital camera.

How you override automatic focus depends on the camera model. An upper-end interchangeable-lens digital SLR most likely has a switch to move from one position to another, and then you focus using the lens focus ring as you would with a 35mm film camera.

In most advanced non-reflex digital cameras, manual override of autofocusing is set using a menu item on the LCD monitor. You then use a multipurpose camera control, such as a dial, to focus manually.

Preparation and Setup

Much of the time, it's easy to use a digital camera in the field—just point and start shooting. Of course, the more you understand about how photography works and the impact of digital technology, the better a photographer you'll be. And, once you understand your camera and its capabilities, the better your photographs will be.

But, you need to be prepared. If you've thought in advance about the field conditions you are likely to meet, you are more likely to bring back great photographs. You can help yourself prepare mentally, as explained in Chapter 1, by understanding the basic principles of photography and how digital cameras work.

Another one of the most important parts of being prepared is making sure that your camera is set up the way it will work best for you, regardless of circumstance. The goal of this chapter is to help you prepare for field conditions, with an emphasis on setting up your digital camera.

Recharging Strategies in the Field

Every digital camera model uses batteries that must be recharged from time to time. Depending on your model, recharging is accomplished in one of several ways, including

+ Replacing the batteries with new ones (for example, when the camera runs on AA size batteries that may be rechargeable or not).

+ Plugging the camera into an adapter that connects to regular electrical current.

✦ Removing the batteries from the camera and charging them in an external device.

> **Note**
>
> *Some cameras, such as the Nikon D70, in an emergency can accept batteries other than those they ship with. However, you should check your product documentation carefully before inserting any batteries other than those that shipped with the camera.*

Generally, it's fairly quick to recharge a camera or its batteries (no more than a hour or two at most). In addition, a single charge usually lasts a long time. Exactly how long the battery charge lasts depends on many factors, including

✦ The kind of batteries

✦ The camera model

✦ The condition of the batteries

✦ Temperature (batteries do not perform as well in low temperature conditions)

✦ How the camera is used

The main variables that impact a battery's charge life are common sense:

✦ Using the zoom lens consumes power.

✦ Using the flash consumes power.

✦ Storing larger-sized and higher-quality images uses more power than smaller images.

✦ Using an LCD viewfinder consumes more power than an optical viewfinder.

✦ Using your LCD viewfinder to review images consumes power.

✦ Extensively and repeatedly using autofocusing places demands on the batteries.

✦ Using slow shutter speeds consumes more power than fast shutter speeds.

When all is said and done, you should be able to get between 400 and 1,000 images per battery charge, assuming the batteries are in good condition and charged up to start with. Your actual mileage may vary, as they say, and some photographers seem to be able to take more than the top end of this range on a single charge, but you shouldn't count on getting more photos than this per battery charge.

If you have access to normal electrical power for recharging if you are away from home, you shouldn't have any problems—provided you take care to fully charge your batteries before heading out on a shoot. But if you are in a location without electrical power for a substantial length of time—such as the wilderness or some exotic location—then you need to consider strategies for recharging in the field (figure 2.1).

The first, and easiest, line of defense is to take more than one set of batteries. If each battery pack is fully charged, simply load the next set when your first set of batteries runs low.

> **Tip**
>
> *When you are working in cold conditions, for example photographing winter in the mountains or a ski event, make sure to keep an extra set of batteries handy and warm. The best way to keep the extra batteries warm is to put them inside your jacket or parka in an inner pocket where they are close to your body.*

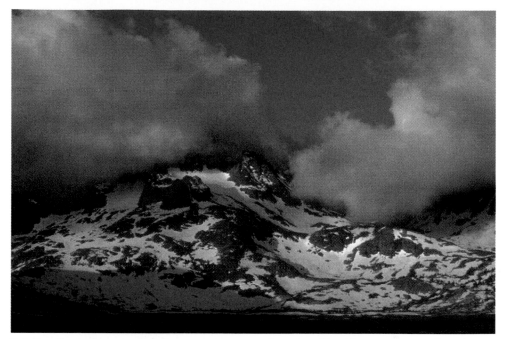

2.1 To effectively use a digital camera in remote locations like this one, you need to plan a strategy for recharging your batteries.

Planning is key. If there is a chance that multiple sets of batteries won't power you through your trip, prepare for that possibility in advance. You can

✦ Plan your trip to only periodically visit locations that have power, even if this means extra travel.

✦ Minimize the power draw of the camera by avoiding use of the LCD and other power-eating actions mentioned in the earlier list.

✦ Depending on the weight restrictions of your trip (for example, you can pack heavier gear on a river raft trip down the Grand Canyon than you can on a backpacking trip to remote areas of Alaska) and the type of rechargeable battery your camera uses, you can bring along a solar-powered recharger.

Note

You can find many types of solar-powered battery rechargers by searching the Internet. Before using this kind of equipment in the field, you should check with your digital camera manufacturer to make sure a solar charger won't damage the batteries. Also, you should test the solar-powered recharger in conditions that are similar to those you will encounter in the field, if possible.

Tip

Rechargeable batteries deteriorate over time. Some batteries loose power just sitting around (NiMH) and others have a finite number of times they can be recharged (lithium-ion), and they also have an age-based life of between two and three years from manufacture if they are used or not. Part of good digital camera maintenance is replacing the batteries your camera uses every year or so.

Setting the Camera

Before you head out on a field trip (whether that is a trek to the wilderness or a visit to a neighboring garden), you should define certain basic camera settings that are not likely to change. You should make these settings based on your personal situation and preferences. The specifics of the menus and menu items used for these configuration options will vary depending on your camera make and model. But no matter what camera you are using, you can (and for the most part should) set

✦ Date, time, and language

✦ LCD brightness

✦ Image quality

✦ Autofocus options

With these basic options set, the camera will function in a predictable manner, so you know you will be able to shoot quickly when necessary. Even when you don't need to take a quick shot, having basic parameters set up will allow you to shoot more and adjust less.

If you've already used your camera, you've probably already set these things. But you should check them before you proceed to the field to make sure all is in order.

It's a great idea to take some practice pictures before starting out on a trip. Get the kinks out while you are still at home. After all, the best way to become a good photographer is to practice.

You may want to have the specific kind of photography you are going to be doing in mind. For example, if you plan to photograph a garden, you should be clear about how to set your camera to take close-ups. That way, if you see the flower shown in figure 2.2 briefly lit, you will be ready to take the picture.

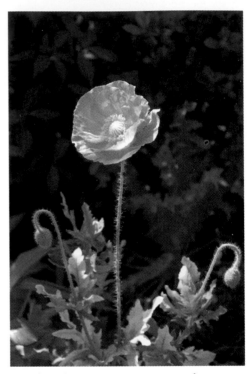

2.2 If you've got your camera set the way you want, you can take advantage of the moment (the light on this poppy faded a moment after the picture was taken).

Cross-Reference *You'll find more information about photography under a variety of field conditions in Chapter 6.*

Setting LCD brightness

As part of the setup options in the main menu for most digital cameras, you can set the brightness level of the LCD screen. Generally, cameras have at least two settings: Normal and Bright. If you don't change the setting, the Normal setting is used as the default.

The Bright setting for an LCD, though certainly brighter, uses more power than the Normal setting; but you can see the LCD more easily in high light conditions, such as those one is likely to encounter outdoors. However, if the light will be very bright, such as in figure 2.3, you should use the optical viewfinder because the LCD may simply not be usable in high light conditions.

Tip *If you have a choice in your camera between an optical viewfinder and an LCD screen, and have gotten used to the LCD because of its accuracy, you should familiarize yourself with the optical finder (and understand how to compensate for its inaccuracies) before taking your camera into high light conditions.*

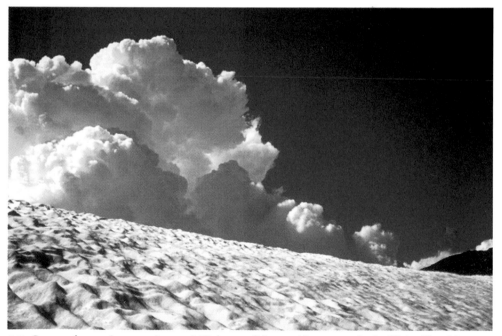

2.3 Composing a picture using an LCD in conditions with a great deal of light, like this snow field, can be almost impossible.

Don't Forget the Date, Time, and Language!

You should have set date, time, and language options when you first took your camera out of its box. But, if you have removed the power source for any length of time, you may need to do it again.

Your digital camera provides timekeeping capabilities. This feature is used to date stamp your photographs. Date and time information is then transferred with the photos to your computer when the images are downloaded. This data — called EXIF information — which includes photo-specific information such as f-stop and shutter speed, can be read in image editing programs such as Photoshop. (This is different from the capability provided by some cameras of printing the date and time on actual photos that are taken.)

Also, don't forget to set the correct language for the menu on your LCD. There are few things more frustrating that being in the field, ready to take the perfect shot, and finding your camera speaks a language that you don't!

Setting autofocus options

Depending on the digital camera, you can either focus manually or choose between two autofocus modes. Different camera manufacturers use different terminology, but essentially the first method locks the focus when you depress the shutter release partway. In contrast, the second method continuously focuses as long as the shutter release is partially depressed. (This second method is sometimes called *tracking*.)

A single-lock mode when you partially depress the shutter release is the best setting for most situations (it also uses less battery power than continuously focusing).

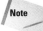 *With some cameras, single-lock mode some cameras prevent you from taking a picture unless the camera can focus — which may prevent you from exposing when you want to.*

Continuous autofocus makes sense only in situations in which you are photographing a rapidly moving subject, for example, young children at play (see figure 2.4) or a sporting event.

Note *There are some kinds of surfaces that fool autofocus devices (for example, highly reflective metal). If your camera cannot autofocus correctly because of the nature of the thing you are photographing, then you should manually focus.*

2.4 If your subject is in constant motion, as young children tend to be, continuous mode autofocus makes sense.

Choosing Your Format

Most digital cameras allow you to choose between JPEG and RAW formats for saving your photos. In addition, many cameras allow you to save images in both formats simultaneously.

RAW means that the bits of information in your photograph have not been compressed, adjusted, or enhanced. It's up to you to tweak the RAW negatives in a program such as Photoshop or Photoshop Elements.

JPEG stands for Joint Photographic Experts Group who devised the format. It is said to be a *lossy* format, meaning that as you add compression of the image, you lose information that can never be recovered.

The bottom line is that if you are just taking a snapshot to use with e-mail or on the Web, JPEG is the better choice. Because JPEG images are compressed, the file size for each image is smaller, so you can fit more of them on your camera's memory card.

However, if you are serious about the quality of your digital photographs, and want to use them in demanding applications, you should make sure to save images in RAW format. In particular, if a photo depends on precise delineation of textures to make a graphic impact, such as in figure 2.5, you will need the greater level of tonal detail that RAW provides.

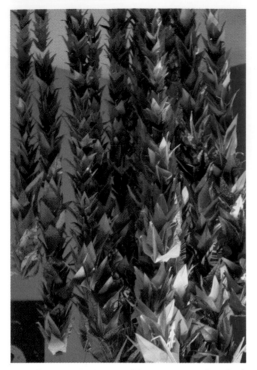

2.5 Camera RAW provides a greater level of tonal detail that is needed for photos with subtle patterns.

Nothing in life is as simple as it ought to be, and there is a wrinkle involving the RAW format: Each camera manufacturer has created their own proprietary version of RAW (some of these variations are shown in Table 2.1).

Note *You should think of RAW and digital raw capture as general terms that describe a number of proprietary formats (specific to each camera manufacturer) that all have a lot in common.*

If you save a photograph in one of the RAW formats, you will need to adjust it later in your computer using a program such as Photoshop or Photoshop Elements.

Cross-Reference *For more information about image editing software, see Chapter 7.*

Specifying image quality

With most digital cameras, you have a great deal of choice about the quality of image that the camera creates. In digital photography terms, when the image is encoded as a JPEG file, image quality refers to how compressed the image is; the less compressed the image — and the larger the resulting image file — the higher the quality is said to be.

Tip *Image quality is related to image format choice, which is discussed later in the chapter.*

Table 2.1
Proprietary Versions of RAW

Manufacturer	RAW Name
Canon	CRW file, CR2 file
Minolta	MRW file
Nikon	NEF file
Olympus	ORW file

Memory Cards

Before you used your digital camera the first time, you should have inserted and formatted a memory card of some kind. The most common digital camera memory device is a card called CompactFlash (or CF for short), shown here.

You should follow the instructions in your camera manual for inserting a memory card. Once you insert the card, formatting may be necessary. Because formatting erases any photos that are on a memory card, most digital camera manufacturers provide a two-step confirmation process to prevent you from erasing important images.

Choosing a level of image quality is largely a matter of personal choice and depends on what you will use the photographs for. It might sound logical to take all your pictures with the highest possible image quality, but the downside to this choice is that the higher the quality of the image, the larger the file size of the saved image. Larger file sizes mean fewer images saved on a given memory card.

If all you want to do is post your images on the Web (perhaps you maintain a Web site or a photo blog), there is no reason to choose a very high level of image quality. On the other hand, if you think your photos may be used for a large, high-resolution print, then certainly you should go for the highest possible quality your camera supports.

Most digital cameras allow you to choose from three JPEG modes, with compression ratios ranging from 1:16 (this is sometimes called *basic* quality) to 1:4 (or *high* quality). Many cameras have two settings for images: The size of the file and the amount of compression. The highest quality JPEG images will have a large size and little compression. Basic quality is suitable for use on the Web, but not for more demanding applications such as the creation of large high-quality prints.

Choosing a Memory Card

Even though your camera came with a memory card, you will, no doubt, want to get an additional card or larger capacity card at some point. So, this section covers some of the details you should know before choosing a new card.

The number of photos a memory card stores depends on three variables:

✦ The size of the memory card.

✦ The format (or formats) selected for saving images.

✦ The resolution (size) that the camera is capable of capturing (for example, 3000×2000 pixels).

Table 2.2 shows fairly typical image capacity for a 512MB memory card.

 Note *Double the number of photos for a card with 1 gigabyte of memory, and cut the number in half for a card with 256 megabytes.*

Memory cards are the film of the digital age — the photos that you take are stored on a memory card just as they used to be stored on film. So it is important when planning your outings to make sure to have enough memory for your trip. There's nothing more disconcerting than running out of memory just before you see the photo opportunity of a lifetime.

An advantage of digital photography, of course, is that you can make room on your memory cards in the field by deleting rejects. (Be careful not to reject your photos unless you are sure the image is something you do not want to keep!) But still, there's no reason not to load up on plenty of memory — particularly as the price of memory cards keeps coming down.

Tip *If you don't want to carry lots of memory cards because of the conditions of your field work, you can download pictures onto a laptop computer to clear them from your memory card.*

Table 2.2
Typical Image Capacity (512MB Memory Card)

Image Format	Capacity
Camera RAW	80 photos
JPEG (medium compression)	300 photos

Protecting Your Camera

If you stop to think about it, a digital camera is essentially a special-purpose electronic computer with a lens on its front. This means (among other things) that your digital camera is extraordinarily vulnerable to weather such as rain and snow, and other conditions such as dust and sandstorms.

You wouldn't think of taking a normal computer out into bad weather conditions; but if you don't take your digital camera into at least some challenging conditions, you will miss many good photo opportunities (figure 2.6).

There's a balancing act here: On the one hand you don't want to needlessly risk your expensive digital camera, but on the other hand too much caution may make your field photographs less exciting. Bad weather can be good weather for the digital field photographer because bad weather can make for exciting, moody, and expressive photos. For example, a photograph of an oncoming storm can convey a sense of nature's grandeur and power in the way that a blue sky cannot (see figure 2.7).

It's important to have a good, padded waterproof case or bag for your equipment if you are bringing your camera into challenging field conditions.

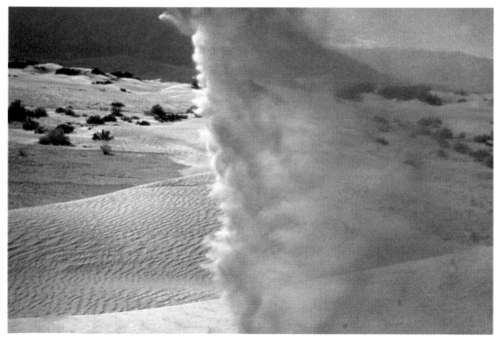

2.6 Weather conditions like this sandstorm can make for great photos but are tough on cameras.

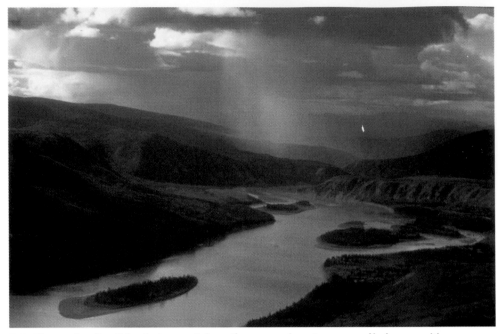

2.7 Moments after this photo was taken, the oncoming storm engulfed my position.

A technique that professionals use in challenging weather conditions is to keep the camera covered until the instant before they are ready to take the picture. That way the camera is exposed to weather for the shortest possible time.

Another good idea is to buy — or improvise — a cover for your digital camera. This can be as simple as a plastic bag or a shower cap, or it can be bought specially for the purpose of providing water- and grit-protection for your camera. In any case, before you set off to take pictures outdoors, you should be sure that the camera cover is really weatherproof (water resistant). You need to also make sure that the cover is easy to get off and on in a hurry.

Companies including Lowepro, Tamrac, and Tenba make good camera bags that are effectively resistant to a variety of adverse weather conditions.

> **Note** *Weather resistant is not the same as waterproof. The only truly waterproof camera housings are made for scuba divers — and these are too awkward to use in normal conditions.*

You shouldn't let nasty weather stop you from taking great pictures, but it is also reasonable to be concerned about your expensive digital photography gear. Think through the precautions you should take to deal with challenging weather before the difficult conditions are upon you.

Getting Permission to Photograph

Being legally and ethically able to take a picture is different from being able to use a photo. As a photographer, you should understand

+ What pictures you can (and cannot) take.

+ What uses of your pictures require releases.

+ What a release should say.

+ How to obtain a release.

What pictures can you take?

Generally speaking, as long as you are in a public area, such as a road, sidewalk, or public park, you are legally allowed to take pictures of anything you see. But being allowed to take a picture does not necessarily give you the right to publish a picture, particularly if you get paid for it. In addition, there are even some restrictions on your right to take pictures. For example, you may run into trouble taking pictures of military installations, even from a public road.

It's important to be respectful of people you are interested in photographing. If at all feasible, ask permission before taking someone's photo (you'll be amazed at how often people agree to it), and remember that you cannot sell a picture of a person without explicit permission from that individual. This explicit permission usually takes the form of a *release*, also called a *model release*.

What uses require releases?

Any recognizable photograph of a person requires the explicit permission of the person (or the parent or guardian of a child) before the photograph can be published. Publication includes posting to your Web site or photo blog, so it's safest to just get a release if you think you might need one.

The requirement of getting permission before an image can be published extends beyond people to their recognizable personal and real property. In other words, you can't publish a photograph of someone's house, or car complete with license plate, without written permission (meaning a signed release).

Theoretically, the First Amendment to the U.S. Constitution creates an exception to the need for a release: You may be able to take a picture of a public figure, such as a celebrity, and publish it without permission. Do yourself a favor and consult with a lawyer before trying this trick.

What should a release say?

Professional photographers know that it is easier to get a release on the spot. If you have to reconstruct contact information after the fact by tracking someone down and then getting him or her to sign a release, your photo may never get released. So serious photographers carry blank releases, and get their subjects to sign them every time they take a photo of a person.

A release need not be very complex. It should be dated, and provide a name and contact information for the subject. The subject (or parent or guardian if under 21) should sign it. Here's the text of a simple standard release:

"For value received, I consent to the publication of my photograph used by [Digital Photographer's Name] whether or not with my name or any text, captions, illustrations whatsoever, and I release him or her from any liability for such use in any and all media."

If you are serious about your digital photography, and think there is even a chance that you may want to publish your photographs, you should include some release forms as part of your field kit.

Getting someone to sign a release

If you've read the sample bit of release text in the previous section, you may have wondered what "value received" meant. Because usually you are not paying someone to take his or her picture, the value received is your efforts in taking the picture. This text reflects the fact that most people like having their picture taken (see figure 2.8).

> **Note** *Offering to send someone a copy of his or her photo is often an effective way to get them to sign a release.*

If you approach your subjects with respect, 99 times out of 100 they will sign a release. So just ask!

2.8 Most people like having their picture taken and will sign a release if requested.

Creating Great Photos with Your Digital Camera

Photography Basics

Digital cameras are great! The computers that are the brains inside these hunky little machines do a magnificent job of properly exposing and focusing photographs for you most of the time. But the key phrase here is "most of the time." When you point and shoot, your digital camera does not always get it right.

You need to know when and how to control your camera manually to make sure that the program inside your camera doesn't make mistakes. (Yes, you can be smarter than your digital camera!)

Understanding when and where your digital camera can go wrong, and how to fix the problem, requires understanding the basic principles of photography, which you learn all about in this chapter.

In addition to good digital cameras doing the wrong thing, there's another reason to learn the basics of photography: Good photography often goes beyond point-and-click. If you want to be the best photographer you can be, the more you understand about the basics, the better!

Understanding Exposure

Properly exposing a photograph is the most difficult technical challenge facing digital photographers. If a photograph is improperly exposed, it doesn't matter how wonderful everything else in the photograph looks: You might as well not have bothered taking the picture.

On the surface, exposure doesn't seem that difficult. You tend to know good exposure when you see it, and you also know when you see an underexposed photograph (too dark) or an overexposed photograph (too light).

In fact, if a scene being photographed has average tonality — a term popularized by Ansel Adams meaning the consistency of the range from dark to light of the different areas of a photograph — consistent lighting, and a stationary subject (figure 3.1), it's pretty easy to get the exposure right.

However, these are a lot of "ifs." In the real world, not all photographs (including some of the ones you probably most want to capture) meet one or more of these criteria because the subject of the photograph:

✦ Uses a wide tonal range (figure 3.2).

✦ Is inconsistently lit (figure 3.3).

✦ Is in motion (figure 3.4).

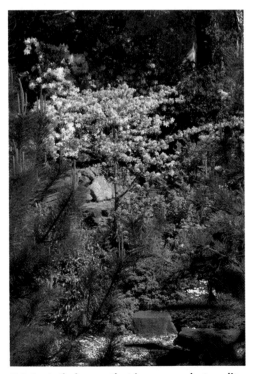

3.1 A static image that is average in tonality and consistently lit, like this photograph of a flowering tree in a Japanese-style garden, is easy to expose properly.

Note *The photograph shown in figure 3.3 actually works because it was exposed for the bright landscape, and the window frame was allowed to become very dark.*

In these situations, you need to have a good grasp of exposure basics to get the best photograph possible in the field.

There's nothing wrong with using your digital camera in one of its automatic modes. But you should know enough about exposure to ensure that the camera's choice of exposure provides the results you want.

One technique for obtaining a good exposure is called *bracketing*. Essentially, bracketing an exposure means taking lots of photographs and varying the exposures, usually by changing the camera's aperture. In fact, some digital cameras automatically bracket for you.

Note *Most bracketing takes more than one stop up or down. You also don't have to bracket a full stop; depending on the camera, you could bracket in half step stops.*

In some very tricky situations, bracketing exposures makes sense. However, there are some downsides to bracketing:

✦ You take more photos, so your storage media gets filled quickly.

✦ Sorting through the resulting clutter of multiple pictures can be difficult.

✦ Most important of all, spending the time to take many pictures of one subject can be impossible in some situations (when the subject is moving, for example) and takes away some of the joy and spontaneity of photography.

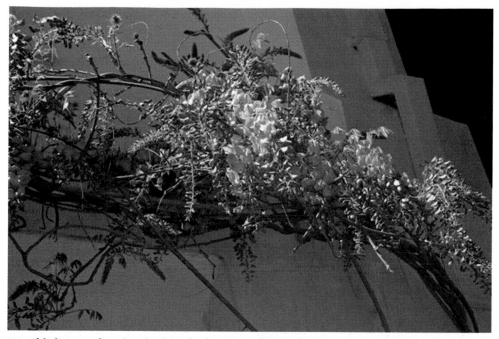

3.2 This image of a wisteria vine climbing a wall presents an exposure challenge because of its tonal range.

Cross-Reference *You can usually correct problems involving exposure or tonal range using digital darkroom software such as Photoshop Elements or Photoshop. See Chapter 7 for more information.*

Proper exposure is ultimately something of a judgment call, and is therefore not something you can expect to always obtain from the automatic capabilities of a digital camera, or even from a light meter.

Essentially, proper exposure means that tonal values, and light and dark, come out the way you want them to. You can expose an image in multiple ways. At the same time,

there is a maximum possible range between light and dark that you can capture. To properly expose a given subject (for example, to make sunlight on turning leaves and a running brook appear to sparkle) you must sometimes allow certain other areas to appear too dark, as in figure 3.5. An easy way to achieve this exposure effect with most digital cameras is to partially depress the shutter release to lock exposure settings on the portion of an image you want to expose for (in this case, the sun on a running brook). Then, shift the camera to the composition you want, with the exposure for the brighter areas still locked in place.

The point is really clear in the photograph of New York City's Chrysler building shown in figure 3.6. Exposing the photograph to average the light in the subject would have produced a poor photograph. To create the dramatic image shown in the figure, it was necessary to choose an exposure for the sunlit Chrysler building in the rear of the photo, and let the in-shadow buildings that frame the photo go black.

If I had had a spot meter handy, using it would have helped me to determine an accurate exposure. I didn't have a spot meter with me, but I knew I would need to underexpose the image related to the in-shadow buildings. Using the camera's overall meter reading as a starting place, I used manual exposure controls to successively stop the camera down, shooting a number of images, and choosing the best one.

3.3 This photograph presents an exposure challenge because the foreground (window) is dark and the background (landscape) much brighter.

Exposing for Light versus Dark

Seasoned digital photographers have learned that it often makes sense to expose for lighter areas of an image, and let darker areas — for example, parts of the photo in shadow — go dark, or even black. This exposure philosophy can work well because it is easier using digital darkroom software such as Photoshop Elements or Photoshop to correct dark areas using techniques such as dodging than it is to cure overexposed parts of a photos by burning details into them. In addition, if you are saving your images in a RAW format, essentially these exposures are automatically bracketed. When you import them into digital darkroom software you can choose which exposure to use — and even pick different adjustments for highlights and shadow areas.

3.4 Subjects in motion, like this photo of a merry-go-round, require an instant grasp of the trade-offs of using different exposure combinations.

3.5 To get the effect of sparkling light on the trees and brook, you need to set the exposure to allow parts of the image to appear almost black.

An automatic exposure system would not likely have come up with the settings used to take the picture shown in figure 3.6, which deprecate one portion of the image to benefit the key element of the picture. This shows you how important it is to understand exposure and not rely solely on automatic camera settings while in the field.

The other side of the exposure coin is that you must sometimes overexpose parts of an image so that the areas you care about come out right. For example, figure 3.7 shows a flower bud embedded in ice by an early spring storm. The photograph had to be exposed to allow the sky to wash out completely, or the flower wrapped in ice (the point of the photograph) would not have been properly exposed.

3.6 This dramatic photograph works, although parts are underexposed.

3.7 This photograph works, although the background is overexposed.

The Three Elements of Exposure

The three elements that combine to make an exposure are the

✦ Sensitivity of the image capture mechanism (ISO)

✦ Aperture setting for the camera lens

✦ Shutter speed used by the camera

Note *Of course, you can't have an exposure without also having a lit subject to photograph.*

ISO (International Standards Organization) refers to the sensitivity of the image capture mechanism. With a traditional camera in the old days, ISO would have meant the speed of the film used (sometimes designated by an ASA number).

The *aperture* is the size of the opening, or *diaphragm*, used by the camera lens. A camera lens open as far as possible is said to be *wide open*.

Shutter speed means how long the camera's shutter remains open while the exposure is being made. Generally, this is a fraction of a second.

Essentially, there's an equation here: ISO + aperture + shutter speed = your photographic exposure. How well or poorly this exposure comes out depends on the light conditions of your subject, and your idea of how the photograph should look. If you don't understand the exposure basics explained in this chapter and leave it up to the camera, then it is the camera's automated software that determines the exposure, not your vision.

The Role of ISO

If you leave your digital camera on automatic and don't change any of the settings, most likely the camera will use an ISO number of 100 or 200. This number is likely to be the lowest ISO that your camera can use. ISO numbers can be set a great deal higher — depending on the camera model, as high as 3200 in higher-end cameras.

The higher the ISO, the better your camera is at taking pictures in low light conditions. Conversely, the higher the ISO, the greater the noise-to-signal ratio (as an engineer might put it). This means that as the ISO used gets higher, you get more and more bad — or erroneous — pixels in your image. You can think of the noise that these bad pixels generate as being essentially random, and the randomness increases the higher the ISO is set. So the goal is to set the ISO as low as possible, as long as the photograph is viable. You don't want to take a picture of a beautiful mountain landscape in broad daylight using a high ISO; it's not necessary, and will degrade the image. On the other hand, raising the ISO may be the only way to get a picture in low light conditions, particularly if a flash cannot be used.

The ISO used by your camera, if you decide to override the default, is set using a scale. In other words, you can't just pick out an ISO number you'd like to use; you must select a number (or *stop*) from the scale. Each number on the scale theoretically doubles the sensitivity of the image capture mechanism.

Here's the ISO scale from 50 to 1600 ("slowest" to "fastest"): 50, 100, 200, 400, 800, and 1600.

If your camera provides this ISO range, you can (in theory) select any one of these six ISO settings. Many cameras provide an

automatic ISO setting, which raises the ISO as needed to capture an image.

 Note *As a practical matter, most of the time you should leave the ISO at 100 or 200.*

Tip *You can think of moving up or down by one on the ISO scale as having the same impact on exposure as changing the camera f-stop by one aperture up or down (or halving or doubling the shutter speed). See the section on "Understanding Aperture" for more information.*

So, if the good news about raising the ISO is that you can take pictures in lower light conditions, and the bad news is that the signal-to-noise ratio degrades, adding garbage to your pictures, how bad is the degradation?

Image degradation depends on many factors, including the engineering of the image capture mechanism, how many sensors are used, and how they are arranged. It's also a statistical effect, which means that it is not predictable. Even at the same ISO, with camera settings all the same, two frames may vary in their level of degradation.

Bad pixels usually appear as white, cyan, magenta, or yellow, but can be any color.

Tip *If you experience a bad pixel or pixels in exactly the same place in many pictures over time, this is probably a camera defect called having a hot or stuck pixel. (Stuck pixels appear all the time, and hot pixels only appear in pictures taken with a long exposure time.) In either case, if you have a recurring bad pixel, you should have the manufacturer examine and repair the camera (particularly if it is still under warranty).*

You tend to get more image degradation at lower light levels than at higher light levels because the software in the camera can better filter out random pixels when it is lighter (when more information is available to be processed by the camera's sensors).

The amount of degradation you get is to some extent random, and depends on many factors, including your camera, the quality of its image capture mechanism and software, and what you are photographing. But roughly speaking, at an ISO of 100 you can expect degradation of less than 1/100 of one percent of the pixels in an image. By the time the ISO has been raised by a factor of 16 to ISO 1600, image degradation can be as high as five percent of the total pixels in an image.

Note *If as much as five percent of the pixels in an image were bad, your photograph would look blotchy most likely, not a result you want.*

So if you boost the ISO due to low light conditions, don't expect pixel-perfect images. And remember to reset the ISO so that your pictures of normal subject matter don't show pixel loss.

Understanding Aperture

The aperture of a lens means how large the opening of the lens is. This size is controlled by a mechanism in the lens called a diaphragm (also sometimes called the *iris*). When the lens is "wide open," its diaphragm is in the fully open position. When a lens is "stopped down," the diaphragm is closed as far as it can be while still being able to take a picture.

Like ISO, the lens aperture is set using a scale containing stop values. The stop values in the scale for lens aperture are called *f-stops*. The lower the number on the f-stop scale, the wider the lens opens. For example, at its most open ("wide open") a lens might be set to f/2.8, and when fully stopped down, the lens might be set to f/32.

Each stop on the f-stop scale lets in half the light to the photograph being exposed than the previous f-stop. Here's the scale with all the full stops between f/2.8 and f/32: f/2.8, f/4, f/5.6, f/8, f/11, f/16, f/22, and f/32.

Because each stop lets in half the light of the stop before, f/8 lets in 1/8 of the light of f/2.8 (there are three stops between them). By the time you stop down to f/32, the lens is letting in 1/64 of the light of the lens at f/2.8.

Tip *If you think of f-stops as fractions (as they actually are), it will help you internalize the notion that a smaller f-stop number represents a larger actual lens opening.*

Unlike ISO, raising (or lowering) the f-stop does not create image degradation. Provided an image is properly exposed (meaning exposed the way you'd like it), the only difference between one f-stop and another is the depth of field produced by using the f-stop.

Cross-Reference *For more on depth of field, see Chapter 1.*

If you close the aperture to get more depth of field, something else has to change to compensate. If you are unwilling to raise ISO due to image degradation, that something has to be lowering the shutter speed.

But it can be difficult to lower the shutter speed if you are photographing a subject that involves motion.

Controlling the aperture (the f-stop) of your photograph impacts both the depth of field of the photograph and (because it impacts exposure time) how motion will appear. So you need to make a decision about how you want depth of field and motion to appear in your photograph — or allow this decision to be made by one of the semi-automatic modes in your digital camera.

Setting different aperture modes

It's possible — and sometimes necessary — to set the lens aperture along with the shutter speed.

Note *Shutter speeds are explained in detail later in the chapter.*

Depending on your camera model, it will almost certainly have an *aperture-priority* mode. In aperture-priority mode, you set the aperture and the camera picks the corresponding shutter speed. (A related mode is *shutter-priority* mode in which you pick the shutter speed, and the camera selects the proper f-stop.)

Note *You may find that different camera manufacturers call these modes by slightly different names, even though they have the same functionality. Check your camera's manual to determine the aperture modes available and what they are called.*

The other aperture modes that are available depend on your camera model. Besides aperture priority, in which the camera picks

the shutter speed, and fully manual modes, most digital cameras have a programmed *aperture multi-mode* available. In programmed aperture multi-mode, the camera shows you the possible aperture and shutter speed combinations that its computer has determined will produce an optimal exposure. You can usually use this mode to automatically bracket exposures, which is explained later in the chapter. This mode can also be used to intentionally underexpose or overexpose an image by a specified percentage without having to concern yourself with f-stops.

> **Note**
> *Almost all cameras also have a fully automatic mode in which the camera does all the work, and the photographer can't fine-tune exposure settings.*

> **Note**
> *The correct exposure is always the one that the photographer deems is right after reviewing the picture that was taken. Underexposure and overexposure from the camera-eye view are theoretical concepts based on a programmatic model of proper exposure. The camera's idea of correct exposure may not produce the best photograph, or one that is exposed the way you'd like it to be.*

Which aperture should you choose?

The choice of aperture has two primary implications. It determines

✦ Depth of field, or how much of the image besides the area focused on appears sharp.

✦ Choice of shutter speed, which impacts how motion is rendered in your photograph, and whether camera shake will be a significant problem.

Lenses are made of optical glass arranged in a complex series. Most lenses perform better — meaning render images with more crispness, and render colors more attractively — at some f-stops than at others. In addition, although lenses are made using modern manufacturing processes with every attempt at standardization, the fact of life is that different pieces of glass vary. So even lenses with identical labeling from the same manufacturer are not all the same.

You will not learn from camera manufacturers which are the best-performing f-stops from an optical viewpoint on a given lens. The only way to find out which f-stops provide the best results is to take lots and lots of pictures, keeping track of the f-stop used for each. Over time, you will get to know the idiosyncrasies of your lens.

Generally the best-performing f-stops on a lens occur in the middle of the range of f-stops the lens provides, usually f/5.6, f/8, and f/11. But the performance difference between the best and worst f-stops can be very slight, so other factors, such as depth of field, and rendering of motion, often determine the choice of f-stop.

Working with shutter speeds

The range of shutter speeds you'll find on your digital camera vary according to the model. It's typical for an advanced amateur camera with an LCD Viewer such as a Canon PowerShot or a Nikon COOLPIX to have a shutter speed range from 1/4 of a second (longest exposure) to 1/2000 of a second (shortest exposure). A digital SLR such as the Nikon D70 is likely to have a range from 30 seconds (longest exposure) to 1/8000 of a second (shortest exposure).

Most digital cameras also allow you to take *bulb* exposures in which you manually keep the shutter open as long as you'd like. With a bulb exposure, you can have exposures as long as several hours, although this isn't done too often because there's usually no need for it, and exposures longer than a few minutes require a great deal of patience.

Using a time exposure, it is possible to take photographs in extremely low light conditions. For example, the photograph of ice skaters in a rink by moonlight shown in figure 3.8 was exposed manually for about 15 seconds.

If you want as much of your photograph as possible to appear sharp, then you need to choose a small f-stop such as f/16 or even lower. In this case, a slow shutter speed will probably be needed. If the camera shakes when a picture is taken at a slow shutter speed, then the whole photograph will look blurry (and having high depth of field does you no good — it is a little like worrying about

mosquitoes when a bear is charging right at you). So photographs where things in both the foreground and background appear sharp, and that use a high depth of field, are usually taken with the camera on a tripod, as was the picture shown in figure 3.9.

Caution

Camera shake is always a possibility at shutter speeds of 1/125 of a second and longer and almost always occurs at shutter speeds longer than 1/30 of a second.

How slow a shutter speed you can use depends on your native ability in this arena, and the position you need to assume to take the photograph. If you have to hold a camera high over your head, obviously it will shake more than if you are able to crouch and brace yourself.

The longer the focal length of a lens on a camera, the more camera shake is a problem, and the faster the shutter speed you need to avoid it.

3.8 Pictures can be taken in extremely low light conditions using manual time exposures.

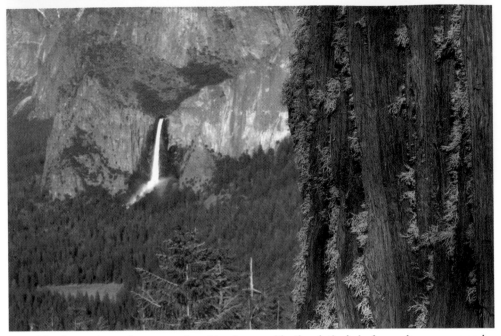

3.9 This photo shows foreground and background both relatively in focus; it was exposed at f/22 using a tripod.

A wonderful effect in the field is to capture motion in a photograph by creating the illusion of stopping motion. This works particularly well with water, but you can apply it to moving trees, grass, clouds, and so on. When you look at flowing water normally, you see the water actually flowing past. But if you use a long exposure, like in the photograph shown in figure 3.10, the water in the stream is apparently solidified as it flows across the picture.

The point of the example in figure 3.10 is that if you require a long time exposure for special reasons — for example, because you want to freeze water in motion — then you need to choose a small aperture such as f/32 that enables a long exposure.

It's often easiest to approach this from the opposite direction. Using the camera in shutter-preferred mode, you select the (slow) shutter speed you'd like. The camera will then select the corresponding (wide) aperture.

Generally, besides the optical peculiarities of specific lenses, and the impact of aperture on depth of field, the other reason for choosing an aperture has to do with its impact on exposure time (shutter speed). You may need to choose a small aperture to get a long exposure time, as in the previous example.

A middle ground is used to create an effect showing partially stopped motion that also appears very natural. For example, the photograph of the waterfall in figure 3.11 shows the water "naturally," pretty much as it would appear to a human observer at the scene of the Columbia Gorge. This water is apparently frozen in mid-tumble. It's not "frozen" so precisely that motion is stopped (there is some blurring caused by the water), but at the same time the water is not "solidified" the way it would be for a time exposure.

The photograph shown in figure 3.11 was exposed at 1/125 of a second, which was chosen to partially stop the motion of the water. For this photograph to be properly exposed, a shutter speed of 1/125 of a second meant using an f-stop of f/8.

Tip *A shutter speed of 1/60 or 1/125 of a second usually creates the effect of partially stopped motion.*

3.10 The flowing water in this photograph of a stream appears "solidified" due to a long exposure time.

Table 3.1 should give you a general idea of how different ranges of shutter speeds render motion.

Conversely, if you want to stop motion, or to negate the effects of camera shake when you aren't using a tripod, you need to use a fast shutter speed. Very often, you will need to open the lens up, choosing a large aperture such as f/2.8, to use a fast shutter speed.

Photography has been called the art of freezing time. Time is frozen by pairing a shutter speed with an aperture. Choosing a combination aperture and shutter speed that produces an effect to match your vision for your photograph is one of the most basic tools available to the photographer.

Note *Using a shutter-preferred mode, you can pick your shutter speed, and the camera will choose the correct corresponding aperture.*

Tip *A shutter speed of 1/500 or 1/1000 of a second will stop (meaning freeze) almost all motion.*

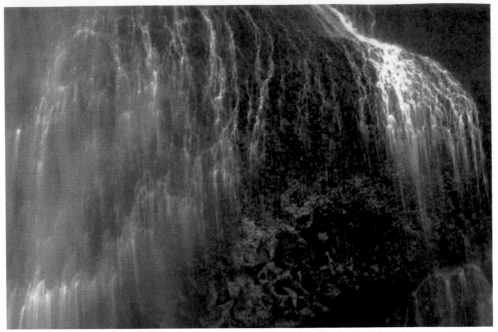

3.11 Due to a moderate exposure time – not too fast, and not too slow – this waterfall appears just about as it would to an on-the-spot observer.

Table 3.1
Shutter Speeds and Motion

Shutter Speed Range (in Fractions of a Second)	Impact on Motion
1/500–1/1000	Freezes most motion
1/30–1/125	Partially stops motion, produces an apparently natural rendering
Slower than 1/30 (longer exposures)	Almost certain camera shake will produce blurry images unless you use a tripod
Slower than 1/2 (longer exposures)	Motion is "solidified" (the longer the exposure the more solid it appears)

Shutter modes

The opposite side of the coin of aperture-preferred exposure modes in a digital camera is to use a shutter-preferred semiautomatic mode.

In a shutter-preferred mode, you pick the shutter speed, and the camera assigns the corresponding f-stop for the camera's idea of the proper exposure.

For example, to create the image shown in figure 3.12 — which shows crisp, still leaves on the water, but also slight tails for leaves in motion — you can put the camera on a tripod and select a shutter speed of 1/4 of a second.

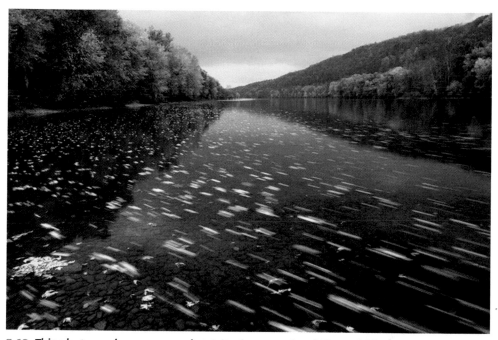

3.12 This photograph was exposed at 1/4 of a second and f/22, which created the effect of adding slight tails indicating the leaves in motion.

Equivalent Exposures

You've probably got the idea by now that at a given ISO, there is a range of equivalent exposures that provide a "correct" exposure for a given subject. Each item in this range of equivalent exposures consists of an f-stop paired with a shutter speed.

> **Note**
>
> *Correct exposure means the desired exposure — because theoretically there is no such thing as a correct exposure, only the exposure that makes your photograph turn out the way you want. If you leave your camera in its automatic, point-and-shoot mode, the camera determines the correct exposure. If you override the camera's measurements and control the exposure yourself (for example, to underexpose an image to favor one area), the underexposure is the correct exposure — provided the photograph turns out the way you want it to.*

There is no difference in the exposure created by any of the f-stop and shutter speed exposure equivalencies. The differences in the final image is due to the optical qualities of your lens at different openings, differing levels of depth of field, and the impact of differing shutter speeds on the depiction of motion.

The digital photographer who is in creative control chooses one exposure equivalency, with or without the help of camera automation. This exposure equivalency best embodies the vision of the photographer. An example will probably help you to get a better feeling for the concept of exposure equivalences.

Suppose you are in the process of taking a picture outside on a very sunny day. A natural exposure in these kinds of conditions might be 1/250 of a second and f/8. Tables 3.2 and 3.3 show the equivalent exposures as you move to faster, such as to stop motion, or slower shutter speeds, for example to get higher depth of field.

There's not a whole lot of apparent difference between the exposure equivalents of 1/125 of a second and f/11, 1/250 of a second and f/8, and 1/500 of a second and f/5.6 (although f/11 does provide more depth of field than f/5.6, and 1/500 stops motion and eliminates camera shake more completely than 1/125).

But at either end of the ranges shown in Tables 3.2 and 3.3, the impact of the choice

Table 3.2
Equivalent Exposures (Faster Shutter Speeds)

Shutter Speed (Fraction of a Second)	F-Stop
1/250	f/8
1/500	f/5.6
1/1000	f/4
1/2000	f/2.8

Table 3.3 Equivalent Exposures (Stopping Down)	
F-Stop	**Shutter Speed (Fraction of a Second)**
f/8	1/250
f/11	1/125
f/16	1/60
f/22	1/30
f/32	1/15

from among the equivalent exposures becomes glaringly obvious. At 1/2000 of a second and f/2.8, depth of field is extremely shallow, and motion is frozen. On the other hand, at 1/15 of a second and f/32, there is tremendous depth of field, motion appears somewhat blurred, and camera shake is a significant problem (you should probably count on using a tripod).

Getting Colors Right with White Balance

White balance is a wonderful tool for getting colors right with a digital camera. Film photography has no facility that compares with the ability to set and adjust white balance in the camera.

The color of light is measured in Kelvin degrees. The lower the Kelvin numbers, the warmer (or redder) the light appears, and the higher the Kelvin number the cooler (or bluer) the light appears. Table 3.4 shows the Kelvin degrees for a number of common kinds of lighting conditions that photographers might encounter.

In the bad old days of film, a given kind of film was rated for a specific number on the Kelvin scale. For example, daylight film was rated for 5,000°K.

If you took a picture with film rated for one kind of light in another kind of light, the colors would be far from expectations. For example, using daylight film rated for 5,000°K, a photograph taken under 3,000°K incandescent light would look orange, a photograph taken in 10,000°K shade would look blue, and a photograph taken in 20,000°K fluorescent would look green.

Note *There's a great range in the possible Kelvin numbers for fluorescent light (although it is usually closer to 10,000°K than 20,000°K).*

White balance is a digital technique for correcting images to make them appear neutral no matter what the lighting conditions.

Tip *You can experiment with changing the white balance settings in your camera for creative purposes, in addition to the primary use of white balance for achieving neutrality.*

Table 3.4
Kelvin Degrees for Common Kinds of Light

Lighting Conditions	Kelvin Scale
Lowest threshold of visible light	~750°K
Sunlight at sunrise	1,800°K
Candlelight	1,800°K
Incandescent lighting	3,000°K
Normal daylight	5,000–5,500°K
Flash	5,400°K
Cloudy daylight	~6,000°K
Daytime shade (can be surprisingly cool)	As high as 10,000°K
Fluorescent lighting (varies tremendously, even with a single light source)	10,000–20,000°K
Northern sky (above the Arctic Circle, around the summer equinox, midnight, camera pointed north)	28,000°K+

Generally, with a digital camera, there are three modes for setting white balance:

✦ Automatic

✦ User-selected mode

✦ Manual (also called *custom*)

In automatic mode, the camera does its best to figure out the kind of light conditions, and to assign an appropriate white balance setting.

In user-selected mode, you pick one of a number of settings that tells the camera about the lighting conditions; it can then use the most appropriate white balance. If you know you are going to be taking pictures in a specific lighting condition, such as under incandescent lights, you should choose this white balance setting rather than relying on the camera's ability to automatically detect the kind of light.

Typical settings include

✦ Incandescent

✦ Fluorescent

✦ Direct sunlight

✦ Flash

✦ Cloudy

✦ Shade

White balance is determined manually by pointing the camera at a reference object, usually a white or grey card, in the lighting conditions you encounter. With the reference object filling the camera, you can use the menus specific to your digital camera (check your camera's manual) to obtain a white balance.

Note *Depending on the digital camera model, you can also save and recall a white balance setting. With some cameras, you can also obtain a white balance setting using another photograph taken by the same camera.*

For example, suppose you are photographing far north in Alaska above the Arctic Circle in midsummer with the light coming from the northern sky. These are conditions that, with a standard white balance setting, produce blue-green images. You may *want* your pictures to appear with this off-color as a special effect (or so that everyone looking at the picture knows you were in the field and off the beaten track); but if you want your photographs to appear with neutral color balance, like the photograph of Alaska in figure 3.13, you should obtain a manual white balance setting for the lighting situation.

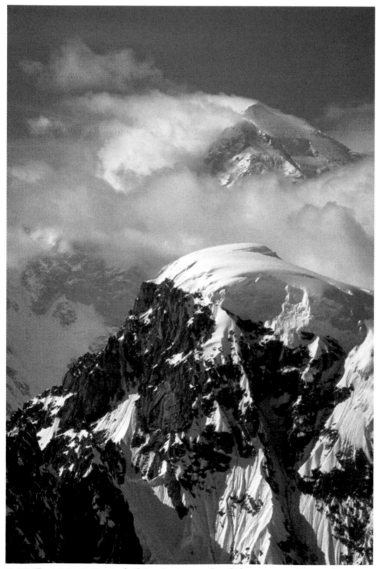

3.13 To appear neutral, this photograph of the remote Moosejaw Mountain in Alaska required a manual white balance setting.

Getting Good Close-Ups

You may use a special macro lens to take close-up photographs, magnification filters placed in front of your camera lens, or simply the zoom lens that came with your digital camera. Whatever lens you use, getting good close-up photographs undoubtedly involves some special considerations.

Close-up means just that — *close*. At close range, defects show. The rule is this: Even if you don't see a flaw when you are composing a picture, it will be very apparent in the final picture. The closer you get, the more apparent.

For example, the image shown in figure 3.14 looked like an attractive photo of saturated flowers in the rain.

One look at this picture on the computer shows the dead buds and other imperfections. If you intend to take a picture of dead buds, that's fine. But usually these imperfections creep into close-ups without the photographer being aware of them.

The moral is to scrutinize imagery extremely carefully. You'll rarely see a close-up that seems perfect to you without taking some remedial action. For example, when preparing for the image in 3.15, I intervened to arrange the curled leaf on top. Although some imperfections still show, there are far fewer than if I had relied solely on nature.

The closer you get to a subject, the less depth of field you have. This means that the in-focus plane is shallower, and that the parallelism of the camera plane to the plane of the subject is more important with close-ups than with distant landscapes. After all,

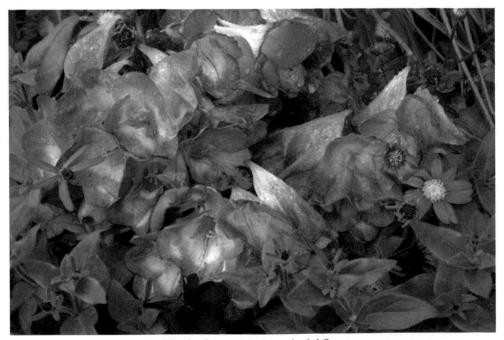

3.14 You can see some dead buds along with the colorful flowers.

3.15 Getting good close-ups often means helping to arrange nature.

what does a divergence of a couple of degrees matter when you are photographing the Matterhorn? No one will ever see the difference in the final photograph. However, minute changes of angle make a huge difference when the camera is close to the subject.

The best way to deal with the shallow depth of field inherent in close-ups (besides stopping down the lens to the aperture with the greatest feasible depth of field) is to locate the most important plane in the photograph, and then make sure the camera is parallel to that plane.

For example, in figure 3.16, the leaves of the exotic geranium go in every direction. But

it's clear that the central leaf is most important to the photograph, so the camera's geometry was aligned with the plane represented by that leaf.

Part of careful observation of a close-up subject is noticing the light that falls upon it. Harsh lighting, often the result of a sunny cloudless day that might seem perfect to a snapshot photographer, often produces close-ups that are too full of light and dark contrast. Overcast, foggy, and misty days produce the best light for close-ups, light that heavily saturates the colors in the close-up. So get out your digital camera and raincoat on those slightly misty days—or move to the moors!

3.16 The camera was positioned to be parallel to the central leaf.

Using your camera's macro facility

Many digital cameras provide facilities or modes specifically intended for use with close-up (or macro) photography.

For example, the Nikon D70 has a Close-up mode in which the camera automatically exposes and focuses for an image in which the main central subject stands out.

> **Note** If you are creating a close-up image that does not meet the criteria discussed in this chapter – for example, the crucial area of the photograph is off to one side – then you should probably not use the Close-up mode with the D70.

Other cameras have close-up, or macro, modes with a somewhat different purpose. In these cameras, such as the Canon PowerShot series, the Macro Mode is engaged to enable the camera to focus closer.

With a camera such as a Canon PowerShot, you can tell that you need to engage its Macro Mode when, as you get closer to a subject, you are no longer able to get the image in sharp focus. Simply engage the Macro Mode to implement a closer range of focusing.

> **Tip** You need to disengage from Macro Mode to focus on objects at a normal distance again.

Note *With a camera like a Canon PowerShot (which does not have an interchangeable lens) the Macro Mode lets you focus close enough so that your entire subject is about the size of a business card.*

Focusing accurately

You may find that the autofocus facility in your camera behaves erratically when you are photographing close, particularly when shiny, reflective surfaces such as glass or metal are involved. Depending on the quality of the LCD Viewer your camera provides, you may be able to tell that there is a focus problem when you review the image. You'll certainly be able to see a focus problem when you download your photograph to your computer — but, of course, that may be a little late to fix the problem.

You'll know your camera is having difficulty focusing if, with the camera held still in one place or mounted on a tripod, you hear the autofocus mechanism continually activating and going back and forth, or if the camera locks and refuses to take the shot because it cannot focus. What is happening is that the beam the camera uses to triangulate and fix its focus is being sent back in a way that fools the camera (figure 3.17). You will need to focus manually.

Focusing problems happen with close-ups more often than you may think. If you detect a focusing problem, you should manually focus, making sure to focus on the most important area of your photograph.

3.17 The reflectivity of the bell on this antique typewriter had the autofocus mechanism stumped.

Composing Great Photographs

Photographic *composition* means the visual organization of your photographs. Composition is a huge subject in itself, closely related to visual and graphic design. Entire books have been written about it.

Composition is very important. To some degree, exposure is an issue of craft — a photograph is either correctly exposed, or it is not. Composition is where the art of photography comes in. Composition is about how you see the world and render it into a two-dimensional photograph that is interesting, informative, or compelling to look at.

You won't learn everything there is to know about composition here. Some of the ability to compose a photograph is probably innate, and a great deal of photographic composition is learned. You learn it by taking a great many pictures, and seeing how you (and other people) respond to the pictures you have taken. As you learn photographic composition, try to use each photograph as a learning experience. Note what worked and what didn't.

Here are some ideas to help you get started with photographic composition.

To start with, you should train yourself to pre-visualize what a photograph will look like. A photograph is a static, two-dimensional rendering not like the real-world dynamic scene you experience that is full of sight, sound, motions, and smells that will never be rendered in the photograph. Surprisingly few photographers make this translation successfully in their heads before they take a picture. Successful translation of the complex multi-dimensional real world to a photograph uses skill in knowing in advance how the subject translates into two dimensions. A useful exercise for teaching yourself to do this is to look at a three-dimensional subject. Next, lock into your memory what you think the photo of the subject will look like. Then take the photo. Finally, compare your memory of the projected photo with the actual photo. You'll be surprised at the difference — but over time, with practice, you can learn to improve this perception.

Ultimately, plan to please yourself. It never works to plan a photographic composition around what you think someone else will like because you can never really tell what anyone else will like anyway.

Make sure to wander around a subject so that you find the best and angle and view for your photograph. Don't assume that what you see first will be the best view for photographing something. If at all possible, take your time looking before you photograph. Make sure you don't accidentally include something in your photograph that shouldn't be there.

Decide what is important about your photograph. Zero in on the important elements, and try to eliminate distractions. For example, a horizon line that is angled rather than straight is a particular distraction for people when they look at a photograph, so try to avoid this in your photographs.

If the subject you are photographing has minor flaws or is improperly lit, try to correct the problem before you take the picture.

Patterns can be extremely interesting compositionally. For example, the pattern of leaves shown in figure 3.18 is attractive because of its motion, color, and symmetry.

Beware of creating boring compositions. The world's full of enough mediocrity; there's no reason your photographs should be conventional. Photographs with the most important part of the subject dead-smack in the middle tend to be dull. Ditto for horizon lines running right through the middle of a photograph.

Presenting the unexpected in a composition, like the rocks *above* the clouds in figure 3.19, can lead to more interesting and intriguing photographs.

3.18 These colorful autumn leaves on a puddle create an interesting pattern.

3.19 This composition causes viewers to do a double-take because the rocks seem to be floating above the clouds.

Putting It All Together

This chapter explained exposure, apertures, shutter speeds, and composition. In other words, all the basics you need to understand how to take a photograph from a conceptual viewpoint. This is a great deal of information, but how do you put it all together under field conditions to take great photographs?

The key ingredient is to be yourself. Your photographs are a reflection of your personality and how you see. Don't try to force them to reflect someone else's vision.

You should try to internalize the key points of exposure explained in this chapter. With some knowledge, you choose whether to rely on your camera's automatic features or to override the automatic settings when they don't provide the results you'd like to see. Regardless, the knowledge you gain from understanding some basic photography concepts will make outings with your camera much more fun and rewarding.

Lighting Your Photos

If digital photography is about capturing time in a two-dimensional frame, the tool used for this capture is light. Reduced to its barest minimum, photography takes place when an *exposure* occurs. To make an exposure means to capture what the cameras sees, and the camera uses light to see. Without light, there is no photograph.

This means that the photographer needs to learn about light, observe light, and learn to light photos.

A possible objection, if you are thinking of nature photography, is that the lighting is not yours but rather chances of weather, position, time of day, and so on. Essentially it is something you can't control. This may be true, but the photographer should learn how to manipulate these elements to take the best possible advantage of existing light. To achieve this goal, the first step is to become a careful observer of light.

If you learn to observe light, and manipulate it when necessary to benefit your pictures, your photographs will improve — and you'll have more fun photographing. This chapter teaches you the basic vocabulary to understand how your pictures are lit, provides you with some photographic techniques to make better use of the light that is available, and shows you how to improve the existing light using flash.

Observing Light

For the most part, the field photographer uses *available* light. Available light is "available" because it is there, as contrasted with the *artificial* light supplied by a photographer and usually used for studio photography. Another word used to describe available light is *natural* light.

Note

To say that field photographers only use available light is a generalization. Field photographers also use flashes (discussed later in this chapter), and, in some cases, still-life studio lighting techniques to enhance natural light.

One great advantage of available light is that you can readily see its effects on your subject. After you're used to observing light, you should be able to predict to a great extent how it will influence the way your finished photographs come out.

Here are some of the most important things you should look for when you are observing light:

✦ The light source

✦ The direction of the light

✦ The character and intensity of the light

✦ The color of the light

✦ How the light is changing

✦ The shadows created by the light

The Source and Direction of Light

The source of most outdoor light is, of course, the sun. The sun illuminates your subject from a particular direction, and you should learn to identify that direction. However, sunlight also behaves in some complex ways:

✦ Sunlight provides general light in a scene. This is called *ambient* light, as opposed to *reflective* light, which is the light falling directly on a subject.

✦ Sunlight bounces off multiple surfaces and objects, and illuminates portions of your pictures indirectly (but brighter than the ambient light level).

The best description of the *direction* of light is the way it falls on a subject relative to the camera's position. There are three basic light directions:

✦ **Front lighting**: lighting from the front

✦ **Side lighting**: lighting from the side

✦ **Backlighting**: lighting from behind

What About Top Lighting?

Because front lighting, side lighting, and backlighting exist in field photography, it's also reasonable to expect that there would be top lighting. Theoretically, top lighting would be light coming down on top of a subject at a 90-degree angle — for example, noon on a sunny day when the sun is directly overhead. But with almost no exceptions top lighting does not produce good pictures. Professional field photographers know this, and follow a general schedule: They are up before dawn, stop work for a good late brunch and a nap, and go back to work in the afternoon as shadows are starting to lengthen. So put your camera away and do something else when the sun is high in the sky at noon!

Front Lighting

In a photograph that uses front lighting, the most important light source falls on the part of the subject facing the camera. Typically, the light is shining from a source behind the photographer onto a subject such as a landscape or a group of people (figure 4.1).

If you have ever taken a picture in a front-lighting situation, you may remember that your subjects were probably staring into the sun. Front lighting minimizes shadows, and makes landscapes appear flat and single-dimensional, so it is not the best kind of lighting for most landscapes. On the other hand, front lighting works well for photos of people and animals in which you want to see the entire picture clearly.

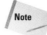 **Note** *Generally, you want pictures of animals to be evenly lit, so front lighting works well for animal photography. However, if you want to create a photographic portrait of a person that is more expressive than a mug shot, front lighting may not entirely be the ticket.*

Side Lighting

Side lighting creates shadows, emphasizing the volume and shape of a subject, and exaggerating the three-dimensionality of textures.

In a nutshell, these effects taken together mean that side lighting makes subjects look very three-dimensional. Therefore, side-lit photographs of landscapes (generally taken in the early morning or late afternoon) can have a powerful impact (figure 4.2).

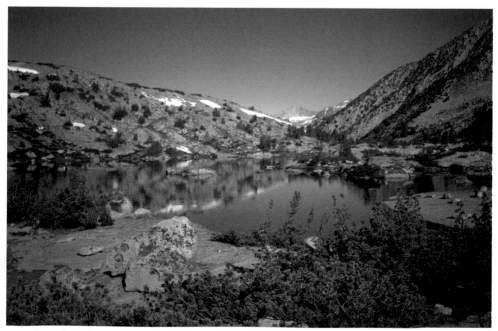

4.1 There is little in the way of shadows in this front-lit landscape.

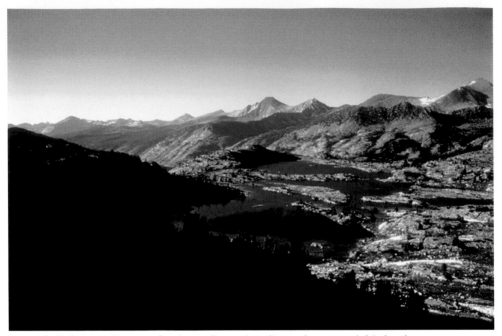

4.2 Side lighting enhances the three-dimensionality and power of this landscape.

Unlike photographs that use front lighting, exposing a side-lit photograph is tricky. Side lighting causes shadows. Most side-lit photographs contain both shadowed and brightly lit areas. It's unlikely that you can expose a side-lit photograph in a way that preserves the mid-range tonalities of both the light and dark areas. This means that you'll have to decide whether you want to expose the picture to preserve the details in either the lighter areas or darker areas. To make this decision, you need to pre-visualize what the photograph is going to look like exposed for the dark areas as opposed to the brighter areas.

> **Tip**
>
> *If you aren't sure of the best exposure, you can simply try taking a photo both ways, exposing it first for the dark areas of a side-lit situation, and next for the bright areas. You can decide later after downloading the photos which exposure works best.*

How shadows are used in field photography often separates good work from the pedestrian. Shadows can be used to great graphic effect, and can have an emotional impact. So consider carefully what the presence of shadows in your side-lit photograph is conveying, both emotionally and in terms of the graphic composition.

In the context of early morning or late afternoon side-lit landscapes, the common decision — which is mostly for the best — is to let the shadows go very dark (or even black) and expose for the sunny areas of the photograph, like in the photograph of the cliff side-lit by afternoon sun shown in figure 4.3.

4.3 With side-lit landscapes, it's common to let the shadows go dark.

Note *Provided your camera is set to an automatic exposure mode, and you don't have the camera primarily pointed at the dark areas of the subject, figure 4.3 illustrates what will happen most of the time even if you don't intervene.*

Backlighting

Backlighting occurs when you are photographing directly into the light source, so that the subject of your photograph is lit from behind. In other words, the subject is between you and the source of the light. With backlighting you are photographing directly into the light source.

It's very rare to find photographs that are solely backlit, but situations that involve some measure of backlighting produce glowing clouds, halos, and patterns of light, and even a silhouette of the backlit subject.

For example, the photograph of Mt. Banner in the Sierra Nevada Mountains, shown in figure 4.4, is both side lit and backlit. The cloud in the photograph appears to glow because it is partially lit from behind by the setting sun.

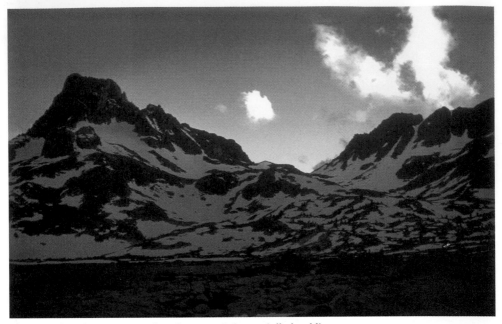

4.4 The cloud appears to glow because it is partially backlit.

Partial backlighting often creates interesting and moody photographs. For example, the photograph of raindrops on the leaves of an exotic Japanese maple shown in figure 4.5 is lit from the front, side, and back. You can best see the backlighting in the lower left of the photo. The contrast of the bright and dark backlighting with the soft lighting on the wet leaves creates an interesting effect.

4.5 Partial backlighting makes this photograph moody and interesting.

Character, Intensity, and Color of Light

The *character* of light essentially means how hard or soft the light appears. The sun on a cloudless day produces hard light, as does the direct flash on a camera. Soft, or diffuse, light occurs on cloudy or rainy days when the cloud cover acts like a giant diffuser.

With hard lighting, there are very dark shadows and a great contrast in exposure values between the light and dark areas of a photograph (figure 4.6).

On the other hand, soft and diffuse light causes no shadows. Images tend to be low in contrast, and have relatively little tonal range. This means it's easy to expose soft-light images because one exposure is usually appropriate for the entire range of lights and darks in the photograph.

Soft light is great for close-ups and bringing out colors, like in this photo of a bright orange flower in the rain (figure 4.7).

Tip *In some situations you can diffuse harsh light in the field with techniques such as putting translucent fabric between the light source and the subject, and by using a reflective material to bounce light into the shadowy areas of a subject.*

4.6 Hard light creates very dark shadows.

4.7 Soft lighting brings out saturated colors, as in this photo of a blooming flower (genus *Clivia*).

Light *intensity* simply refers to the strength of the light. The stronger the light, the greater its intensity. Conversely, the lower the level of light emanating from a light source, the weaker the light's intensity.

It's easy for most photographers to gauge the intensity of light. You squint at the source of high-intensity light, and strain hard to discern details and colors in low-intensity light conditions.

A light source of too great an intensity may produce images with washed-out details in bright areas (and the image as a whole may be overly bright).

On the other hand, colors in very low intensity light may all merge into a dark grey or black. To create field photographs with a low intensity light source, you may need to add supplemental lighting (such as a flash). If you don't (or can't) increase the intensity of the light source, you will almost certainly have to use a tripod to avoid fuzzy pictures caused by camera movement.

A property of light that all photographers should be aware of is its *color*. In terms of physics, light is measured using its temperature on the Kelvin scale. From the viewpoint of human perception, light varies from warm (or reddish cast) along the scale to cool (bluish).

 Cross-Reference *For more on the Kelvin scale, see Chapter 2.*

The color of light does not impact just the light source. Objects are lit because they

reflect a light source. The apparent color of an object depends on the color of the light that shines upon it. As the color of a light source changes, the color of the things lit by that source change as well. So you need to be aware of the color of the light source and how the light source changes the way the things look in your photographs.

If the light source shift is substantial, the resulting photograph may look odd or unnatural. For example, the shifting color of the light source caused the water in the lakes in figure 4.8 to look a bit purple — not a very natural color, but not a displeasing effect either.

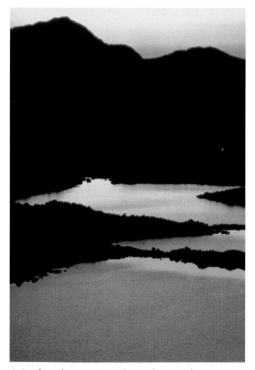

4.8 The change in color value as the sun set made these lakes appear purple.

If shifting color values of the light source cause strong color shifts in the objects that appear in your photograph, you must decide if you like the effect. If not, you can use your digital camera's white balance control to take pictures that appear neutral even though the color balance of the light source has changed.

Note *If you are using a Camera RAW format for your images, the color balance can easily be adjusted in an image editing program such as Photoshop Elements or Photoshop.*

Note *Another approach for dealing with color shifts is to use an external corrective filter.*

Cross-Reference *For more about setting your white balance, see Chapter 2. For more on using filters, see Chapter 5.*

How Light Changes

One of the most important things to observe about light is how it changes.

Natural light changes all the time. It changes as sunlight changes in the course of a day. It changes as the wind blows clouds and trees. In the mountains particularly, light changes as clouds form, grow, and pass from the scene.

Light also changes as you shift your position. Walk ten feet in any direction, and the light has changed from what it was. And, as a result, the photograph will look different.

Changes in light can also occur over a long period of time, such as from season to season. The light on a subject from the same

position at the same time of day is vastly different in midsummer than it is in the depth of winter because both the angle of the sun (it is lower in the winter than the summer) and the color temperature of the sun have changed. A favorite photographic location may (or may not) be as beautiful in one season as another — but the way it is lit will certainly be different.

> **Tip** *On days with general overall cloud cover, light does not tend to change quickly.*

As a field photographer, you need to pay attention to shifting light. Is the lighting of your subject better if you change your position? Will shifting sun or clouds make the lighting better (or worse)? Is the light changing so fast that you should quickly take your photograph?

Anyone can observe how light changes, and how it shifts when you change position. You don't even need your camera. You just have to spend time watching the pattern of the light change.

> **Note** *It's hard to find time in the hustle and bustle of modern life to simply kick back and watch wind, weather, and changing light. But if you really want to take first-rate pictures, the time you spend in this way will pay dividends.*

Shadows Created by Light

Shadows are an extremely important component of many field photographs. For example, the shadows in the photograph of a cliff wall at the bottom of the Grand Canyon, shown in figure 4.9, are the whole point of the photograph.

Table 4.1 shows the rules of shadows.

4.9 The shadows on the cliff wall are the point of this photograph.

Table 4.1
The Rules of Shadows

Situation/Condition	Impact on Shadows
Light gains in intensity	Shadows become stronger and blacker
Light loses intensity	Shadows become weaker and muted
Sunlight in winter, oblique angle of the sun	Long, low shadows
Sun at noon, directly overhead	No shadows
Deep valleys or canyons	Dark shadows in morning and afternoon
Front lighting (the light is behind the photographer and straight on the subject)	Shadows stretch behind the objects in the photograph
Side lighting (the light is from the side)	Shadows form in the direction away from the light source; best opportunity for interesting shadows in photographs
Backlighting (light is from behind the subject)	A backlit, silhouetted subject can create interesting and unpredictable shadows

Many photographs are essentially about the interplay of shadows and light, so it's very important to understand the rules of shadows.

Ambient Light

Ambient light is the overall light in a situation, not the light specifically reflected by an object, or directed toward that object. It's quite possible that you will make the decision about what exposure settings to use based on non-ambient light — the light specifically falling on an important part of the subject. But the ambient light is important to the general characteristics of a photograph. If there's a lot of ambient light, you'll be able to capture details in shadow areas, as in figure 4.10.

Still confused? Think of it this way: Ample ambient light does not equal ample light because not all light is ambient. It is the background light in a scene.

Generally, high levels of ambient light resolve some of the technical problems of field photography. You can use a fast shutter speed and still have reasonably high depth of field. Also, scenes with high ambient light tend to be more evenly lit, and present very few exposure conundrums.

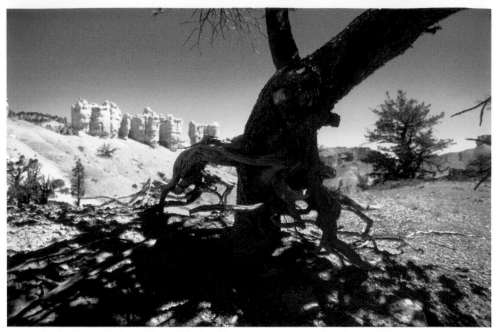

4.10 The high level of ambient light in this desert scene makes it possible to capture shadow details as well as the overall landscape.

Sunlight

Sunlight is the miracle that makes our world — and most field photography — possible.

There's very little in the way of field photography that doesn't involve the sun. The sun itself is a popular subject for photography, when it rises or sets as a great orange or red ball (figure 4.11) and sets the world on fire with colorful, reflective side lighting (figure 4.12). Photographers generally agree that an hour before sunset and an hour after sunset provide light with a unique, warm tone, often referred to as the "golden hour." These late afternoon, sunset, and twilight times also present photographic challenges due to lower levels of ambient light and stark contrast between shadow and light areas.

4.11 Sunsets are a favorite photographic subject in the field.

Tip *To make photographs of sunsets rise above the bland, try to include interesting foreground subject matter along with the sunset.*

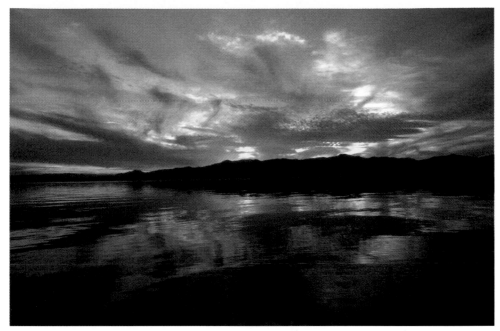

4.12 As the sun sets, it flamboyantly lights water and clouds.

Essentially, it's easy to understand sunlight as a light source. The closer to sunrise or sunset you are, the redder and more oblique the sun is as a light source. (*Oblique* means side lighting from a low angle.) In this situation, shadows grow long and dark, and photography poses technical difficulty.

Conversely, the closer the sun is to high noon and directly overhead, the bluer on the Kelvin scale the light becomes, and the fewer the shadows. (There are no shadows at all at noon when the sun is directly overhead.) Scenes become flat and unmemorable, but technical challenges are lessened because of the comparatively high levels of ambient light.

It's fairly simple to understand sunlight, but what a myriad variety of light the sun produces!

Incandescent and Fluorescent

Incandescent light is created with ordinary household light bulbs. It is warm, rich, and red, and can be flattering to the objects it lights.

Fluorescent light is created using fixtures that pass low-voltage electricity through tubes containing argon gas under low pressure, mercury, and a coating of phosphor powder. Fluorescent light is coolish, blue, and (for the most part) unflattering. Fluorescent light is also remarkable because it comes in many varieties (many different color temperatures). Because of the way fluorescent light is generated, even a single fluorescent tube can vary tremendously from moment to moment in the color of its light.

Tip *Because fluorescent color temperature fluctuates so wildly, both from tube to tube, and even from a single fluorescent fixture over time, if you'd like to create photographs with neutral colors, make sure that any pictures you take are balancing correctly under specific fluorescent conditions, and reset the white balance as necessary.*

When working indoors, carefully consider whether you need to reset your camera's white balance to make objects appear neutrally colored. It may be more interesting to leave your camera at its daylight white balance settings. For example, part of what makes the photograph of a spiral stairway shown in figure 4.13 interesting is the greenish tinge created by using a normal white balance with the ambient fluorescent light.

On-Camera Flash

Your digital camera comes with an integrated electronic flash. In theory, the flash is balanced to have the same color temperature as middle-of-the-day daylight.

On-camera flash, though having many uses in the field — ranging from lighting a subject that would otherwise be too dark to photograph, to lightening shadow areas in a photograph — can come across as very harsh because of its intensity as a single pinpoint source.

In the days of film, one of the objections to flash that many photographers had was that they couldn't see the results of using the flash until they processed their film. This meant that photographers had to learn to pre-visualize the results of using flash — or wait for the results and possibly learn that their photograph hadn't worked.

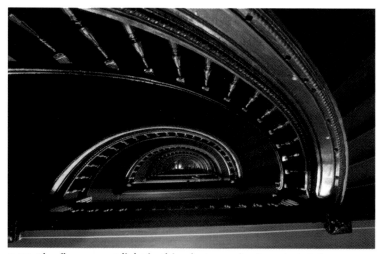

4.13 The fluorescent light in this photograph of a spiral stairway casts a greenish light.

With your digital camera, this is not quite as much of a problem because you can get instant feedback using your camera's LCD display. If the flash hasn't worked the way you wanted, you can adjust it and try again.

> **Note** *Reviewing photographs in the camera's LCD display isn't perfect. The display tends to be quite small, and can be very hard to see in strong daylight. But it should provide enough visual information so you can see whether or not you need to adjust your settings.*

Unless you tell your digital camera not to use flash, the camera will probably do so automatically in conditions that its controller deems necessary.

In some situations, you definitely don't want to use your flash, but your camera doesn't necessarily know this. For example, you might be photographing a flower in fairly low light conditions with the camera mounted on a tripod. If you don't want to use the flash, you need to either take the camera out of automatic mode and set the exposure yourself, or use the override controls to tell the camera not to use its flash.

Flash is used in two primary ways:

- ◆ *Fill* flash, in which a picture that has non-flash light sources is improved in its dark areas through use of a flash, primarily for lightening shadows in daylight photos.

- ◆ *Direct* flash, in which the flash is the direct and primary light source, for example when you want to photograph a person or thing that is in the dark.

The idea of using a flash to fill an area of a photograph is that some, but not all, of the

photograph is already reasonably lit due to ambient or reflective light. But some key area or areas of the photograph aren't bright enough. The fill flash is used to brighten critical areas of the photo.

For example, in the photograph of the camellia in the rain shown in figure 4.14, there was plenty of shadowed ambient light, but the camellia itself was in shadow. Fill flash helped to turn this into an attractive image by making the flower brighter than its surroundings.

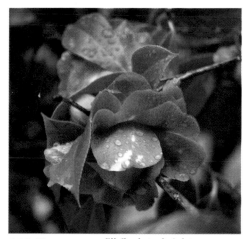

4.14 You can use fill flash to brighten important areas of an image.

> **Note** *You can also use reflectors, which are metallic or white sheets or boards, to bounce light into a scene or illuminate a subject that is part of a scene.*

> **Tip** *Depending on the fill flash situation, you may need to review the photograph taken with the flash and use your camera's controls to adjust the level of flash output if the subject appears too bright or too dark.*

Direct flash is used in the field in low light conditions, and often when photographing people.

The red-eye effect occurs when a direct flash bounces off the back of the retina in the subject's eye. The effect gives the subject a rather demonic red glow in the eye.

 Cross-Reference *For more on red eye correction, see Chapter 7.*

You can minimize red-eye by setting your camera to use its flash in an anti-red-eye mode. You can easily remove any remaining red-eye during the digital retouching process.

 Cross-Reference *For more on the digital retouching process, see Chapter 7.*

When photographing indoors, a flash is often required to get a good image (see figure 4.15). This is especially true for capturing motion such as a rambunctious child or an excited pet. However, you can get some interesting and moody portraits using only window or incandescent light (but don't try this with a squirming toddler!).

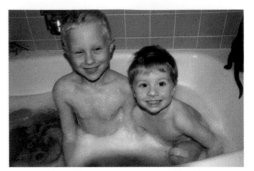

4.15 Indoor images are generally taken using a flash.

Using Accessories and Filters

 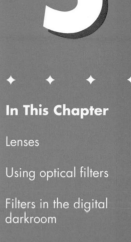

You can take lots of wonderful photographs with your digital camera alone and no additional accessories. But sometimes you need additional equipment to solve a specific photographic problem. In addition, using accessories with your camera can be just plain fun.

Filters, whether they are optical and added to the front of your camera lens, or digital (and invoked postproduction) are great fun and add pizzazz to your work.

This chapter explains the kinds of situations in which you are likely to need accessory equipment, and how to use the equipment. For example, it is hard to take good macro pictures without using a tripod. This chapter also gives you some ideas about how to creatively use filters and other accessories to have more fun with digital photography in the field.

Lenses

Lenses are among the most significant accessories you can add to really change the way your photographs look, and to increase the capabilities of your digital repertoire. However, additional lenses can be extremely expensive, and many digital cameras simply do not accept interchangeable lenses. The good news is that your camera's original lens (or only lens if it is not an interchangeable-lens camera) provides plenty of functionality for most situations with a nice range of focal lengths and good macro facilities.

Interchangeable lenses are one of the best reasons to use a digital SLR.

Lenses made specifically for your digital camera will work with the automation in your camera. Older lenses not made for digital cameras may mount on your camera, and may be used for taking pictures, but usually only work in completely manual mode.

You might want to change lenses to

✦ Use a telephoto that brings subjects closer (figure 5.1).

✦ Use a wide-angle lens to take pictures that include a wide area of subject matter with high depth of field (figure 5.2).

✦ Take close-up, or macro, photos (figure 5.3).

✦ Use a lens that is faster (with a wider maximum aperture) than a typical zoom lens so that you can shoot in low light conditions.

✦ Use lenses, such as pre-digital lenses, on your digital SLR.

✦ Experiment with different lenses to see how things come out.

If you don't happen to have any predigital lenses lying around, you may want to use lenses specifically designed for your digital camera — which narrows the selection field considerably.

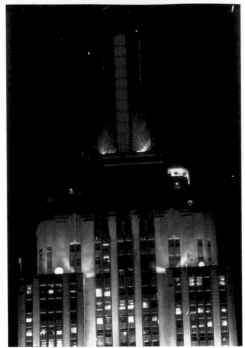

5.1 A telephoto lens was needed to bring the Empire State Building close.

Table 5.1 shows some of the lenses Nikon makes specially for Nikon digital SLRs such as the Nikon D70. A vast range of Nikon lenses not specifically designed for digital SLRs can also be used on the Nikon digital SLRs.

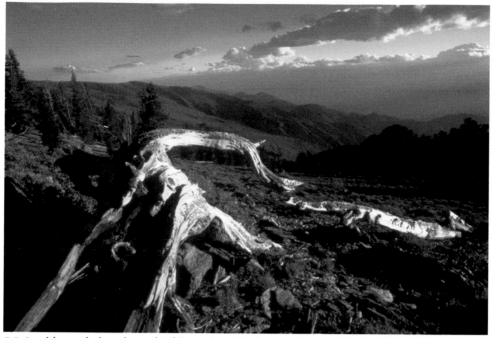

5.2 A wide-angle lens brought this ancient bristlecone pine and the background landscape into focus.

> **Note**
>
> *Nikon has a 1.5 magnification factor, which you can use to calculate the 35mm equivalence of a lens on a digital camera. For example, a 40mm lens on a Nikon digital SLR will be equivalent to a 60mm lens on a 35mm camera.*

Table 5.2 shows the lenses Canon makes available for its digital SLRs such as the Cannon EOS Digital Rebel. This table should give you a pretty good idea of the range of lenses available, and what you might want to use them for.

Table 5.1
Selected Nikon DX Lenses

Lens	Category	Reason for Use
10.5mm f/2.8 Fisheye ED-IF AF-S DX	Fixed focal length, ultrawide angle	Extreme wide angle, equivalent to a 16mm lens on a 35mm camera; means greater angle of subject-matter inclusion and greater depth of field; lens is great for special effects. This is a great, unique lens for digital photography — not suitable for everyone or every occasion, but to die for!
12–24mm f/4 ED-IF AF-S DX	Ultrawide-angle zoom	Extreme wide subject-matter inclusion (roughly comparable to a 18–36mm lens on a 35mm camera); high depth of field; good for low light conditions; the zoom allows angle adjustments
18-70mm f/3.5–f/4.5 ED-IF AF-S DX	Standard zoom lens, which ranges from moderate wide angle to telephoto	Zoom with a great range of focal lengths; possibly the only lens ever needed; usually comes as the standard lens with Nikon D70

5.3 Macro lenses help you take good photos of close-ups such as this flower composition.

Table 5.2
Selected Canon EF Lenses

Lens	Category	Reason for Use
EF-S 10–22mm f/3.5–f/4.5	Ultrawide-angle zoom	Extreme wide angle means greater angle of subject matter inclusion and greater depth of field; the zoom allows minor angle adjustments
EF 16–35mm f/2.8	Ultrawide-angle zoom	Wide area subject matter inclusion; high depth of field; good for low light conditions; the zoom allows angle adjustments
EF 15mm f/2.5 Fisheye	Fixed focal length, ultrawide angle	180-degree fisheye is great for special effects
EF 28mm f/2.8	Fixed focal length, wide angle	Good, relatively inexpensive, wide-angle lens for greater angle of inclusion and depth of field
EF 28–300mm f/3.5 - f/5.6	Standard zoom lens, that ranges from moderate wide angle to telephoto	Compact zoom with a great range of focal lengths; possibly the only lens ever needed
EF 100–400mm f/3.5–f/5.6	Telephoto zoom lens	Designed for high-speed action photography; equipped with built-in stabilizer to compensate for camera shake
EF 300mm f/4.0	Telephoto	Compact fixed focal length telephoto with stabilizer to compensate for camera shake; ideal for sports and portraiture
EF 1,200mm f/5.6	Extreme telephoto	Gets you very close to difficult subjects (think hungry polar bears); equipped with stabilizers; claims to be the longest autofocus telephoto lens made
EF-S 60mm f/2.8 Macro	Macro lens	Primarily used for close-ups, but can also be used for general photography; roughly equivalent to a 96mm lens on a 35mm camera; can focus as close as life-size magnification (1:1); length of lens is fixed across its focusing range, which is an important issue in macro photography

Note *Depending on the lens, there may be some loss of automation. For example, Nikon series G lenses are specifically designed for digital cameras. Older Nikon series D lenses work well with digital cameras. And, some older Nikon lenses can be used with Nikon digital cameras, but only manually.*

Note *Canon has a 1.6 magnification factor, which you can use to calculate the 35mm equivalence of a lens on a digital camera. For example, a 40mm lens on a Canon digital SLR will be equivalent to a 64mm lens on a 35mm camera.*

Although the wide range of lens offerings that Canon makes available specifically for its digital cameras is impressive, you should bear in mind that much of the time the one lens that you purchased along with your camera will do everything you need. In addition, lenses not specifically intended for use on your digital camera usually work reasonably well.

Tip *Although every brand is different, manufacturers of digital SLRs besides Nikon and Canon provide lenses to support their digital SLRs that are roughly comparable to the Canon offerings (or the Nikon offerings augmented by Nikon lenses not specifically designed for digital cameras).*

Lenses attach to digital SLRs that accept interchangeable lenses using a *bayonet* mount. The specifics of the bayonet mount are a little bit different for each camera brand. As a general matter, to remove a lens, you depress a release button and turn the lens clockwise until it can be gently removed from the camera.

Note *Depending on the camera, the lens may remove with a counterclockwise rotation rather than clockwise.*

To put another lens on the camera, reverse the process by lining up the dots on the lens base and camera, and rotate the lens counterclockwise until it audibly snaps into place.

Optical Filters

In the days of film, there used to be only one kind of filter — placed in front of the camera lens. These days, with digital cameras, you have two options:

✦ You can put a filter on the front of your camera lens just as you would have in the old days.

✦ You can apply a filter in a digital-manipulation program such as Photoshop after you've taken the picture and downloaded it to your computer.

Note *Not all digital cameras can accept external filters, but almost all digital SLRs can. To determine if your camera and lens can accept an external filter, see if the camera lens is threaded in front of its outermost element.*

A glass filter that you put in front of your camera is called an *optical* filter. Using optical filters can be thought of as a kind of preprocessing (processing before the photograph is exposed), whereas filtering achieved via digital manipulation is post-processing (processing after the photograph has been exposed).

To paraphrase the great playwright Bertolt Brecht, the advantages of the one are not the disadvantages of the other.

Optical filters can easily create some effects that are very difficult to achieve in Photoshop. They also let you see what you are doing in real time, so you can adjust and change the effect as needed.

On the other hand, using the filters in a program like Photoshop gives you many more choices and options than you get with optical filters. Many of these postproduction filters can produce wild and crazy effects that have very little to do with the effects created by optical filters.

With postproduction digital filters you are not rushed by field conditions. You can take your time manipulating your digital photograph and reverse any changes you make by applying a digital filter if you don't like the results.

Fitting a filter

Filters are designed to fit specific lens sizes. Fitting an optical filter simply means finding one that will screw onto the external threads on your specific lens. This means your filter has to be the right diameter. You should check your camera and lens documentation to determine the diameter measurement to use for filters — or you can simply take your camera with you and try the filter on it if you are buying the old-fashioned way, in-person.

Tip | *Sometimes this information is printed right on the lens, or on the lens cap that comes with the lens.*

For example, Nikon's 18–70mm f/3.5–f/4.5 ED-IF AF-S DX zoom lens that usually is sold as part of a package with the popular Nikon D70 digital SLR accepts filters with a 67mm diameter.

Tip | *Tiffen, www.tiffen.com, is a great resource for learning about (and purchasing) the wide variety of optical filters. Tiffen filters fit any camera brand, provided the diameter measurement of the lens screw fits the filter.*

Filter types

Optical filters come in a huge (and sometimes confusing) variety. Some optical filters that are very useful with film cameras are less so with digital cameras. For example, with a film camera in the field, a UV (ultraviolet) filter is very helpful for eliminating excess UV light (which can cause film to appear overexposed). But digital cameras are much less sensitive than film cameras to UV light, so you probably do not need to pack a UV filter in your kit.

Optical Filter Downsides

Optical filters do have some downsides (never mind that that they cost something to buy and rattle around in your field kit). By adding a piece of optical glass to the front of your camera lens, you are increasing the possibility of unwanted lens flare. There's also an increased chance that your photograph will include dust or scratches (two pieces of glass are twice as likely to be dirty or scratched than one).

> **Note**
>
> *Some digital photographers do find that UV filters help cut down on color irregularities in strongly backlit conditions. While most digital photographers do without UV filters, if your backlight images produce a persistent purple fringing, a condition sometimes called chromatic aberration, you may want to try using a UV filter.*

The kinds of optical filters most likely to be found in a digital photographer's kit are

✦ Protective filter (also called a *neutral density filter*)

✦ Polarizing filter

✦ Macro filter (also sometimes called a *close-up lens*)

✦ Color-correction filter

✦ Artistic and creative filter

Protective filters

The point of a protective filter is to protect your lens. The filter has no other purpose in life. Generally, photographers use a clear filter made of optical glass as a protective filter, but some photographers also use UV filters (filters that screen out some ultraviolet light) as protective filters.

The drawback to a protective filter is that it may cut down on the optical qualities of your lens. It becomes another polished glass surface for flares and reflections to bounce off of. And, it is another surface to gather dust.

If you know you will be exposing your camera and lens to harsh conditions — such as a sandstorm or stormy conditions at the beach when the wind is blowing toward the shore — it's probably a good idea to protect your lens.

In other conditions, the advantages may be less clear, and outweighed by the hassle of bothering with another accessory as well as an optical detriment.

Using a Self-Timer or a Remote Control

Most digital cameras come with a self-timer, a remote control, or both. (In some cases, such as with the Nikon D70, a remote control is available, but only as an optional accessory you need to buy.)

With a self-timer, you set the time delay (often the delay is ten seconds). The camera counts down (usually making a ticking noise or a light blinks while it does) and exposes the photograph after the interval.

Some timers use a remote control with an infrared receiver to control the shutter from a distance. These usually have a maximum range of about 15 feet.

Both a self-timer and a remote control are most often used when the camera is positioned on a tripod (if a tripod isn't available, some other surface will often do as a resting place) and usually used to take pictures that include the photographer or to trip the shutter without creating camera shake.

Check your camera manual for instructions about how to activate the camera's self-timer.

A polarizer is a photographer's best friend

Hands down, the polarizer is the most useful filter a digital photographer can have in the field. Polarizers consist of a rotating piece of optical (dark polarized) glass that you turn.

Note *There are two types of polarized filters available, called circular or linear. The terms have nothing to do with the physical shape of the filter. You should purchase a circular polarizer for use with your digital camera (or any camera that sets exposure through the lens).*

Depending on the lighting conditions, with the polarizer rotated, this filter can make the sky appear deeper and richer without negatively impacting the overall color balance of an image (figure 5.4)

You can also use a polarizer to change the way reflections and water surfaces appear. Depending on the situation and how the polarizer is rotated, it will bring out and magnify reflections, or minimize them. Water surfaces can be rendered richer and darker or more transparent (figure 5.5)

Macro filters

Macro, or magnification, filters are reading glasses for your lens. (These filters are also sometimes called *close-up lenses*.) If your

5.4 The sky in this image was enhanced using a polarizer.

lens doesn't have a macro capability, a macro filter can turn your non-macro digital camera into a reasonable macro digital camera. If your camera and lens already have a macro facility, macro filters will let you get even closer. If you are interested in close-up photography and don't want to invest in a lens specially designed for extreme macro photography, a set of macro filters is a good purchase.

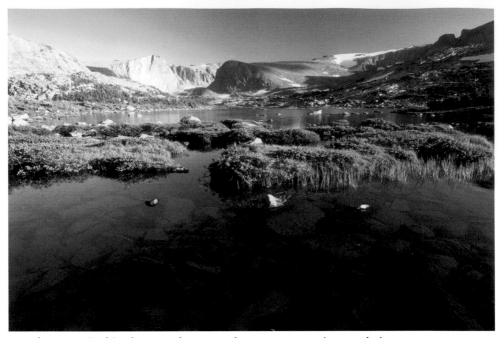

5.5 The water in this photograph was made transparent using a polarizer.

A set of macro filters usually comes with strengths of +1, +2, and +4 diopters (the same unit of measurement used when specifying reading glasses). You can combine macro filters to increase magnification when one macro filter is not enough, so with the standard set the maximum magnification is +7. How close this will get you to your subject depends on the lens you are using, but it is usually pretty close indeed.

Tip *If you combine more than one macro filter, the macro filter with the strongest magnification should be closest to the camera.*

Color-correction filters

Color-correction filters, also called *warming* or *cooling* filters, correct or improve the color of the light hitting the camera.

Color-correction filters address the same problem that the white balance feature built into most digital cameras does. Some digital photographers feel that in some situations color-correction filters do a better job than white balancing. If you end up photographing in the field in all kinds of weird lighting conditions, you should probably experiment with color-correction filters.

Cross-Reference *For more information about white balance, please see Chapter 3.*

Note *In theory, adjusting the white balance of your digital camera adds processing to each rendered image. This in turn slightly worsens the signal-to-noise ratio for each image, implying (once again, in theory) that you may get images with less signal to noise by retaining daylight white balance and using cooling or*

warming filters (rather than correcting the white balance settings). A worsening signal-to-noise ratio is exactly the same problem you get when you raise the ISO a camera is using.

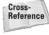

Cross-Reference *See Chapter 3 for an explanation of ISO and signal to noise ratios.*

Artistic and creative filters

Artistic and creative filters come in a huge variety. If you are interested in this kind of filter, you should experiment and see how you like the results.

Some of the most well-known and fun filters of this type are

✦ **Star filters:** These filters produce a star around beams of light in the image.

✦ **Center spot:** Used in portraiture, these filters create a clear area around the subject's head, and a fuzzy effect everywhere else.

✦ **Color-graduation filters:** Used primarily in landscapes, these filters add graduated color to one or more portions of a photograph (figure 5.6).

5.6 A red-blue color graduation filter and a polarizer were used to create this provocative landscape.

Tripods

Tripods are used to steady a camera. This is vital when the length of exposure requires slow shutter speeds. When using slow shutter speeds, camera shake, which means your pictures will come out fuzzy, is almost inevitable. The problem gets worse with a longer (meaning more telephoto) focal length lens. Camera shake kicks in at higher and higher shutter speeds. Things work the same way with close-ups: The greater the magnification of your photo, the more you need to use a tripod to get a steady and clear photograph.

Tripods come in a number of different weights, or styles, ranging from massive (and very heavy) studio tripods to lightweight, flimsy models. Studio tripods tend to have a wealth of features, including levels for all three planes. In contrast, the best field tripods are simple affairs, usually made of high-grade aluminum.

Don't think that simple necessarily means inexpensive. Expect to pay as much for a good tripod as you would for a decent lens.

A good tripod is rugged enough to withstand almost anything, and is flexible so that

Photographing Close Without a Tripod

Sometimes photographers in the field find themselves in situations that they know call for the use of a tripod. Perhaps the subject is a beautiful flower in low light conditions, or a detailed portion of tree bark. Whatever the subject, a slow shutter speed is likely required — resulting in some degree of camera shake, meaning the photograph won't come out acceptably. What can be done?

It is a fact of life that some photographers are steadier than others. If you are Cool Hand Luke with the digital camera, you can probably take an acceptable handheld photograph at 1/60 second, or even 1/30 second.

But even the cool-hands of the world know that bracing and body posture count for a great deal. Try to get yourself in a position where your body is at rest and braced against something. You should be comfortable and absolutely motionless before you depress the camera's shutter release. You should hold the camera as close to your body as possible, so that you're not leaning out with it. Depress the shutter release slowly and smoothly so that the very act of depressing the shutter doesn't cause camera shake.

As an alternative to shooting handheld when no tripod is available, consider looking around for a flat surface that you can use as a makeshift tripod.

you can use it as a stable platform no matter the ground conditions. It needs to solve the engineering challenge of being sturdy enough to withstand a variety of conditions, but lightweight enough so you can carry it without stress.

Good tripods:

✦ Let you easily rotate the mounted camera to any position.

✦ Provide a solid locking mechanism for the camera after it is in position.

✦ Have telescoping legs for easy adjustment to various heights.

✦ Provide a mechanism for continuously adjusting the central pole of the tripod.

✦ Let you adjust the angle of the tripod legs to fit a variety of angled terrains.

Tip *My favorite tripod is made by the European manufacturer Gitzo. Whatever brand you buy, it's worth investing in a good one. It will be a pleasure to use in the field, and you will probably have it for a lifetime.*

Recipes for Great Photos

There's no formula anyone can give for taking perfect pictures all the time. Making great photos is a little like cooking: If you understand general cooking techniques, and can follow a recipe, you can come up with passable dishes. But to be really great, you need to add a bit of inspiration and practice.

When you want to take a specific kind of photograph, you can start with:

✦ The inspiration and rationale behind how and why the specific kind of photograph is made

✦ The basics of digital photographic technique related to the type of photograph

✦ Some ideas about how to practice taking the kind of photograph in question

This chapter provides this information for many of the kinds of photographs you are likely to encounter with your digital camera in the field. In addition, you'll find tips and techniques that will help you bridge the gap between following a recipe and taking great photographs.

Abstract Photography

The appeal of the abstract photo rises from the human desire to impose order on natural human activities, and reverse the process of entropy. Entropy, or natural decay, simply means that things fall apart. A photograph that creates an abstraction that imposes order on an apparently abstract subject has succeeded in reversing the process of entropy, for however short a time, and may win plaudits from those looking at the photograph.

The best abstract photos give the viewer an "aha" moment. For example, if you look at the abstract colorful swirl of paint shown in figure 6.1, you may not be sure what you are looking at. But pretty quickly you will realize that you are seeing a mixing area for colors, probably the palette of a painter. The revelation comes because the painting is supposed to be the subject of the photo, not the palette.

Scrap work that people inadvertently create — artist's palettes, peeling billboards, fading murals, and so on — makes great potential subjects for photographic abstracts.

6.1 This artist's palette is a good abstract subject.

Inspiration

At the heart of things, the same forces that inspire abstract painters inspire abstract photographers.

As a photographer, you are trying to show people who look at your photographs new ways to see things. Your photographs should make the commonplace vibrant and magical.

There are many kinds of abstract painters. Some make paintings that are full of drips and swirls (called *abstract expressionism*). Others make patterned paintings (often called *op art*).

You can find these styles in abstract photography. A crumbling side of a building, or a swirl of found color, is abstract expressionism. A found pattern, like that shown in figure 6.2, is closer to op art.

6.2 The circular pattern in this manhole cover makes a neat, abstract optical effect.

Also, like many painters, abstract photographers find inspiration in nature. An image of a common vegetable, like an artichoke, like that shown in figure 6.3, becomes highly abstract when it is brought in close.

6.3 Up close, this artichoke becomes abstracted and makes an interesting pattern.

Abstract photography practice

6.4 The striations in these cliffs made for an interesting abstraction.

Table 6.1 Taking Abstract Pictures	
Setup	**Practice Picture:** The copper oxide in the striations of the cliff shown in figure 6.4 makes the pattern that is this basis for the interest of this picture. **On Your Own:** Look for unusual colors in landscapes and cityscapes, and then get close enough so you can abstract the image — make the viewer initially unsure about what they are seeing. Try to flatten the image — most abstract photographs are fairly two-dimensional.
Lighting	**Practice Picture:** Natural light was oblique and from behind — classic backlighting. This might not be the best lighting for many subjects, but with an abstraction, it has the advantage of being unobtrusive. **On Your Own:** The lighting of an abstract subject should not be the subject of the photograph; you want your abstract subject to be the center of attention. Avoid flash. Look for uniform lighting, unless the contrast between bright and shadow areas is part of the abstraction.

Continued

Table 6.1 (continued)

Lens	**Practice Picture:** Nikon D70, AF-S Nikkor 18–70mm 3.5–4.5G ED at 70mm (105mm 35mm equivalence). **On Your Own:** You should avoid lenses with noticeable lens-related optical distortion (extreme wide angle and telephoto lenses). Unless you are photographing an up-close abstraction, a slightly longer-than-normal focal length works well (because of its shallow (less) depth of field).
Camera Settings	**Practice Picture:** RAW capture, Automatic mode, f/8, 1/250 second. **On Your Own:** You'll often want to control the depth of field, so use an Aperture-Preferred mode with the f-stop set for high depth of field. If the shutter speed is less than 1/125 second, use a tripod. Experiment with Macro mode.
Exposure	**Practice Picture:** ISO 200, f/8, 1/250 second. **On Your Own:** If your subject has depth, you'll probably want maximum depth of field, so stop the lens down (perhaps to f/22).
Accessories	Use a tripod for most abstract photographs. Even if you don't need a tripod to increase the depth of field, using one enables you to take the time to survey the composition carefully. If your abstract involves a small subject that is dimly lit, you should plan on lighting the subject, possibly with a mirror or silver reflector card.

Abstract photography tips

✦ **Abstract photographs are about composition.** Carefully check the composition of your abstraction. If the composition is less than interesting, your photograph may be as well. Be sensitive to where the boundaries of your abstraction begin and end, and do not cut the photograph off arbitrarily — particularly if cutting off the edges of the photograph works badly with a pattern in the composition.

✦ **Make sure you are as perpendicular as possible to the subject.** If the camera isn't pointing squarely at the subject of an abstract, the angles in the composition may likely start to look very peculiar in the finished photograph — distracting from the abstract effect.

✦ **Abstract photographs should be abstract, at least at first glance.** Being abstract doesn't mean that a careful viewer can't recognize parts of the image and what they represent in the real world. It does mean that the overall subject should not be obvious at the first glance. An abstract is a photograph about colors, texture, and composition, not about a specific object.

✦ **Look carefully at the colors in an abstract photograph.** Colors are very important in an abstract photograph. Make sure that the colors in your photograph work well together. Aim for areas of complementary colors — blue hues next to yellow hues, and red hues next to green hues — to give your abstract pizzazz.

✦ **Plan to use a tripod.** It's easier to compose an abstract photograph using a tripod. Even if you don't need the tripod to keep the camera steady when you slow the exposure down to getter more depth of field, using a tripod helps you compose accurately without moving the camera too quickly from one proposed composition to the next.

✦ **Turn off the flash.** For the most part, you should photograph abstract compositions without a flash.

Action Photography

From the viewpoint of the photographer, an action scene usually involves people and sports in the outdoors. For example, if your photographic subject is kayaking, sailing, skiing, or surfing, then the scene is one of action. Figure 6.5 shows a typical action scene, a kayaker getting wet in the Colorado River rapids of the Grand Canyon.

Inspiration

The trick with action photography is to stop the motion. The interest here is not so much glorious color or gorgeous composition — although no one has ever complained about a photograph that has wonderful colors and great composition. Instead, the emphasis is the activity that people are accomplishing in collaboration with — or in spite of — nature.

6.5 Action scenes generally involve people doing things outdoors.

The idea is to show what the action's protagonists are doing. Your photograph should also convey enough background so that someone looking at it will understand the context. For example, it's clear what the kayaker shown in figure 6.6 is up against — massive and rapid white water!

Some people like to view action photographs of people in nature for vicarious thrills. If you look at a photo of people in a challenging action scene with nature at its wildest, you can imagine you are there with the wind and water whipping through your hair. You don't have to experience the discipline, physical pain, and tedium that the real athletes actually experience. If your photographs can convey with immediacy the idea of "you are there with the subject," then they are successful action scenes.

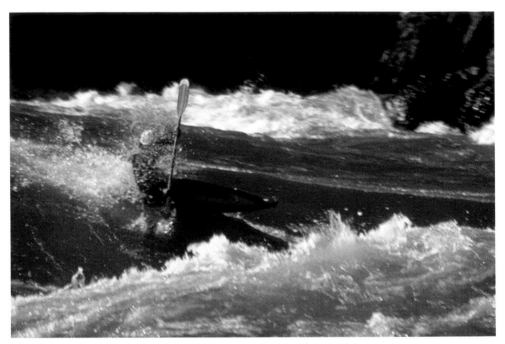

6.6 The emphasis is the kayaker, but you can also see the rapids.

Action photography practice

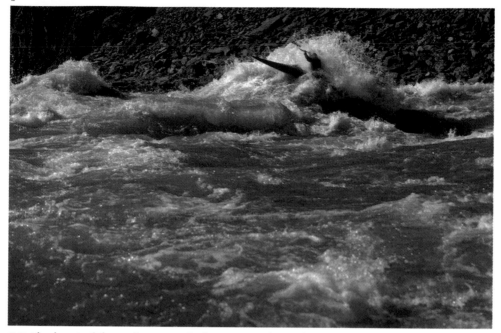

6.7 The heart of the action scene is the protagonist performing the action.

Table 6.2
Taking Abstract Pictures

Setup	**Practice Picture:** In figure 6.7, the focus is on the kayaker and the motion of the kayak, not the setting. **On Your Own:** Try to get close enough so you can really experience the action.
Lighting	**Practice Picture:** High midday lighting was unobtrusive but strong enough for a fast shutter speed. **On Your Own:** Look for strong, bright, natural lighting. Action photographs are rarely successful in low light conditions.
Lens	**Practice Picture:** Nikon D70, AF-S Nikkor 18–70mm 3.5–4.5G ED at 70mm (105mm 35mm equivalence). **On Your Own:** Although it's good to be close enough to really get a feeling for the action, you may want to experiment with longer lenses to bring the action even closer. It's realistic to consider handholding cameras with 35mm equivalent focal lengths of up to about 200mm at high shutter speeds.

Continued

Table 6.2 *(continued)*

Camera Settings	**Practice Picture:** RAW capture, Sports mode, f/4, 1/2000 second. **On Your Own:** Because a fast shutter speed is necessary, you should use a shutter-preferred exposure mode (or a sports exposure mode, if it is available on your camera).
Exposure	**Practice Picture:** ISO 400, f/4, 1/2000 second. **On Your Own:** Boost the ISO if necessary to get a really fast shutter speed (faster than 1/1000 of second) to stop motion. Don't worry too much about depth of field as long as your primary subject is in focus.
Accessories	If you are using a lens with a 35mm equivalence of 200mm or greater, you should consider using a tripod, although this may not be practical in all field conditions. Care must be taken to protect equipment when photographing action scenes in the field. Use waterproof containers for transporting your cameras and lenses if you are near water.

Action photography tips

✦ **Be ready.** Action scenes move quickly. If you're not ready to take the picture as it happens, you'll miss it forever. Prepare your camera and exposure in advance, and then don't hesitate.

✦ **Pick your position carefully.** You want to be close enough to get a feel for the action, and to have a good view. You don't want to endanger yourself or your equipment, or get in the way. Choosing the right location for action photography is crucial.

✦ **Action photography is still about people.** The people who view your action photographs will care most about how the people in the photographs are performing. Make sure your photographs tell this story.

✦ **Look for bright light.** Action scenes are almost always shot in broad daylight with bright light.

✦ **Action means a fast shutter speed.** You'll always want to photograph action scenes using a fast shutter speed.

✦ **Protect your equipment.** Nothing can ruin expensive digital photographic equipment faster than a dunk in the river or ocean. Take care to protect your equipment, both during transport and when you are using the equipment to photograph action scenes.

Animal and Wildlife Photography

The key thing to remember about wild animals is that they are, well, the only word for it is wild. Animals don't pose for you. They don't hold still. They are unpredictable and sometimes dangerous. You should learn about the habits and characteristics of wild animals you'd like to photograph, respect them, and follow all the rules of the park or wildlife management district you are in.

Expecting the unexpected and taking advantage of it is the watchword of wild animal photography. For example, consider the photograph of wild mountain goats shown in figure 6.8.

I was cooking my supper at a campsite high in the mountains in Olympic National Park when these goats came along. I think they thought I was invading their territory. Fortunately, I was able to make my peace with them while taking a quick animal portrait.

Inspiration

Animals are exciting. Animals are fun. Animals are part of what makes the wilderness wild.

It's good to practice your wildlife photography under controlled conditions. You'd be surprised how many good pictures can be taken at a zoo. And, it's easier to relax and concentrate on your photography when you know you won't get eaten or mauled by a lion, tiger, or bear!

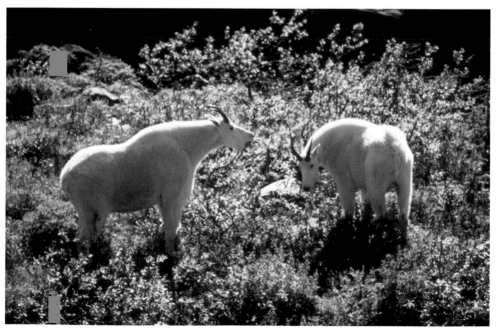

6.8 It's exciting to be this close to wild animals.

A portrait of an animal can be a window into the soul of a world that is very different than ours. Birds and smaller animals can be just as wonderful as larger animals. If you take the time to wait for the animals, like the birds shown in figure 6.9, your photographs will be worth the effort.

Wild animals are about the hardest thing to photograph because they are in constant motion, hard to communicate with, hard to find, and possibly dangerous. If you thrive on challenges in the field, go after big game with your digital camera—and bring back some pictures that will amaze your friends.

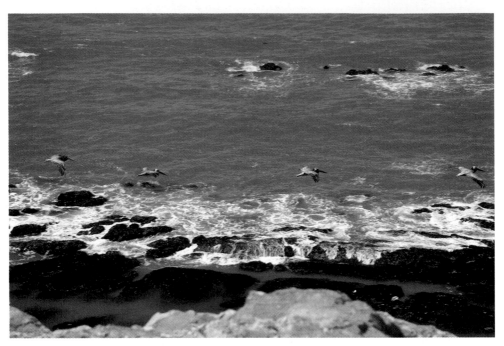

6.9 These pelicans make an otherwise boring photo interesting.

Animal and wildlife photography practice

6.10 You can take surprisingly good pictures of wildlife in a zoo, like this portrait of a lion.

Table 6.3
Taking Animal Pictures

Setup	**Practice Picture:** The lion in figure 6.10 stayed still just long enough for a portrait. **On Your Own:** At the zoo, try to frame your pictures to avoid showing they are taken in a zoo. In other words, avoid bars, cages, and spectators. Regardless of where you take the photograph, remember that it is a portrait of the animal. Frame the picture to reveal the character of the animal, and to tell the story of why it is special.
Lighting	**Practice Picture:** Subdued but bright light fell from behind the camera, and across the lion's face. **On Your Own:** You'll need light that is bright, but not overwhelming, to take successful animal photographs.
Lens	**Practice Picture:** Canon PowerShot G3, Canon Zoom Lens 7.2–28.8mm 1:2.0–3.0 at 28mm (135mm 35mm equivalence). **On Your Own:** You'll need a longer lens to bring your animal subjects closer for portraits (because you will have to keep your distance).
Camera Settings	**Practice Picture:** RAW capture, Automatic mode, f/8, 1/200 second. **On Your Own:** Generally, you can shoot animal pictures in a zoo using auto exposure modes.
Exposure	**Practice Picture:** ISO 100, f/8, 1/200 second. **On Your Own:** If the animal is in motion, boost the shutter speed to capture the motion, raising the ISO if necessary.
Accessories	You can use a normal or telephoto focal length to successfully photograph animals in a zoo or in the wild. If you are using a longer focal length lens, consider using a tripod. If you are photographing animals in the wild, you may need to follow some of the techniques employed by hunters, such as using a blind so that you are not seen.

Animal and wildlife photography tips

✦ **Be ready.** Animals are in constant motion. You must be ready to capture the photograph when the perfect moment comes along.

✦ **Don't endanger yourself.** Wild animals can be dangerous. Learn about the animals and their habitats. Don't get too close. Don't stick your camera through the bars in a zoo in pursuit of the perfect photo.

✦ **Don't feed the animals.** Don't bribe animals to sit for a portrait using food (unless it's OK with a zoo or wildlife manager). Feeding wild animals can be dangerous to you, and can also put the animals at risk.

✦ **Look for bright light.** Because animals move and are unpredictable, you'll want bright but not harsh lighting.

✦ **Try for character.** The best photographs of animals tell something about the animal's character.

Architectural Photography

Architectural photography means taking pictures of buildings and other man-made structures. There are a variety of commercial applications for architectural photography, but it can also be simply fun and interesting. Some photographers like to photograph mountains, and others like to photograph buildings. In many ways, the photographic challenges are similar: Mountains and buildings are both massive three-dimensional geometries that don't move, and they are both subject to ambient light.

Architectural photography can be about the grand shapes presented by buildings, bridges, and so on, but good architectural photographs can also concentrate on architectural details, such as the exterior decorative sculpture on a New York tenement shown in figure 6.11.

Inspiration

One of the reasons that photographers like buildings, bridges, and other structures is that they offer interesting stationary subjects that can change drastically with minimal shifts in light. You can photograph a structure to try to give an idea of the entirety of

6.11 The sculpture on this façade makes an interesting detail photograph.

its architecture or of the detailed materials used to build it. You can also use architectural photography to convey something about architecture in general rather than a specific building, like in the photograph shown in figure 6.12.

Note *Many kinds of photography overlap. Depending on how you look at things, this could be called an abstract or a pattern photograph.*

6.12 At first glance, it's hard to tell that the patterns in this photograph are architecture.

Architecture can be a metaphor for human accomplishment. It's hard to look at the soaring span of the Golden Gate Bridge (shown in figure 6.13) and not think of the miracle of modern civilization.

6.13 The Golden Gate Bridge is one of the most photographed pieces of architecture in the world.

Architecture photography practice

6.14 A zoom lens was moved during exposure to create this unusual architectural effect.

Table 6.4 Taking Architectural Pictures	
Setup	**Practice Picture:** With the camera on a tripod, and using a slow exposure, the interesting effect in figure 6.14 was created by moving the zoom lens through its range.
	On Your Own: It's fun to experiment with architectural photography. One thing you can try, as in the practice photo, is mounting your camera on a tripod, and experimenting with the effects you can create by moving the zoom during exposure. But also think about what you can do to make the architecture special. Perhaps a unique angle, or a little camera motion will make an extraordinary image.
Lighting	**Practice Picture:** Natural light of early evening.
	On Your Own: The zoom-in-motion effect only works when the ambient light is less intense than the light produced by the buildings in your photo.

Continued

Table 6.4 *(continued)*

Lens	**Practice Picture:** Nikon D70, AF-S Nikkor 18–70mm 3.5–4.5G ED at 18mm through 70mm (28mm through 105mm 35mm equivalence). **On Your Own:** Any zoom lens.
Camera Settings	**Practice Picture:** RAW capture, Manual mode, f/22, 1/2 second. **On Your Own:** To set the shutter speed slower than any automatic mode would allow, you must use Shutter-Preferred or Manual exposure.
Exposure	**Practice Picture:** ISO 200, f/22, 1/2 second. **On Your Own:** Make sure the shutter speed is long enough so that your zoom effect can be seen in the final picture.
Accessories	A tripod is required for this zoom effect and for almost all architectural photography. A polarizer can help make architecture that includes windows or reflective water ponds more dramatically colored.

Architectural photography tips

✦ **Consider the composition as abstract shapes.** Forget for a moment that you are photographing buildings, and think about how your photograph looks as a two-dimensional rendition of a three-dimensional sculpture.

✦ **Watch perspective lines carefully.** Nothing looks weirder than pictures of a building in which the lines of the building are not parallel to the photographic planes. Check this issue out carefully when you compose your architectural photograph.

✦ **Watch shadows carefully.** In architectural photography, shadows tend to define the shapes of the structure. Observe the shadows created by current lighting conditions, and determine the optimal shadow direction. Come back if necessary at another time of day for more exciting shadows.

✦ **Watch the details.** Architectural details can be as interesting as the overall architecture. Consider photographing the details in addition to, or instead of, a structure as a whole.

✦ **Plan for high depth of field.** Buildings don't move. For the most part, when you are photographing architecture, you can expect a static subject. This means that you can take longer exposures, and take advantage of higher depth of field.

✦ **Plan to use a tripod.** A tripod is a must for many architectural photographs. Even if you don't absolutely need a tripod, you are more likely to compose architectural photographs carefully if you use one.

Cityscape Photography

If you live in a city or have ever visited a city, chances are that you have tried your hand at photographing a cityscape. Cityscapes are architecture writ large: Your photograph of a cityscape captures multiple structures, not one or two buildings. In this way, photographing a cityscape is like photographing a mountain range rather than a single mountain.

Inspiration

Like the subject matter of architectural photography in general, cityscapes are essentially sculptural, but they are not static. They change. They grow. The best photographs of cityscapes show idiosyncratic features of a particular city, such as a photograph of New York's rooftop water towers shown in figure 6.15.

The most well-known cityscape views have been photographed often. As a photographer, part of your job is to take a well-known city vista and transform it into a unique photograph, a view perhaps no one has considered before.

6.15 These water towers make for an interesting cityscape.

Cityscape photography practice

6.16 The Golden Gate Bridge combines with the cityscape to make an interesting photograph.

Table 6.5	
Taking Cityscape Pictures	
Setup	**Practice Picture:** The unusual viewpoint in figure 6.16 shows the Golden Gate Bridge and the San Francisco cityscape with a freighter in the foreground. **On Your Own:** Plan to create an unusual photograph using a famous landmark. Take time to scout the best viewpoints.
Lighting	**Practice Picture:** Unusually clear and crisp spring day with little smog or fog. **On Your Own:** Wait for a clear day.

Lens	**Practice Picture:** Nikon D70, AF-S Nikkor 18–70mm 3.5–4.5G ED at 30mm (45mm 35mm equivalence). **On Your Own:** Normal focal length or slightly wide-angle lenses are best for cityscapes with an expansive vista.
Camera Settings	**Practice Picture:** RAW capture, Automatic mode, f/10, 1/400 second. **On Your Own:** Provided there is plenty of light, you can use an automatic exposure.
Exposure	**Practice Picture:** ISO 200, f/10, 1/400 second. **On Your Own:** Exposure is not a huge issue for this kind of cityscape, so you can leave the camera on automatic.
Accessories	A polarizing filter can help to make skies appear vivid.

Cityscape photography tips

✦ **There are three secrets of cityscape photography.** Location, location, and location. Scout around for the best location. It's worth spending some time really looking around without taking any pictures.

✦ **Don't photograph into the sun.** If you photograph a cityscape while facing directly into the sun, you are unlikely to get a vibrant photograph.

✦ **Look for items of interest.** Can you find something interesting in your cityscape that other people haven't seen?

✦ **Combine foreground interest with background cityscape.** Compositionally, it often works to combine a feature of architectural interest in the foreground with a cityscape in the background.

Cloud Photography

Landscapes or cityscapes without clouds tend to be boring. The best way to introduce interest and excitement into a landscape photograph is to add clouds. For example, the photograph shown in figure 6.17, taken in Arches National Park, has interest largely because of clouds. And, clouds can be very dramatic, as in figure 6.18.

Inspiration

Why photograph clouds? Clouds are ephemeral, lacy, full of life but made of vapor, ever changing, sometimes white, sometimes colorful beyond imagination, castles in the sky, transient. If you've ever dozed off in a mountain meadow and awakened in the late afternoon to watch the clouds chasing each other into an alpine

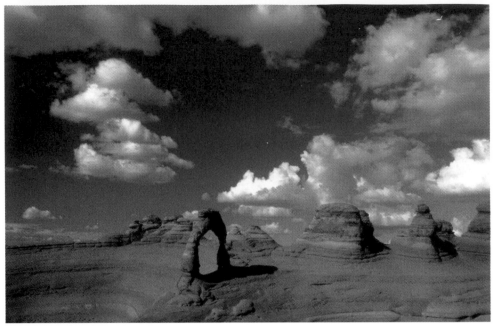

6.17 A polarizer made the sky more vivid in this image of clouds above Delicate Arch.

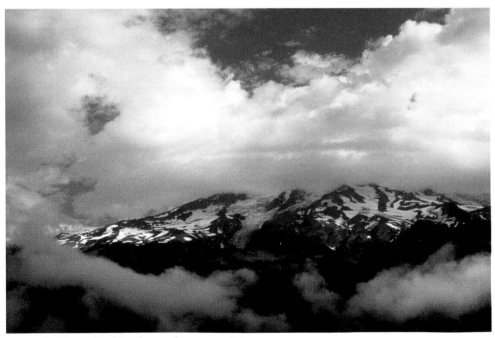

6.18 Clouds make this photo of Mount Rainier.

evening (as in figure 6.19), you'll know that clouds can be all these things, and more.

The greatest challenge you'll face as a photographer of clouds is their formlessness. If you are going to photograph only clouds (meaning no landscape or other objects in the image), make sure that the light on the cloud is so compelling that the photograph works despite the lack of other compositional elements.

6.19 Many people could spend hours just looking at clouds.

Cloud photography practice

6.20 These clouds were fleetingly lit by the setting sun.

Table 6.6
Taking Cloud Pictures

Setup	**Practice Picture:** At sunset this cloud in figure 6.20 was briefly and gloriously lit. **On Your Own:** Waiting for sunset on a day with intermittent clouds is often a very successful approach to photographing clouds. More generally, study the direction of cloud movement, and the movement of the sun. How do these two forces interact? There are likely one or two dramatic moments when clouds and sun combine to make the most striking image. If you are ready for it, you can take a very dramatic photo.
Lighting	**Practice Picture:** Light from the sun was underneath and behind this cloud. **On Your Own:** There's usually one perfect moment to photograph a cloud when the sun is setting. Wait for it.
Lens	**Practice Picture:** Canon PowerShot G3, Canon Zoom Lens 7.2–28.8mm 1:2.0–3.0 at 28mm (135mm 35mm equivalence). **On Your Own:** For a photograph that emphasizes a single cloud, a moderate telephoto is best.
Camera Settings	**Practice Picture:** RAW capture, Landscape mode, f/4.5, 1/60 second. **On Your Own:** Automatic exposure should work.
Exposure	**Practice Picture:** ISO 100, f/4.5, 1/60 second. **On Your Own:** Automatic exposure should work.
Accessories	A polarizing filter can help to make skies appear vivid depending on the direction of light. Tripods can be helpful, but you may not be able to maneuver as quickly as needed if you are using one.

Cloud photography tips

✦ **Wait for the special moment.** There's usually a unique moment in which the lighting on a cloud is just right. Clouds move quickly, so if a cloud isn't perfect one moment, it might be the next. That said, if you see a great picture, don't hesitate.

✦ **Use a telephoto focal length for a single cloud.** A moderate telephoto lens works best to photograph a single cloud.

✦ **Use a wide-angle lens for landscapes with clouds.** Use a moderate wide-angle lens to photograph landscapes and cityscapes where clouds contribute to the photographic interest.

Flower Photography

There's nothing like a flower to kindle romance or set the pulse of the photographer racing. Flowers are beautiful, subtle, sensuous, and endlessly varied. There are so many varieties of flowers, and so many ways to photograph them, that some professional photographers have specialized and only take pictures of them.

Do you love roses the best? Then you may enjoy creating close-up views of these masterpieces of the floral world, like the photograph of the Fourth of July variety shown in figure 6.21.

Do the vibrant colors turn you on with their inimitable display of flower power? In that case you should look for bright flowers in the morning or evening, lit by subdued light, such as the South African gazanias shown in figure 6.22.

You'd think it would be hard to miss with flowers because they are so beautiful. But in fact there's a great difference between mediocre flower pictures and those taken by a digital photographer at the top of his or her game.

6.21 This Fourth of July rose makes a great photographic subject.

Inspiration

Flowers are flowers, or, as Gertrude Stein famously and fatuously remarked, "A rose is a rose is a rose." It's hard not to feel compelled by the beauty, strangeness, and sensuousness of a flower. Who wouldn't be inspired?

If beauty and grace are not enough, consider rarity. Many times, getting truly great field photographs of flowers requires following the seasons. Desert flowers bloom during certain, brief times of year (and only then if the year has had a good rainy season).

6.22 Purple gazanias make for a vibrant show of color in subdued lighting.

Mountain wildflowers are gorgeous in their prime, but they are preceded by bogs and mosquitoes and followed by autumn snow. The tree peony flower shown in figure 6.23 blooms only one day a year, so if you catch it, you are lucky.

Catching the perfect flowers in bloom and recognizing that perfection can include imperfections are the two biggest challenges for the photographer of flowers.

6.23 The first rays of sunrise hit this rare tree peony.

Flower photography practice

6.24 Mixed lighting makes this picture of a red rose successful.

Table 6.7
Taking Flower Pictures

Setup	**Practice Picture:** The rose in figure 6.24 was found early in the season in a public rose garden. **On Your Own:** This flower was one of the first of the year, and in general early blooming flowers make better photos than ones later in the season. Whatever time of year you look for a flower to photograph, you should be aware that imperfections in a flower can mar flower photography. So inspect your buds carefully!

Continued

Table 6.7 (continued)

Lighting	**Practice Picture:** The rose was lit both in front and from behind, in the middle of a darker area, making for a picture with dramatic contrasts. **On Your Own:** Look for dramatic lighting to enhance your flower pictures.
Lens	**Practice Picture:** Nikon D70, AF-S Nikkor 18–70mm 3.5–4.5G ED at 70mm (105mm 35mm equivalence). **On Your Own:** A moderate telephoto focal length helps you get closer to flowers that might otherwise be hard to reach.
Camera Settings	**Practice Picture:** RAW capture, Automatic mode, f/5.6, 1/125 second. **On Your Own:** Automatic exposure, Macro mode, or select an appropriate exposure.
Exposure	**Practice Picture:** ISO 200, f/5.6, 1/125 second. **On Your Own:** Automatic exposure should work. If your camera provides a Close-Up or Macro exposure mode, use it.
Accessories	A tripod is often essential to taking good pictures of flowers if high depth of field and/or a slow shutter speed are required. A polarizer can help create dramatic color effects.

Flower photography tips

✦ **Strong composition helps floral pictures.** Flower photographs are not just about the flowers. They are also about how the flowers work in a two-dimensional design. Pay attention to the design aspects of your flower photographs.

✦ **Flowers are about color.** If the colors in your flower photo are not striking, you don't have anything. Move on to another flower.

✦ **Take care with surrounding colors.** Observe the colors that are not central to your composition, and make sure they help you. Use depth of field to emphasize or de-emphasize areas in your photograph, depending on how they work with the overall composition.

✦ **Plan to use a tripod.** You may need a tripod to photograph flowers if the light is dim, or if you'd like high depth of field and must therefore use a slow shutter speed. Even if you don't need it, using a tripod should help you take your time with composition.

✦ **Turn off the flash.** For the most part, you should photograph flowers without a flash.

Landscape Photography

A landscape photograph can be many things. When you think of landscape photographs, you perhaps first think of stunning black-and-white Ansel Adams imagery or lush Sierra Club–style portraits of the vanishing wilderness.

Other landscapes are quieter, intimate affairs. The best photographs of this kind of landscape show an everyday setting that is somehow magical.

Yet other landscapes incorporate artifacts of humanity. Suburban, gated communities comprised of nearly identical McMansions can form a landscape, as can "farms" where the crop consists of tailfins of old Cadillacs.

Without going to these extremes, the fairly placid landscape shown in figure 6.25 is only interesting because of the boat reclining on the mud bank.

Inspiration

Landscapes inspire for their grandeur and, paradoxically, their intimacy. Some landscapes make you want to go to the place photographed; others make you afraid.

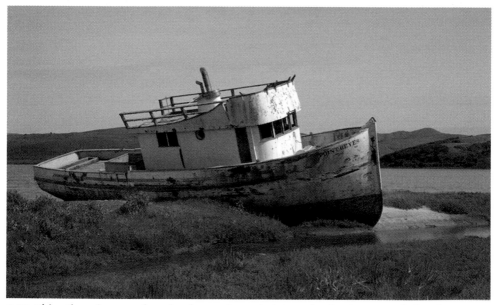

6.25 This otherwise mundane landscape is made interesting by the grounded tugboat.

You can photograph a landscape in the middle of the day, lit from above, and get dusty, vapid imagery that says nothing to your viewers. Or else you can wait for wild weather, clouds, and a rainbow like that captured in the photograph shown in figure 6.26. Regardless of your situation (you can't always order up a rainbow), try to find the best angles and the most interesting subjects. With careful observation, even the mundane can be interesting.

Another approach is to create photographs of landscapes that are largely graphic in impact. This kind of landscape photograph has as one of its antecedents Chinese brush landscapes. The ancient tradition of Chinese landscape painting continues to this day, and you won't find much realism in these paintings. But you will recognize the brush strokes as symbolic of a landscape, and perhaps be moved by the simple graphic designs used.

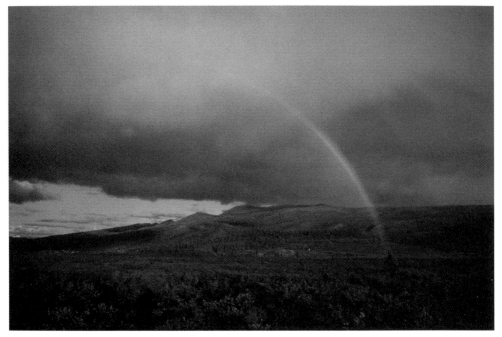

6.26 Clouds and a rainbow help emphasize the grandeur of this landscape.

Landscape photographs that go down this path tend to have few details and rely on overall shapes and colors, like the photo-graph of Mirror Lake in Yosemite Valley shown in figure 6.27.

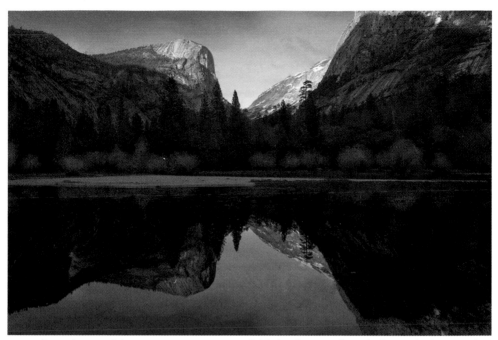

6.27 The rather stark but sumptuous nature of this landscape photo helps make it evocative.

Landscape photography practice

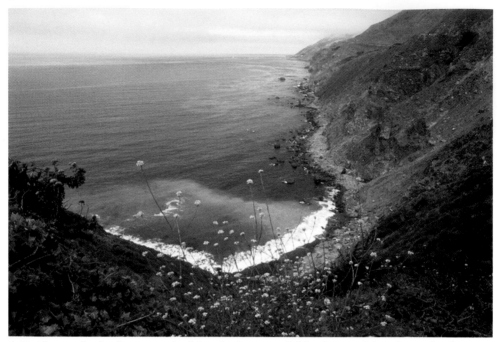

6.28 Flowers in the foreground add to the interest of this picture of the Big Sur landscape.

Table 6.8	
Taking Landscape Pictures	
Setup	**Practice Picture:** Foreground flowers make the photograph in figure 6.28 more interesting than it would be as just a distant landscape. **On Your Own:** See if you can find a landscape that combines foreground interest with background excitement. Try to get close to the foreground element while still capturing the landscape.
Lighting	**Practice Picture:** Side lighting lit the Big Sur landscape. **On Your Own:** Look for dramatic lighting to enhance your landscapes.

Lens	**Practice Picture:** Canon PowerShot G3, Canon Zoom Lens 7.2–28.8mm 1:2.0–3.0 at 7.2mm (35mm 35mm equivalence). **On Your Own:** A moderate wide-angle lens brings the foreground and background into one picture.
Camera Settings	**Practice Picture:** RAW capture, Aperture-Preferred mode, f/16, 1/125 second. **On Your Own:** If your landscape combines a foreground element with a background, use Aperture-Preferred metering to make sure you have enough depth of field for the foreground and background to be in focus.
Exposure	**Practice Picture:** ISO 100, f/16, 1/125 second. **On Your Own:** Set the aperture first, using Aperture-Preferred metering.
Accessories	If you need high depth of field to bring foreground and background into focus, you'll often need to use a tripod because of slow shutter speeds. A polarizer can bring out colors in the skies in a landscape, depending on the lighting condition.

Landscape photography tips

✦ **Consider the point of your photo.** Is your landscape photo about clouds, mountains, shapes and colors, or the wrecked and rusty tractor in the field? Be conscious of the most important element of your photograph, and emphasize it.

✦ **Composition counts.** Landscape photographs can be boring if they are not well composed.

✦ **Observe how the landscape is lit, and follow the light.** Landscape lighting varies from one spot to another, and from one moment in time to the next. Changing light, and changing photographic viewpoint, can make the difference between a throwaway shot and a great landscape photograph. So observe light and weather carefully, and go where the action is best.

✦ **Plan to use a tripod.** It's the rare landscape that won't benefit from the use of a tripod. If your landscape combines foreground and background elements, you almost certainly should use a tripod to achieve higher depth of field.

✦ **Turn off the flash.** There's nothing sillier than the photographers who aim a flash at the Grand Canyon. (Note to these shutterbugs: Your flash doesn't have that kind of range.) So don't use a flash with most landscapes. The sole exception: You may want to consider using fill flash to light a foreground subject that is in the shadows when the background landscape is brightly lit.

Macro and Close-Up Photography

How do you best get to know something or someone? By getting close to them. That's why macro and close-up photography is so important and fun.

You can probably do some close-up work with the lens that came with your camera. However, for really close precision work, you may need to buy a macro lens or close-up filters.

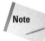 **Note** *Less-expensive digital cameras that come equipped with an LCD viewfinder may actually have better macro capabilities than the lens that comes with a through-the-lens digital SLR, although you can always get a special macro lens for your SLR.*

Macro photography can reveal the hidden magic of nature. For example, the close-up of the desert wildflower in the spring shown in figure 6.29 reveals the beauty of the desert.

You may also want to use macro photography in a more basic way: to get close to objects. For example, the picture of the stone heart shown in figure 6.30 lets the viewer have a good close look at the rock from which this heart was carved.

6.29 A macro shot of a desert wildflower.

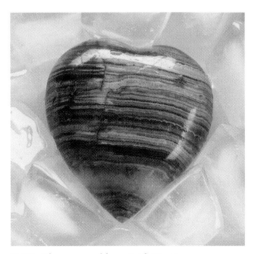

6.30 Close-up of heart of stone.

Inspiration

In the 1950s movie *The Incredible Shrinking Man,* the protagonist realizes by the end of the movie that if you get small enough, a new world opens. This is what happens with macro photography.

Becoming good at macro and close-up photography enables photographers to enter the brave new world of the tiny and the fine detail. If you didn't see it in your camera viewfinder, or in the final image, would you ever have thought the center of a rose looked as it does in figure 6.31?

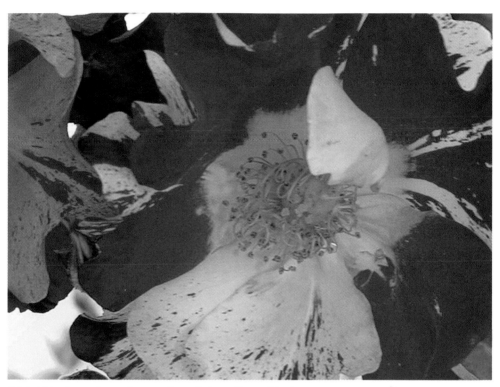

6.31 This close view of a rose is an interesting subject.

Getting close is also a good way to visually understand the details of a mechanism, like the watch shown in figure 6.32.

6.32 You need to get really close to capture the beautiful details of small objects like this watch.

When you use photo composition techniques to combine images created using a digital camera's macro facility with broader views of landscapes and skies, you can get some very inspiring pictures. For example, the image shown in figure 6.33 combines a macro photograph of a painting of hearts with an image of distant clouds and a sunset.

6.33 This photo composition uses a close-up photograph of painted hearts as one of its elements.

You can transform macro photographs of mundane objects like the printer's slug (an antique typesetting tool) shown in figure 6.34 so that the viewer no longer knows what the image represents.

Using digital photo composition techniques, you can then take the macro photograph one step further, creating effects like the one shown in figure 6.35 — a whole new world from a simple macro photograph of a very small object.

6.34 Numbers are reversed in this macro shot of a printer's slug.

6.35 Applying a Photoshop embossing filter to the macro shot of a printer's slug creates this scarab-like effect.

Macro and close-up photography practice

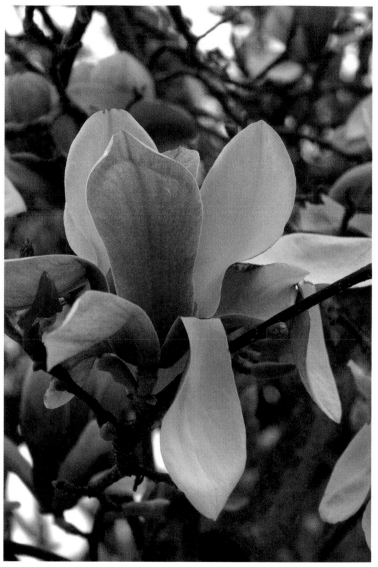

6.36 A moderate telephoto focal length brings this magnolia blossom in close.

Table 6.9
Taking Close-Up Pictures

Setup	**Practice Picture:** A moderate telephoto focal length brought the magnolia blossom in figure 6.36 close. **On Your Own:** Flowering trees and bushes can present a compositional challenge because without a central point of interest, compositions can be boring. So try to arrange your close-up photograph around a feature of special interest.
Lighting	**Practice Picture:** Bright overcast lighting works well for moderate close-ups. **On Your Own:** Look for overall bright lighting for close-ups.
Lens	**Practice Picture:** Nikon D70, AF-S Nikkor 18–70mm 3.5–4.5G ED at 70mm (105mm 35mm equivalence). **On Your Own:** A moderate telephoto focal length lets you get visually close to subjects that are otherwise out of range for close-ups.
Camera Settings	**Practice Picture:** RAW capture, Automatic mode, f/8, 1/160 second. **On Your Own:** Consider your depth of field requirements carefully, and use Aperture-Preferred metering if you need to stop the lens down.
Exposure	**Practice Picture:** ISO 200, f/8, 1/160 second. **On Your Own:** If you are not looking for high depth of field, you can use Automatic exposure mode, or Macro exposure mode if available.
Accessories	A tripod will help you compose better macro and close-up photographs, and is required much of the time.

Macro and close-up photography tips

✦ **See the details.** Macro and close-up photographs are about revealing details. Make sure that the details your photograph reveals are the secrets you want viewers to see — and not ugly or irrelevant details.

✦ **Center the composition.** Macro and close-up photographs can be boring unless they feature a central item of interest.

✦ **Consider your depth of field requirements.** Think carefully about what level of depth of field would be best for your image. If everything needs to be in focus, set the aperture accordingly. Otherwise, having unimportant portions of the image appear out of focus may work best. That's fine — just create the effect intentionally, not by accident.

✦ **Get the right equipment.** If you'll be doing a great deal of close-up work, invest in a good macro lens, perhaps with a moderate telephoto focal length.

✦ **Use the right mode.** If you are shooting close, use your camera's close-up setting or Macro mode.

✦ **Plan to use a tripod.** It's the rare close-up that won't benefit from the use of a tripod.

Mountain Photography

Famous California mountaineer and naturalist John Muir wrote "Climb the mountains and get their good tidings. Nature's peace will flow into you as sunshine flows into trees. The winds will blow their own freshness into you and the storms their energy, while care will drop off like autumn leaves."

As Muir knew, mountains are very special places, and special places can make for interesting photographs. If you are looking to take a striking photograph of a mountain, you should consider waiting for the flattering light of late afternoon or sunrise. You should also see if there are interesting topographic features (like Wonder Lake in the foreground of the photo in figure 6.37) that can improve your mountain composition.

Inspiration

Mountain views are the quintessential landscape vista. A mountain summit speaks of inspiration and grandeur.

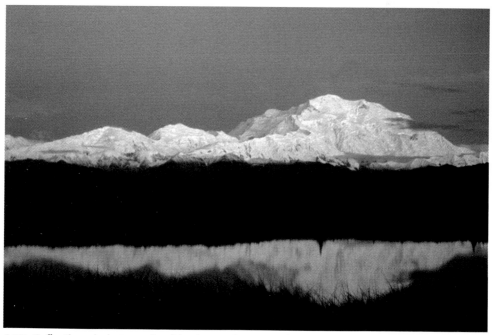

6.37 Reflections help to make this photo of Mt. Denali more interesting.

You should realize that to take great mountain photographs, you'll have to get up the mountains—at least most of the time! The key trick with mountain photography is being there. (If you are involved in any serious climbing, the other trick is getting yourself and your pictures home safely.)

Of course, great light and high depth of field can help, as in the photograph of a mountain and glacier shown in figure 6.38.

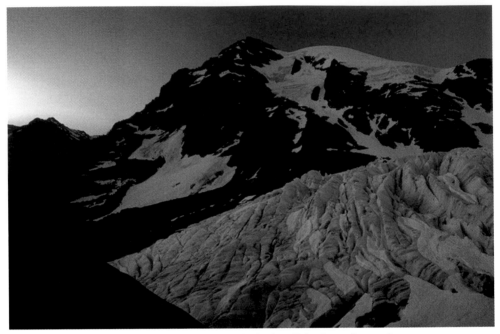

6.38 Mt. Olympus and the Blue Glacier catch the last light from the setting sun.

Mountain photography practice

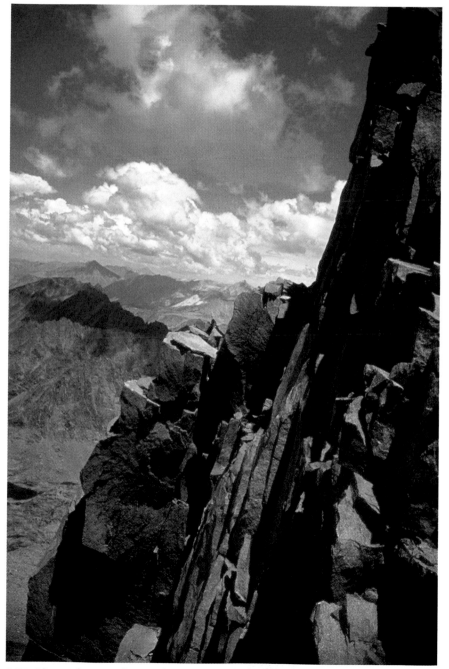

6.39 Mountain summits are dramatic places by their very nature.

Table 6.10
Taking Mountain Pictures

Setup	**Practice Picture:** Approaching the summit of Mt. Sills in figure 6.39, I made sure of my footing before snapping this photo. **On Your Own:** If you are going to climb mountains and take pictures, it's key to get back safely. Practice full safety precautions, and make sure that your own footing is secure before taking pictures. Even roadside vistas in the mountains tend to be perched above steep drops.
Lighting	**Practice Picture:** I thought this summit photo more interesting than the view from the summit. **On Your Own:** Look for dramatic views of the summit.
Lens	**Practice Picture:** Canon PowerShot G3, Canon Zoom Lens 7.2–28.8mm 1:2.0–3.0 at 7.2mm (35mm 35mm equivalence). **On Your Own:** A moderate wide-angle lens helps make the summit look more dramatic.
Camera Settings	**Practice Picture:** RAW capture, Automatic mode, f/11, 1/400 second. **On Your Own:** Automatic exposure should work fine.
Exposure	**Practice Picture:** ISO 100, f/11, 1/400 second. **On Your Own:** Automatic exposure should work fine.
Accessories	Keep photographic equipment lightweight — bring only the absolute essentials.

Mountain photography tips

✦ **Think about the summit.** A mountain summit may be more interesting than the view from the mountain. Photograph accordingly.

✦ **Wait for the light.** Mountain photographs are landscape photographs. Like other landscape photographs, the lighting is crucial. Wait for the right light.

✦ **Be there.** There's usually nothing particularly fancy about photographing mountains, but you have to be there to do it.

✦ **Be safe.** Don't get so distracted by photography and photographic equipment that you neglect safety precautions.

Night Photography

Night photography can be problematic for photographers because on a dark night there is very little light. And without light, there are no photographs.

So, really, when photographers speak of photographing at night, mostly what they really mean is in the evening, or at dawn, or in situations in which there is plenty of non-solar ambient light (such as the evening cityscape shown in figure 6.40).

Inspiration

One of the neatest things about photographing in nighttime conditions, which usually involves a mixture of evening (or early morning) solar light and artificial light, is that the blending light often creates cool effects that the photographer could not have anticipated. For example, the street and building lights come together in the photograph shown in figure 6.41 to create an effect that makes the streets appear to be paved with gold.

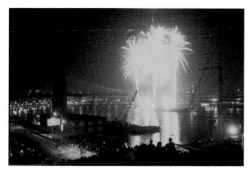

6.40 The skyline starts to get interesting when the city lights come out.

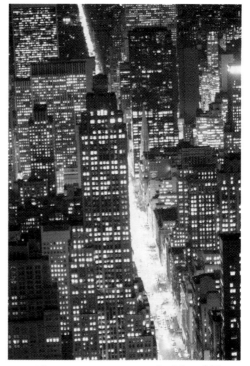

6.41 The streets seem paved with gold in this nighttime photo.

Night photography practice

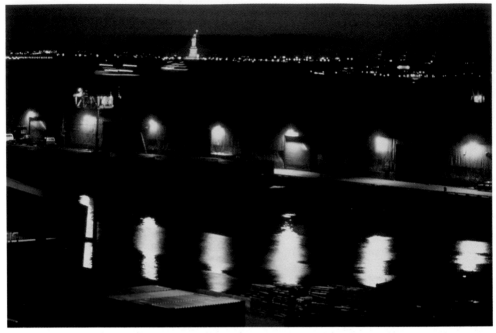

6.42 Multiple lighting sources created an interesting nighttime effect.

Table 6.11
Taking Night Pictures

Setup	**Practice Picture:** The unusual photograph in figure 6.42 shows a shipyard with the Statue of Liberty behind it, and many kinds of light, from sunset to fluorescent. **On Your Own:** Find a good nighttime spot where you can set up a tripod, and where the scene will be illuminated by different kinds of light.
Lighting	**Practice Picture:** White balance was set for daylight, so foreground lighting created an unusual effect by throwing the light off balance. **On Your Own:** See what happens if you set your white balance for daylight and shoot a variety of nighttime photos.
Lens	**Practice Picture:** Nikon D70, AF-S Nikkor 18–70mm 3.5–4.5G ED at 18mm (27mm 35mm equivalence). **On Your Own:** Normal focal length or slightly wide-angle lenses are best for night scenes with an expansive vista.
Camera Settings	**Practice Picture:** RAW capture, Manual mode, f/16, 4 seconds. **On Your Own:** Provided there is plenty of light, you can use an automatic exposure. If there's not a lot of light, experiment.

Exposure	**Practice Picture:** ISO 800, f/16, 4 seconds. **On Your Own:** You'll need to experiment with exposures for nighttime pictures, probably setting exposure manually.
Accessories	A tripod is required for most night photographs. Also bring plenty of warm clothing, and gloves if it isn't a balmy summer night.

Night photography tips

✦ **Check the white balance.** Review the coloration of your photos, and reset the white balance accordingly.

✦ **Night photography takes time.** Getting the hang of nighttime photography takes a while, both in terms of understanding how light is rendered, and the time taken to set up and wait. Don't expect instant results.

✦ **Bracket exposures.** If you are in doubt about the exposure, bracket like crazy (your digital camera may have a feature that helps you to automatically bracket).

✦ **Use a tripod.** You'll want to photograph most nighttime scenes using a tripod.

Panoramic Photography

From the very earliest days of photography, the ability to create panoramas — views with a scope of more than 180 degrees either vertically or horizontally — has been a passion for many photographers.

But until the advent of digital photography, specialized and expensive equipment was required to create panoramic photographs.

Now you can take contiguous photographs with almost any camera, and your digital darkroom software — Photoshop and Photoshop Elements in particular — can arrange the photographs into a continuous panorama (although Photoshop does the better job of this).

Other Panoramas

Theoretically, you could have spliced together pieces of film in the darkroom to create a film-photograph panorama, but this was laborious and rarely satisfactory. Another pre-digital approach, used by David Hockney and other artists, was to paste together numerous small prints.

Extreme wide-angle lenses do give a panoramic field of view, in some cases as much as 180 degrees or more. But these lenses also produce an effect of extreme optical distortion — cool if you want it, but not natural looking.

Inspiration

It's great to see a panorama because panoramic photos are usually presented in interesting shapes — tall and skinny (vertical panorama) or wide and narrow (horizontal panorama). In addition, panoramas as photographs are closer to a normal field of view than most photographs. In other words, as humans we see in panoramas rather than in the cut-off view presented by a normal photograph.

You can create panoramic photos in a couple of ways. Perhaps the most common way is to create a panorama in your editing software, such as Photoshop Elements or Photoshop. To do this, start by taking a number of contiguous pictures. After you get them in the software, place these pictures together to create the panorama.

To create a panorama using Photoshop, open Photoshop and choose File ⇨ Automate ⇨ Photomerge. When prompted, make sure that Open Files is selected in the drop-down list, select the photos to include in the panorama, and click OK.

The Photomerge dialog box, shown in figure 6.43, opens with the photographic pieces arranged in a panorama. Dang, that software is smart!

> **Note** *I've created a vertical panorama for this book, because it makes the most sense in relationship to the size proportions of the book's pages. For your own use, you may want to create horizontal panoramas instead of, or in addition to, vertical panoramas.*

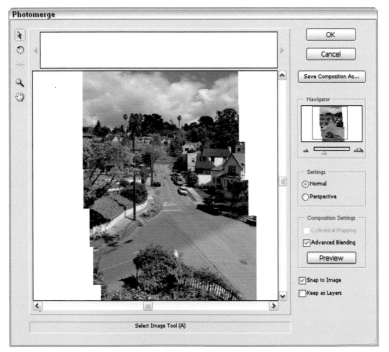

6.43 The Photomerge software does a great job of aligning pieces to make a panorama.

Panoramic photography practice

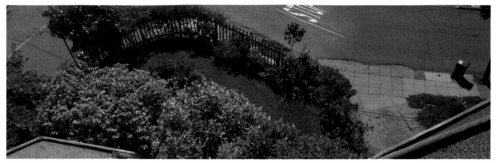

6.44 This vertical panorama gives more angle of view without distortion than you could get using normal photographic techniques.

Table 6.12 Taking Panoramas	
Setup	**Practice Picture:** Four horizontal frames stack to create a vertical panorama in figure 6.44. **On Your Own:** Find a scene, either horizontal or vertical, you would like to run into a panorama. Shoot contiguous frames with a slight overlap.
Lighting	**Practice Picture:** Normal bright sunny day. **On Your Own:** You can take digital panoramas in almost any lighting.
Lens	**Practice Picture:** Nikon D70, AF-S Nikkor 18–70mm 3.5–4.5G ED at 34mm (50mm 35mm equivalence). **On Your Own:** Normal focal length or slightly wide-angle lenses are best for creating panoramas that don't appear to be distorted.
Camera Settings	**Practice Picture:** RAW capture, Automatic mode, f/10, 1/320 seconds. **On Your Own:** Provided there is plenty of light, you can use an automatic exposure.
Exposure	**Practice Picture:** ISO 200, f/10, 1/320 second. **On Your Own:** No special exposure issues for panoramas.
Accessories	No accessories are necessary (except a digital camera and a computer equipped with Photoshop).

Panorama tips

✦ **How about that David Hockney effect?** If you don't want to create a Hockney-like collage effect, work in Photoshop to square edges. (However, the Hockney effect is also pretty cool.)

✦ **Plan your panorama.** Panoramas work best if you plan them in advance. Try to visualize what your panorama will look like when it is done so you can take the pictures to support your goal.

✦ **Play and experiment.** Panoramas, photo collages, and photo merges are great fun. So have fun playing and experimenting!

✦ **Keep track of the boundaries.** You want a slight overlap between each photo that comprises a piece of your collage. Make sure to keep track of the boundaries so that there are no gaps in coverage.

People: Baby and Child Photography

Photographing babies and children is wonderful because they don't have the inhibitions of adults and are very natural and playful. Kids let it all hang out! But, because photographing kids is so much fun, you should make sure to take some great pictures of them, not just off-the-cuff snapshots. A little preparation goes a long way.

Baby photography

Photography of babies has unique challenges and joys. It's not unreasonable for a photographer to think of babies as small animals. But, if you are a parent, don't take this the wrong way. All I mean is that babies move around a lot and cannot easily be directed by a photographer. So the photographic challenges are essentially the same whether it is a pet or a baby.

There's nothing as special as a baby's relationship with its parent, particularly its mother. So why not start your photography

of babies — whether it's your baby or someone else's — in the same way, by photographing the baby in his or her mother's arms (see figure 6.45).

6.45 There's nothing more special than a baby in mom's arms.

Inspiration

If you have a baby, you want to photograph it. If you are a photographer and your friends have a baby, they likely want you to photograph their baby. To a new parent, nothing is more special than a baby! It's as simple as that.

Babies are tiny compared to adults. So, it's important to provide a sense of scale in your photographs of babies by placing them near (or in) recognizable objects, like the photo of a baby in a laundry basket shown in figure 6.46

6.46 This baby in a laundry basket is having a very good time!

Baby photography practice

6.47 It can be a trick to get the baby to smile for the camera.

Table 6.13
Taking Baby Pictures

Setup	**Practice Picture:** The baby in figure 6.47 was playing with a toy and looking at Mom. **On Your Own:** Find a way to get the baby to look in the right direction and have a happy, or at least peaceful, expression.
Lighting	**Practice Picture:** Direct-camera strobe (flash) with red-eye reduction. **On Your Own:** A flash is good for stopping the motion of the baby, but it may upset him or her. If in-camera red-eye reduction doesn't eliminate red eye, you can take care of this in post-processing.
Lens	**Practice Picture:** Nikon D70, AF-S Nikkor 18–70mm 3.5–4.5G ED at 70mm (105mm 35mm equivalence). **On Your Own:** A moderate telephoto helps bring a baby closer without the baby feeling overwhelmed.
Camera Settings	**Practice Picture:** RAW capture, Portrait mode, f/4.5, 1/60 second, on-camera strobe, red-eye reduction. **On Your Own:** Automatic exposure mode is probably fine.
Exposure	**Practice Picture:** ISO 200, f/4.5, 1/60 second. **On Your Own:** Expect to use high natural light levels or on-camera strobe.
Accessories	Having plenty of toys on hand helps to make photographing babies easy and fun.

Baby photography tips

✦ **Babies like toys.** Make a baby happy, and distract them, with age-appropriate toys.

✦ **Use a parent.** If you position Mom or Dad, the baby will look towards them. You can take advantage of the position of the parent to direct the baby.

✦ **Scale your pictures.** When possible, include objects in your photos that provide a sense of scale so the size of the baby is evident.

✦ **Red eye can be cured.** If your baby pictures show red eye, even after in-camera red-eye reduction, don't worry: You can pretty much eliminate red eye in digital post-production.

✦ **The best baby pictures have a sense of wonder.** Your pictures should show it.

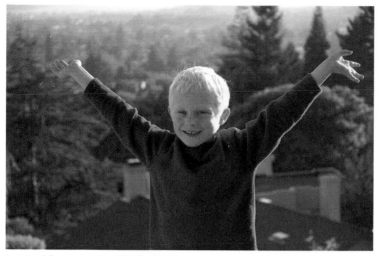

6.48 Kids are rarely still, but if you are ready to take the picture when that moment of stillness occurs, you can get great portraits.

Child photography

Kids! Kids! Kids! Who doesn't want to photograph their kids? Or, if your friends have kids, they probably like to see good pictures of their little darlings.

Unlike babies, to some degree you can ask kids to pose or give them other directions. Whether they will follow the directions is, as all parents know, debatable. Kids seem to be constantly in motion, so a neatly posed picture may not always be a realistic option — but if you are lucky and patient, you can get a great photo (see figure 6.48)

Some of the best photographs of kids are portraits. A portrait tells something about the personality or the character of the subject, as seen in figure 6.49.

6.49 This portrait tells the viewer that this is a happy, outgoing, charismatic boy.

Inspiration

One reason for photographing kids is to play. Children love to play. They live to play. As an adult photographer, you can enter this play for a while.

For example, in figure 6.50, it is not entirely clear whether the boy is a construction worker or a firefighter, but whatever he is, he is having fun. (And so did the photographer taking the picture.)

Holidays that give an opportunity for dress-up and fantasy are a great time for photographers. Children get caught up in the excitement of the moment, and forget to be self-conscious. They also may be wearing really cute costumes (see figure 6.51).

6.50 Kids love to play dress-up, providing excellent photo opportunities.

6.51 Halloween, like other occasions for playing with costumes, is a great time for photographing children.

Child photography practice

6.52 Children can enjoy your photography field trips too.

Table 6.14
Taking Pictures of Children

Setup	**Practice Picture:** Julian was having a great time looking for photo opportunities with me, when I decided that he was the photo, as seen in figure 6.52. **On Your Own:** Take a child (yours or someone else's) on a photography field trip. When you get bored with photographing flowers, take some pictures of the little companion instead.
Lighting	**Practice Picture:** Bright overhead but cloudy light, good for moody portraits. **On Your Own:** Don't try to take portraits in strong, harsh light.
Lens	**Practice Picture:** Nikon D70, AF-S Nikkor 18–70mm 3.5–4.5G ED at 70mm (105mm 35mm equivalence). A moderate telephoto helped bring my subject closer. **On Your Own:** A moderate telephoto lens will bring kids closer and make it easier to take portraits.

Continued

Table 6.14 *(continued)*	
Camera Settings	**Practice Picture:** RAW capture, Automatic mode, f/8, 1/250 second. **On Your Own:** Automatic exposure mode is probably okay.
Exposure	**Practice Picture:** ISO 200, f/8, 1/250 second. **On Your Own:** Use a portrait exposure mode if it is available on your camera.
Accessories	Bring a sense of wonder, fun, and play.

Child photography tips

✦ **Children like toys.** If you have age-appropriate toys around, kids won't get bored and will be easier to photograph.

✦ **Use a parent.** It's important that kids feel safe and comfortable. You can facilitate this by having a parent present when you photograph.

✦ **Familiar locations mean safety.** Children are likely to feel safer on their home ground. Consider photographing them at home, or someplace else they know well.

✦ **Kids are the ultimate action subject.** Get ready for action. If you hesitate, you may lose a good photograph. Use fast shutter speeds. Consider using a flash to stop motion.

✦ **Red eye can be cured.** If you use a flash and your pictures show red eye, even after in-camera red-eye reduction, don't worry: You can pretty much eliminate red eye in digital postproduction.

✦ **Get down on the child's level.** Pictures of children can be much more effective if they are taken from the level of the child rather than from above looking down.

✦ **Have fun!** Kids are about fun! If you have fun along with the kids you are photographing, your pictures are likely to come out better.

Pet Photography

People love their pets and photograph them often. There are professional photographers who photograph nothing but pets. All this says that photographing pets is a serious specialization.

Good pet photography is irresistible to those who love animals (see figure 6.53).

Inspiration

By photographing your pets, you get to combine two passionate interests into one: pets and photography. Although pets are not easy photographic subjects — they move around a lot and don't usually take direction — your photographs can convey the essence of your favorite pet, how well they interact with others, and what you enjoy most about your pet.

6.53 Who could resist these puppies?

Pet photography practice

6.54 It's fun to take portraits of your pets.

Table 6.15
Taking Pet Pictures

Setup	**Practice Picture:** Close-ups of pets can be more interesting than full or distant views, as shown in figure 6.54. **On Your Own:** As with pictures of people, photos of animals are portraits. The best of these reveal the character of the animal. This can often be achieved by taking a close-up portrait of your favorite pet. Even if you don't move in close, think about taking pictures that reveal details of the characters of the pet.
Lighting	**Practice Picture:** Flash will likely scare your pet, so try for bright but subdued lighting. **On Your Own:** Don't try to take pet portraits in strong, harsh light.
Lens	**Practice Picture:** Nikon D70, AF-S Nikkor 18–70mm 3.5–4.5G ED at 70mm (105mm 35mm equivalence). **On Your Own:** A moderate telephoto helps bring the cat's face, or other pet, closer.
Camera Settings	**Practice Picture:** RAW capture, Automatic mode, f/8, 1/125 second. **On Your Own:** Automatic exposure mode is probably okay, but you may have to compensate for the pet's color.
Exposure	**Practice Picture:** ISO 200, f/8, 1/125 second. **On Your Own:** Sports exposure mode may be a good choice for photographing pets, if it is available on your camera.
Accessories	Treats for your pet are likely to make photography sessions more enjoyable.

Pet photography tips

✦ **Pets like toys.** If you provide a cat or dog toy, you may get better pictures.

✦ **Reinforce with treats.** It's important to reinforce the photographic experience with treats. If a pet gets used to associating photography with treats, your photography is likely to go better.

✦ **Portraits can reveal more.** Consider moving in close for a better, more revealing portrait.

Still-Life Photography

Literally, the term *still life* means anything that is still and doesn't move. But usually a still life is comprised of a visual *arrangement* of some sort that is pleasing to the eye, whether outdoors or in, and whether found or styled.

Like *ikebana*, the Japanese art of flower arrangement, still-life photography is probably more about arranging and creating your still-life subject than about photography per se. There's great variety in the kinds of subject matter that are appropriate for still-life photography, ranging from flowers indoors (figure 6.55) and a single bud in water (figure 6.56) to mechanisms like the antique calculator shown in figure 6.57.

6.55 This lily was arranged indoors with colored paper as a backdrop.

6.56 A still-life arrangement can be as simple as a single bud in a shallow bowl of water.

Inspiration

If you've found something wonderful, like the white window and flowers shown in figure 6.58, then you've found a still life.

Whether you find a still life or arrange one like a fine example of *ikebana,* photographing a still life is an act of Zen (as in figure 6.59). Great still lifes are seamless. You don't know who created what or whether it was arranged or found — and it probably doesn't matter.

6.57 This antique circular calculator was placed on a mirror.

6.58 This white window and flowers is a found still life.

6.59 These leaves were arranged by the photographer to make a still life.

Still-life photography practice

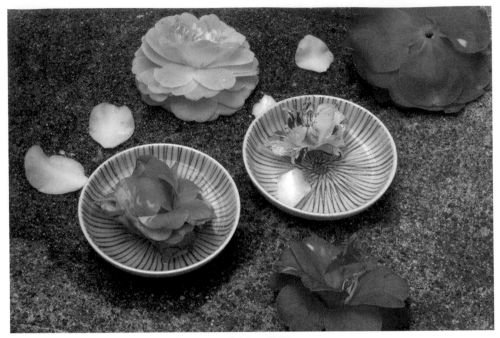

6.60 It was fun arranging the elements of this still life.

Table 6.16
Taking Still-Life Pictures

Setup	**Practice Picture:** A few buds were taken from a garden and arranged for the shot in figure 6.60. **On Your Own:** Take a few things that you like and arrange them pleasantly, or look for an opportunity to do so when you are out and about.
Lighting	**Practice Picture:** Bright overcast lighting works well for still-life photography. **On Your Own:** Look for bright but overcast light outdoors, or bring your still life inside where you can control the lighting.
Lens	**Practice Picture:** Nikon D70, AF-S Nikkor 18–70mm 3.5–4.5G ED at 60mm (90mm 35mm equivalence). **On Your Own:** A moderate telephoto focal length lets you get visually close to subjects and provides an impression of optical flatness.

Camera Settings	**Practice Picture:** RAW capture, Aperture-Preferred mode, f/22, 1/25 second. **On Your Own:** Consider your depth-of-field requirements carefully, and use aperture-preferred metering if you need to stop the lens down.
Exposure	**Practice Picture:** ISO 200, f/22, 1/25 second. **On Your Own:** Generally, you will want to take still-life photographs with high depth of field, so use aperture-preferred metering and stop the lens down.
Accessories	A tripod is pretty much required for effective still-life photography.

Still-life photography tips

✦ **Watch your arrangement unfold.** Still-life photographs are about special worlds you've created or uncovered. Make sure your photograph shows these worlds: There should be more than one way to look at a successful still-life photo.

✦ **Composition matters.** Just as your arrangement of objects should be pleasing, so should your composition.

✦ **Details count.** You may have had a teacher who said that neatness counts. Neatness — and details — definitely counts in still-life photography. One misplaced detail can spoil an entire, otherwise wonderful still-life arrangement.

✦ **Use high depth of field.** Most still-life photographs benefit from high depth of field.

✦ **Plan to use a tripod.** Unless you don't want high depth of field (unlikely with a still life) use a tripod. Even if you don't need the tripod because of shutter-speed issues, a tripod will help you make better still-life compositions by enabling you to look more carefully.

Sunset and Sunrise Photography

There's not much difference between photographing sunsets and sunrises, except that you are more likely to be wide awake at sunset. Technically, sunsets do last a little longer than sunrises, but the light from sunrise and sunset has virtually the same qualities.

Photographs of sunsets can be banal because they are clichés. That said, sunset and sunrise are glorious times of day for the photographer. The wonderful light at the beginning and end of the day cannot be replicated any other time. So the trick for the photographer is to create interesting or unusual imagery of sunsets and sunrises.

When all is said and done, there's nothing more wonderful for the photographer than to stand on a high place at sunset, camera on tripod, and photograph the silhouette of ridge after ridge, as in figure 6.61.

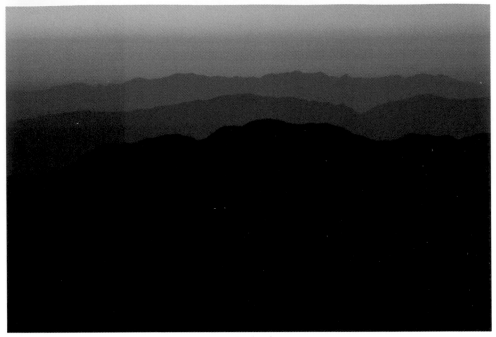

6.61 It's glorious to watch a sunset from a high place.

Inspiration

It's darkest, as they say, just before dawn, and it can be the coldest too. If you've been holding a cold vigil in the early hours before the sun comes up, maybe your photographs can express the joy that the dawn of a new day brings, as shown in figure 6.62.

6.62 Sunrise lights the clouds near this mountain.

Sunset and sunrise photography practice

6.63 Stark trees make a contrast with the light of the setting sun on the clouds.

Table 6.17
Taking Sunset Pictures

Setup	**Practice Picture:** In figure 6.63, a sunset in the woods made an interesting contrast with the sky and clouds at sunset. **On Your Own:** In the practice photo, there's contrast between a stark foreground and the sunset. This is pretty typical of sunset and sunrise photography in general. You should look for photographic opportunities where the drama of the stark contrast between the sunset and the darkening world lessens the need to show details in shadow (because mostly these won't be very visible).
Lighting	**Practice Picture:** The clouds were photographed and the trees allowed to go black. **On Your Own:** Find a foreground subject of interest to combine with your sunset.
Lens	**Practice Picture:** Canon PowerShot G3, Canon Zoom Lens 7.2–28.8mm 1:2.0–3.0 at 7.2mm (35mm 35mm equivalence). **On Your Own:** Use a moderate wide-angle focal length to combine foreground with sunset.
Camera Settings	**Practice Picture:** RAW capture, Automatic mode, f/4.5, 1/60 second. **On Your Own:** Expose for the sky, not the trees. Automatic exposure should work. It's always a better idea to expose for the darker area (trees, rocks, etc) rather than the bright setting sun.
Exposure	**Practice Picture:** ISO 100, f/4.5, 1/60 second. **On Your Own:** Let the foreground go black. Expose for clouds and sunset.
Accessories	A polarizing filter can help to make sunset skies vivid depending on the direction of light. Tripods can be helpful, depending on light and field conditions.

Sunset and sunrise photography tips

✦ **Wait for the special moment.** There's usually a special moment in which the sunset is just right. That said, if you see a great picture, don't hesitate.

✦ **Use a wide-angle lens for landscapes with clouds.** Use a moderate wide-angle lens to photograph landscapes with foreground interest and sunset clouds.

✦ **Use an alarm for sunrise.** If you are going to photograph a sunrise, don't forget to set the alarm.

✦ **Sunrise is the opposite of sunset.** Because the sun is setting opposite to where it rises, you have two whacks at the apple. You can choose which light direction works best for your photo.

✦ **Know your timing.** Local papers or the Web will tell you the time for sunset and sunrise, no matter where you are. Use this information to keep your date with the sun.

Water Photography

Water is one of the most powerful forces of nature. Over time, streams and rivers carve canyons. Storms and moisture create landscapes and determine whether a location is a desert or a verdant jungle, oceans carve coastlines, and so on.

Without water, there is no life. It's not surprising that people are fascinated with water, and that water tends to play an important role in photography.

The key technical issue to understand about water photography is that there's a direct relationship between the camera's shutter speed

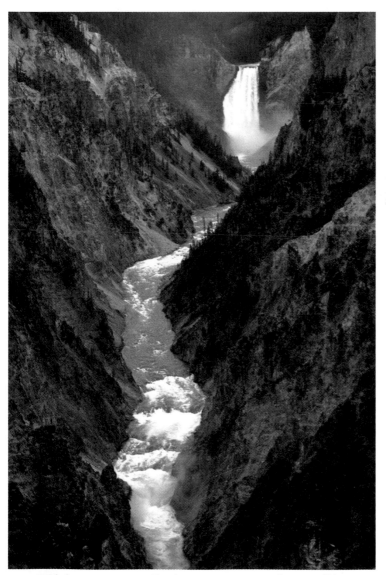

6.64 With long exposures, flowing water appears almost solid.

and the appearance of water. With long exposures — slow shutter speeds — moving water appears solid, frozen in place, like something flowing slowly, as in figure 6.64.

With shutter speeds in the intermediate range (between 1/30 second and 1/125 second) moving water appears partially frozen, and partially blurred as in figure 6.65.

A fast shutter speed appears to stop moving water, as in figure 6.66, although viewers don't perceive the water as motionless. Interestingly, the human eye never sees moving water as stopped (as it appears when photographed with a fast shutter speed), although that's the way it is most usually photographed.

Inspiration

Water is a wonderful and challenging photographic subject. It's constantly moving, changing, and reshaping itself. If you stand in the same place and take two pictures of a waterfall, each photograph will be different.

It's possible to create attractive photographs that appear to "solidify," partially stop, or fully stop moving water. The challenge to the photographer is to pre-visualize the effect you'd like and select the corresponding shutter speed.

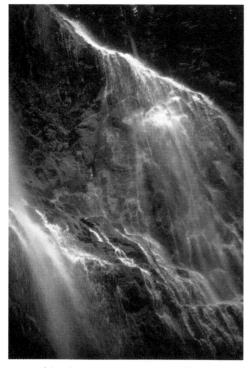

6.65 This photograph of Proxy Falls in Oregon was fast enough to stop some, but not all, water motion.

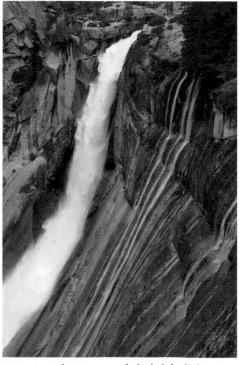

6.66 Fast shutter speeds in bright light stop the water motion.

Water photography practice

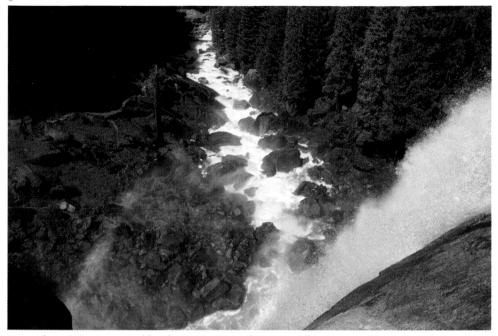

6.67 The rainbow created by the spray from the waterfall helps to add another dimension to this image.

Table 6.18	
Taking Water Pictures	
Setup	**Practice Picture:** Leaning over the edge of Vernal Falls in Yosemite created this interesting view with the rainbow and Mist Trail in the background (see figure 6.67). I made sure to hold on to the camera and to the ledge! **On Your Own:** In your own photos of waterfalls, try to capture the motion of water by photographing details and aiming to partially stop the motion of the water. When photographing other bodies of water, look for reflections and interesting light or other unique features.
Lighting	**Practice Picture:** Natural overcast lighting. **On Your Own:** It's tough to photograph moving water in bright light because of the harsh contrasts. Wait for bright but overcast days.

Continued

Table 6.18 *(continued)*

Lens	**Practice Picture:** Nikon D70, AF-S Nikkor 18–70mm 3.5–4.5G ED at 25mm (37.5mm 35mm equivalence). **On Your Own:** A moderate telephoto focal length helps you close in on waterfalls, rain, and other moving water without getting you or your camera wet.
Camera Settings	**Practice Picture:** RAW capture, Automatic mode, f/10, 1/320 second. **On Your Own:** To partially stop water, you need a shutter speed in the 1/30 to 1/125 second range.
Exposure	**Practice Picture:** ISO 200, f/10, 1/320 second. **On Your Own:** Automatic exposure should work if light conditions are dim enough to force the shutter speed you'd like. Otherwise, you should use shutter-preferred metering to pre-select a shutter speed in the 1/30 to 1/125 second range.
Accessories	You need a tripod for long exposures that freeze the motion of water. A polarizing filter may produce a pleasing effect, and certainly should be tried if you are photographing still water.

Water photography tips

✦ **Be careful not to get your camera wet.** Waterfalls can shift when the wind shifts. Take care to position yourself so that you and your camera are safe.

✦ **Previsualize.** Try to determine in advance what water effect you'd like.

✦ **Experiment with a polarizer.** Try a polarizer on water to see what it does (the impact will depend on the light direction and how fast the water is flowing).

✦ **Use a tripod to freeze the motion of water.** If you are freezing the motion of water with a slow shutter speed, you'll need to use a tripod.

✦ **Use shutter-preferred metering.** Use shutter-preferred metering to select the shutter speed that provides the effect you like.

✦ **Slow shutter speeds solidify water.** To create the effect of solid, molten water, use a shutter speed of 1/4 second or slower.

✦ **Intermediate shutter speeds create a mixed effect.** To create an effect in which some water motion is stopped, and some is blurred, choose a shutter speed between 1/30 and 1/125 second.

✦ **Fast shutter speeds freeze motion.** To freeze the motion of water, use a shutter speed of 1/500 second or faster.

Weather Photography

Water shapes the landscape, but weather shapes our view of the landscape. Weather adds drama and poetry to your photographs, as evident in figure 6.68.

Without adverse weather conditions, outdoor photographs can be boring and placid. With the effects of adverse weather showing, even mundane landscapes can look special, as shown in figure 6.69.

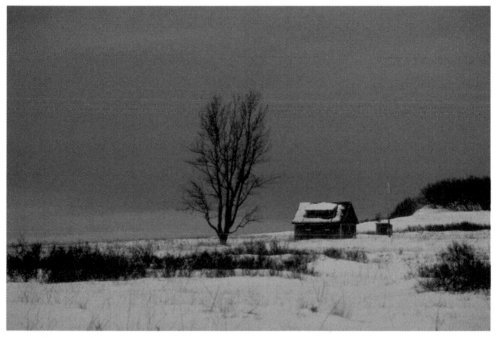

6.68 The gray clouds of approaching snow make this image of a lonely cabin in winter feel cold.

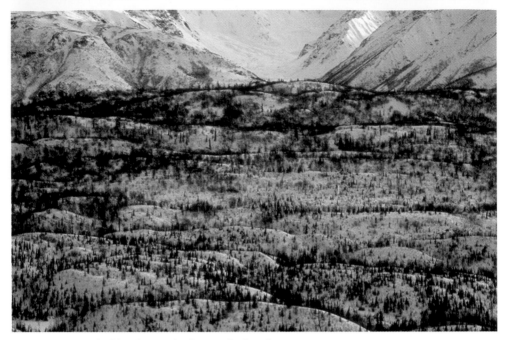

6.69 Even a typical landscape looks magical under snow.

Inspiration

One of the most special finds of all in the field is a plant or tree encased in snow or ice, creating an lovely natural sculpture as in figures 6.70 and 6.71.

Unless the weather cooperates, you don't usually get to see the ice sculptures that nature creates — but when you do it is inspiration for any photographer.

Inspiration for you might be found in the light just before or after a storm, or perhaps a stand of trees covered with a fresh, wet snow. Even a sunny morning can be inspiring if your subject is compelling, so pay attention to your surroundings. You never know when a great opportunity to capture a weather-inspired image will present itself.

6.70 Winter weather adds ice to plants, and interest to your photos.

6.71 Ice storms make for tricky driving, but interesting photographs.

Weather photography practice

6.72 After the storm, raindrops lay on the leaves.

Table 6.19
Taking Weather Pictures

Setup	**Practice Picture:** After a rain shower ended, the plant shown in figure 6.72 was decorated with water droplets. **On Your Own:** It's difficult to photograph during a storm because weather and atmospheric conditions make for murky photos and wind keeps subjects in motion. However, before a storm begins, you can often find moments of dramatic weather that make great photos. And, as soon as the storm is over, get out your camera and try to photograph the traces the storm left behind, such as water on leaves, and wind-swept vistas.
Lighting	**Practice Picture:** Natural overcast lighting. **On Your Own:** Lighting conditions following rain are usually very favorable for close-ups.
Lens	**Practice Picture:** Nikon D70, AF-S Nikkor 18–70mm 3.5–4.5G ED at 46mm (69mm 35mm equivalence). **On Your Own:** Almost any focal length is appropriate for photographing the aftermath of a storm. Try for a natural effect with a more-or-less-normal focal length.
Camera Settings	**Practice Picture:** RAW capture, Macro mode, f/4.5, 1/80 second. **On Your Own:** Automatic exposure should be okay if there is enough light.
Exposure	**Practice Picture:** ISO 200, f/4.5, 1/80 second. **On Your Own:** Experiment with setting the camera for greater depth of field using aperture-preferred metering and a small f-stop.
Accessories	If you use a small f-stop and the corresponding slow shutter speed, you'll need a tripod. A good camera case or bag is a must for inclement weather. Plastic bags and plastic shower caps can help keep cameras dry in the rain, particularly if the cameras are mounted on tripods.

Weather photography tips

✦ **Protect your camera in storms.** Storms of any kind can be devastating to electronic instruments. Take good care of your digital camera so that it will continue to take good pictures for you.

✦ **Put your camera in its case if things get too wet.** If the weather is too wet and wild, or if a sandstorm is blowing, make sure your camera is put away in a secure location. Often, conditions for good pictures occur just before or after the storm has passed.

✦ **Use plastic bags.** Plastic bags and shower caps can help keep your camera dry if you must have it out.

✦ **Storms and rainy weather bring out the colors.** After a storm, look for saturated colors to delight the eye.

Editing and Sharing Your Work

I f a tree falls in the forest, and no one hears it, has the tree really fallen? The digital photography version of this classic chestnut is that taking your photographs is only the first part of the process. You also have to show your photographs to others — or it's as though you had never taken the photographs in the first place.

There are three major steps involved in the process of digital photography: taking the picture, post-processing the photograph using software on your computer, and displaying the photograph to others, either digitally using the Internet or by making a print.

The bad news is that digital photographs are rarely as good as they can be without digital enhancement and retouching using software intended for this purpose — using this software can be thought of as using a digital darkroom. This is also the good news: As a digital photographer you have the panoply of tools available in your digital darkroom to retouch and enhance your digital photos.

This chapter explains the postproduction steps that are important to digital photographers: editing, organizing, and sharing photographs.

About the Digital Darkroom

Digital darkroom is a catch-all term that describes a wide range of software used for postproduction processing of digital photographs. The two major uses of digital darkroom software are

✦ Fixing minor blemishes and defects (this use is called *digital retouching*)

✦ Radically creating new digital imagery based on existing digital photographs (this use is called *image manipulation*)

Note *You can also create composite images by combining images in the digital darkroom.*

The organization of digital darkroom software roughly corresponds to these two purposes. Some software is primarily based around organizing albums of digital photographs while providing some tools for retouching these photographs. In contrast, the primary purpose of more hardcore (and expensive) image manipulation software is to provide mechanisms for creating any imagery that your imagination can visualize, as well as retouching tools.

Note *The improved File Browser introduced with the CS version of Photoshop is a great organizational tool, but it's not the main reason people use Photoshop.*

Table 7.1 provides a high-level comparison of some of the leading digital darkroom software products.

Software such as Google's Picasa (shown in figure 7.1) and Nikon's PictureProject (shown in figure 7.2) work by organizing the pictures on your computer into albums. Within each album you can select a photograph and then apply tools to fix minor problems.

Table 7.1
Image Manipulation Software

Software	Cost	Platform	Primary Purpose
Paint Shop Pro (Corel)	Moderate ($130)	Windows	Image manipulation and digital retouching
Picasa (Google)	Free	Windows	Primarily used to organize photos; includes easy-to-use retouching tools
Photoshop Elements (Adobe)	Moderate (less than $100)	Windows, Mac	Used for organizing photos, digital retouching, and image manipulation
iPhoto	Moderate (less than $100)	Mac	Used for basic organization of photos and minor edits and enhancements
Photoshop (Adobe)	Expensive (about $600)	Windows, Mac	Gold-standard software used for image manipulation and digital retouching
PictureProject (Nikon)	Bundled with many Nikon digital cameras	Windows, Mac	Used to download photos from digital camera and organize photos; digital retouching tools provided

7.1 Picasa searches your computer and creates albums from the images it finds.

7.2 PictureProject downloads and organizes photos from your digital camera (bundled with many Nikon cameras).

After you've selected a photograph in Picasa, you can fix and adjust the photo with the simple tools shown in figure 7.3 that

✦ Crop

✦ Straighten

✦ Fix red eye

✦ Adjust contrast

✦ Adjust color

✦ Add lighting effects

> **Tip** *If you're feeling, well, lucky, you can click the I'm Feeling Lucky button and let Picasa do its thing – adjust your photo automatically.*

Photographs cataloged in PictureProject can be adjusted (as shown in figure 7.4) for

✦ Brightness

✦ Color

✦ Sharpness

✦ Straightness

In addition, PictureProject can also rotate and crop images as well as fix red eye. It also has an Auto Enhance mode.

Table 7.2 shows what software packages are most suitable for certain tasks involving digital photographs.

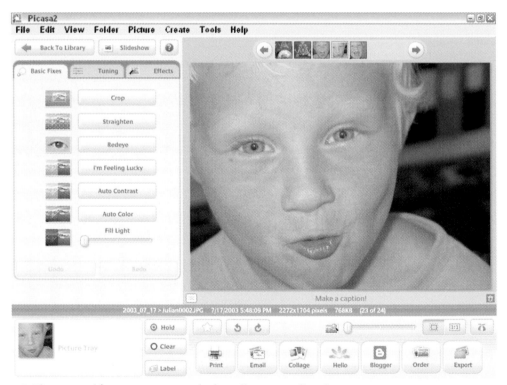

7.3 Picasa provides easy-to-use tools that allow you adjust images.

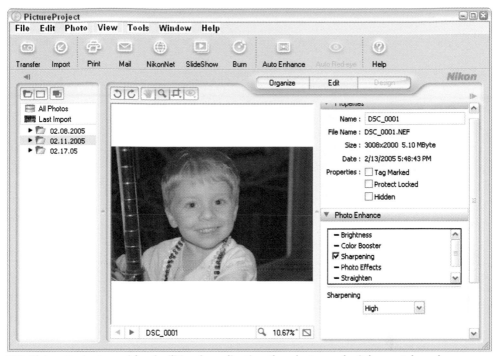

7.4 PictureProject provides facilities for adjusting the photographs it has cataloged.

Table 7.2
Suitability to Task of Digital Photography Software

Task	Software
Image manipulation	Photoshop (Best) Photoshop Elements Paint Shop Pro
Digital retouching	Photoshop (Best) Photoshop Elements (Very good) Picasa (Easy to use)
Organizing photos	Photoshop Elements (Excellent) Picasa (Excellent) Photoshop (Very good) PictureProject (Adequate)
Uploading from camera to computer	PictureProject (Provided with Nikon hardware; other brands provide software with comparable functionality)

Your Memory Card as a Drive

Other brands of digital cameras provide proprietary software comparable to Nikon's PictureProject to help manage uploading pictures from camera to computer.

You don't need to use PictureProject, or any other proprietary software, to upload photographs from your digital camera to your computer. The memory card in your camera appears as a drive on your computer, so you can simply copy (or cut) photographs from a camera connected to your computer to the destination location.

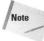

Note *Most computers running current operating systems will recognize your computer as a drive and allow you to download image files.*

Using Photoshop Elements and Photoshop

Photoshop Elements, and the fabulous Photoshop, are probably the most popular digital manipulation programs.

Photoshop Elements provides a Photo Browser, also called the Organizer window, to help organize your photographs into collections. You can also open photographs in the Photoshop Elements Editor window, shown in figure 7.5, for the purpose of retouching and manipulating your images after you've cataloged them using the Organizer (or you can open an image directly by choosing Open from the File menu).

You can easily start Photoshop by opening a single image. Photoshop is focused on manipulating and retouching single images — although, of course, you can have multiple

images open in Photoshop at one time. You can also use the Photoshop File Browser to organize photos.

Note *You can use the Photoshop File Browser to view information stored with each file, including exposure and camera information. Notes or captions can also be added to each file.*

To open an image in Photoshop, choose File ➪ Open. If the image you are opening is in a RAW format, you can adjust some of its properties — such as the white balance settings — using the RAW Adjustments dialog box before the image opens in Photoshop, as you can see in figure 7.6.

If you are already viewing images in the File Browser, you can open an image just by clicking on the desired image. The RAW converter allows most attributes of an image to be corrected or changed depending upon the software used. Photoshop has abbreviated settings as shown. However, Nikon Capture and applications such as Bibble can control many aspects of each RAW image.

Note *Photoshop CS2 has a standalone browsing and organizational tool called the Bridge. It can find photos on your computer and access them for enhancement in Photoshop.*

7.5 You can use the Photoshop Elements Editor to manipulate and retouch photographs.

With the image open for editing in Photoshop, you'll have an immense set of powerful image manipulation tools at your beck and call (figure 7.7).

7.6 You can adjust white balance and other settings for the RAW photographs that you open in Photoshop.

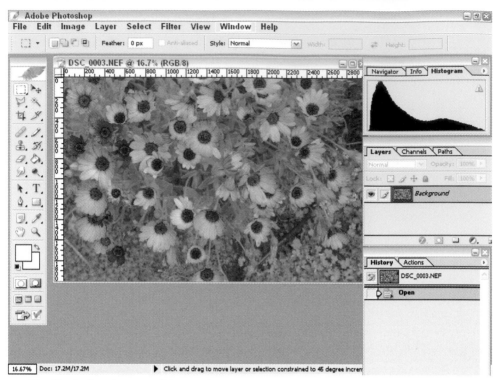

7.7 The Photoshop image-editing environment.

Filters in the Digital Darkroom

There are almost an infinite variety of postproduction filters you can apply to digital photographs using Photoshop or a similar program.

Adobe Photoshop is the premier software used for postproduction manipulation of digital photographs, but it is a relatively expensive software product and not the only game in town. A less-expensive option is Adobe Photoshop Elements. It provides most of the photographic filters available in Photoshop. And products such as Corel's PhotoPaint also provide comparable photographic filters, although the filters are often named differently than the ones in Photoshop.

Before applying a filter to a digital photograph using an image manipulation program such as Photoshop, you should make sure you are not working on the original photographic file. In Photoshop, you can create a copy for working purposes by selecting Duplicate from the Image menu.

You can also choose to save the file in another format. For example, photographers often save JPEG files, which are lossy, as TIFF files, which are not.

Every photographer should know about filters that can be applied to digital photographs as part of the postproduction process. Some of the most useful filters in Photoshop are

✦ Photo filter

✦ Shadow/Highlight filter

Adjustment Layers

Instead of applying the Photo filter to the image itself, you can apply the filter using an adjustment layer. This layer sits on top of the image so you can decide whether you like the effect or not. To add a Photo filter adjustment layer to your image, open the Layers palette and click the Create New Fill or Adjustment Layer button, and then choose Photo filter from the pop-up menu. In both Photoshop and Photoshop Elements, you can also choose Layer ⇨ New ⇨ Layer from the Task bar.

✦ Ink Outlines filter

✦ Unsharp Mask filter

✦ Wind filter

✦ Liquify filter

Photoshop also provides a huge range of filters that are primarily intended for artistic (as opposed to photographic) effects. Only postproduction filters meant to enhance photographs while leaving them still looking like photographs are included here. In other words, no watercolor filters.

Photo filter

The Photoshop Photo filter, which actually consists of some 20 different color effects that can be applied to an image, works like an optical colored filter and applies a single color of your choosing to an image (see figure 7.8 for the original image and figure 7.9 for the image with the Photo Filter applied).

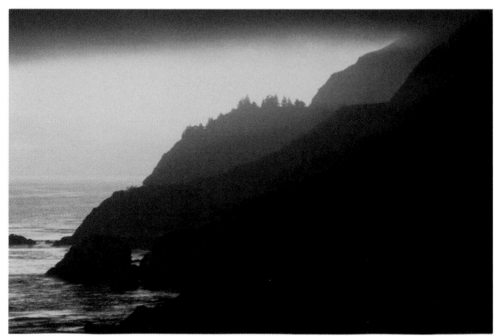

7.8 This image before any digital filters have been applied. . .

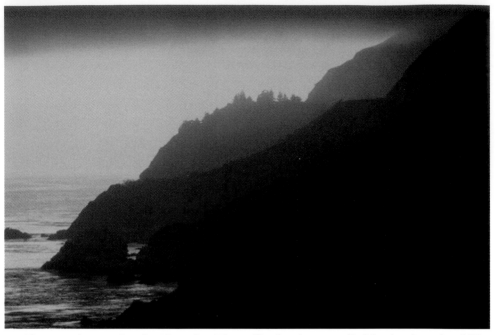

7.9 The same image after the Photoshop Photo filter has been applied (notice the color shift).

To access the Photo Filter dialog box, choose Image ➪ Adjustments ➪ Photo Filter. When the Photo Filter dialog box opens, select the effect you want, and click OK to apply it.

Shadow/Highlight filter

The Shadow/Highlight filter lets you bring out detail in shadow areas that are underexposed (too dark). At the other end of the spectrum, the Shadow/Highlight filter also brings out details in overexposed (washed-out) areas of a digital photograph.

For example, the photograph shown in figure 7.10 is too dark in its background areas.

When the Shadow/Highlight filter is applied, the photograph appears properly exposed. Detail is brought out in the dark areas, without the light areas becoming overexposed (figure 7.11).

7.10 The background area of this photograph is underexposed.

7.11 Applying the Shadow/Highlight filter brings out detail in the underexposed areas of this photo.

To access the Shadow/Highlight filter in Photoshop, choose Image ➪ Adjustments ➪ Shadow/Highlight. From Photoshop Elements, choose Enhance ➪ Adjust Lighting ➪ Shadows/Highlights.

In the Shadow/Highlight dialog box there are two sliders. One adjusts shadows and the other adjusts highlights. These sliders are very sensitive: Small increments and decrements make for big adjustments. So play with them to make sure you get what you want.

Ink Outlines filter

The Ink Outlines filter finds the edges of objects within the area you specify (the entire photograph or a selected area). In other words, the filter is looking for pixel differentiation between lights and darks. So the filter will work best with images that have high contrast (otherwise it has a hard time finding edges).

After the filter identifies the edges, it darkens the edge pixels, creating an outline effect.

Figure 7.12 shows a high-contrast image with the Ink Outlines filter applied to outline the edges in the image.

To apply the Ink Outlines filter in Photoshop or Photoshop Elements, choose Filter ➪ Brush Strokes ➪ Ink Outlines.

7.12 The Ink Outlines filter has been applied to emphasize the edges in this dried-up river bed.

Unsharp Mask filter

The peculiarly named Unsharp Mask filter is the best filter for sharpening digital photographs.

> **Note**
>
> *In pre-digital darkroom terms, a mask is a copy of an original negative. To achieve the effect of apparent sharpening, the mask is sandwiched with the original negative. The pre-digital darkroom mask was called unsharp because it was slightly out of focus (or fuzzy). The benefit of applying an out-of-focus mask was that it would build up the density, or apparent sharpness, of dark areas of the original image without showing up as an added element, and without impacting the light areas in the print.*

The Unsharp Mask filter controls the amount of color difference between adjacent pixels, making digital photographs appear sharper.

To apply the Unsharp Mask filter, choose Filter ➪ Sharpen ➪ Unsharp Mask.

> **Note**
>
> *In the Unsharp Mask dialog box, set the Radius to 1, the Threshold to 0, and play with the Amount percentage. I find that an Amount percentage setting between 130% and 200% usually works best.*

> **Tip**
>
> *You don't have to sharpen an entire photo. You can use the selection tools in Photoshop or Photoshop Elements to select a specific area to sharpen.*

As a general rule, avoid too much sharpening, as this will make your image look strange (unless, of course, this is what you're after).

Wind filter

The Wind filter helps make images dramatic by adding an amount of ersatz wind to the image. For example, figure 7.13 shows a beautiful flowering tree in the spring.

Using the Wind filter to apply motion to the background of the photo adds considerable drama (figure 7.14).

To apply Wind to a photograph, choose Filter ➪ Stylize ➪ Wind. In the Wind dialog box that opens, play with the Wind force and direction.

Liquify filter

The Liquify filter, as you'd probably suppose, is often used to add a watery effect — like that of waves in motion — to increase the drama of photographs of oceans, waterfalls, or lakes. But sometimes the Liquify filter is most fun when used to experiment on unlikely subjects, such as portraits or the fantastic jungle plant shown in figure 7.15.

To use the Liquify filter, choose Filter ➪ Distort ➪ Liquify to open the Liquify window. In the Liquify window, play with the controls to find the effect you like.

7.13 A flowering tree on a fairly still day.

7.14 The flowering tree with the Wind filter selectively applied.

7.15 After the Liquify filter is applied, this jungle plant looks like something out of *Little Shop of Horrors.*

Cleaning Up Red Eye

In the Photoshop Elements Editor and Photoshop CS2, select the Red Eye Removal tool from the Tools palette, and click on the eye; the red will be replaced.

In Photoshop CS, you can use the Color Replacement tool to correct red eye. Here's how:

1. **Select the Zoom tool and click on the image to zoom in on the eye area.**

2. **Select the Color Replacement tool from the Tools palette.** The Color Replacement tool looks like a paintbrush with a little red eye next to it.

3. **Use the Options bar at the top of the window to set the following options: Set Mode to Color, Sampling to Once, Limits to Discontiguous, and Tolerance to 30%. Also select the Anti-aliased option.**

4. **At the left side of the Options bar, click the current brush to select a brush diameter.** Make sure the diameter is smaller than the pupils you are going to correct.

5. **Click on the Foreground Color Swatch in the Toolbox to select a color to replace the red.** Black is usually a good choice.

6. **In the image, click once on the red color that you want to replace.** This tells Photoshop what color should be replaced.

7. **Click and drag the brush over the red-eye area until the pupils are fixed.**

Getting Rid of Imperfections

In both Photoshop Elements and Photoshop, remove any dust and scratches by choosing Filter ➪ Noise ➪ Dust and Scratches.

In both programs, select the Healing Brush tool from the Tools palette and apply it to minor imperfections in your photographs such as discolorations.

Adjusting contrast, tone, and color

In the Photoshop Elements Editor, you can adjust contrast, tone, and color levels in one fell swoop by choosing Enhance ➪ Autosmart Fix. You can also individually adjust levels, contrast, and color by choosing any of the following: Enhance ➪ Auto Levels, Enhance ➪ Auto Contrast, or Enhance ➪ Auto Color Correction.

In Photoshop, you can make similar adjustments by choosing Image ➪ Adjustments ➪ Auto levels, Image ➪ Adjustments ➪ Auto contrast, or Image ➪ Adjustments ➪ Auto color.

> **Note** If you want to adjust tone by hand in Photoshop, choose Image ➪ Adjustments ➪ Levels to access all the Levels controls. For Elements, choose Enhance ➪ Adjust Lighting ➪ Levels.

Working with shadows and highlights

With an image open in Photoshop Elements or Photoshop, you may want to adjust either the shadows or the highlights. Shadows are adjusted to bring out details

that would otherwise be too dark, and highlights are adjusted if bright areas are too light for details to show up.

To adjust shadows and highlights in Photoshop Elements, choose Enhance ➪ Adjust Lighting ➪ Shadows/Highlights to open the Shadows/Highlights dialog box (shown in figure 7.16). In Photoshop, open the Shadow/Highlight dialog box by choosing Image ➪ Adjustments ➪ Shadow/Highlight.

Use the sliders in the Shadows/Highlights dialog box to lighten shadows, darken highlights, and to adjust mid-tone contrast.

Tip *If the Preview box is checked, you can see the impact your changes make on your photo as you move the adjustment sliders.*

7.16 Use the Shadow/Highlights filter to bring out details in shadows and highlights.

Composites

Photo collages and photo sandwiches, also called *composites* — putting together two or more images — have been possible since the very early days of chemical photography. These (and other) photo manipulation techniques have been notoriously used to rewrite history — for example, erasing purged soviet politicians from historical photos.

Image manipulation to rewrite history, for artistic effect, to improve photographs, or

simply for fun is so much easier with digital photography and digital darkroom software.

For example, take the picture of rubber ducks in a bathtub shown in figure 7.17.

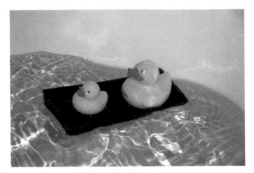

7.17 These rubber ducks are floating in a bathtub.

This photograph might really be fun if the ducks appeared to be sailing under a real cloudy sky. If you have a photograph of the sky in your library of digital images, it's easy to put it into the duck photograph in Photoshop using these steps:

1. **With your image open, open the Layers palette and make sure the image is on a regular layer, not the Background layer.** If the layer is contained in the Background layer, convert it by selecting Layer ➪ New ➪ Layer from Background.

2. **Select the Magic Wand tool and select the background area.** The Tolerance setting in the Options bar should be set pretty high; try a setting of 50 in order to select more of the background area. If you need to, use the other selection tools such as the Lasso or Rectangular Marquee tool, to finish selecting the background.

3. **Press Delete on the keyboard or select Edit⇨ Clear to remove the selected background area.** The area will now be transparent (shown in Photoshop by a checked background).

4. **Open the image containing the sky.**

5. **Copy the sky image and paste it into the duck document.** Using the Layers palette, drag the layer containing the sky image onto the image window containing the ducks. You will now have two layers in the duck document: the duck layer and the sky layer.

6. **Make sure the duck layer is listed above the sky layer in the Layers palette.** This puts the sky layer behind the duck layer in the stacking order. If the layers are not in the correct order, you can simply drag the duck layer up to position it above the sky layer.

7. **With the sky layer selected in the Layers palette, use the Move tool to position the sky behind the ducks by clicking and dragging the area into position with the tool.**

The result: a fun image of ducks on an ocean under a variable sky, shown in figure 7.18.

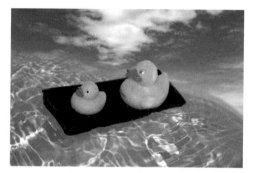

7.18 Now the ducks are adrift on a Photoshop sea.

Interview with a Photoshop Guru

Phyllis Davis is the coauthor of *Photoshop CS For Dummies*, and the author of *Photoshop CS Timesaving Tips and Techniques For Dummies* and many other fine books about image manipulation. She's a highly experienced and creative hand with Photoshop. (She also happens to be my spouse, an arrangement I recommend to every digital field photographer!)

Q: What are your favorite Photoshop tools for working with photographs?

PD: *Just off the top of my head, the Healing Brush tool and the History Brush are Photoshop tools I use everyday with photographs. The Healing Brush is great for cleaning up dust and scratches and quickly getting rid of imperfections in a photograph. The History Brush is used in conjunction with the History palette. After manipulating a photo, you can use the History Brush to subtly (or not so subtly!) paint in an earlier version of itself.*

Continued

Continued

Q: How can a photographer best learn Photoshop?

PD: It's best to learn by doing specific tasks. Photographers should develop a checklist of routines that they put every image through. To start with, these routines should include cleaning up any flaws in the image, adjusting levels, and finally sharpening it.

Once you've mastered these basics, you can go on to experiment and have fun. Remember: If you work on a duplicate, you don't ever have to worry about ruining an original photo.

Q: Is there a special way you should prepare your digital photographs if you know they will be post-processed in Photoshop?

PD: Photographers should shoot their digital images using RAW instead of (or in addition to) JPEG. You simply lose too much information with JPEG. You should pay very close attention to the details of your photograph, particularly the background in close-ups. It's much easier to clean up a background if it isn't full of extraneous details.

Preparing Photographs for the Web

Digital photographs are graphics files. Two kinds of graphics files, JPEGs and GIFs, are widely viewable on the Web. The JPEG format is more suitable for photographs. JPEG files are normally saved with a .jpg file extension.

When you are preparing photographs for use on the Web — or for distribution as e-mail attachments — you should bear in mind that the larger the file size, the longer it will take for the photo to load in a browser or e-mail program. The actual load time depends on the speed of the Internet connection of the person loading your photograph. But you don't want to make anyone wait too long, so you need to keep your file sizes small, usually to 50K or less.

This process is the opposite of making a fine print from your photograph. Generally, the larger the file size, the better the print. But you simply can't have files that are too big downloading from the Web because they take time to load into a Web page.

To save a photograph for the Web, open the image in Photoshop Elements Editor or Photoshop and choose File ➪ Save for Web. The Save For Web dialog box opens, as shown in figure 7.19.

In the Save For Web dialog box, choose JPEG as the file type. Make sure the Constrain Proportions box is checked, and enter a width dimension in pixels appropriate in size for display on a Web page — say, 300 pixels wide. The constrain proportions option means that the height dimension automatically adjusts to the corresponding width without changing the ratio of the dimensions.

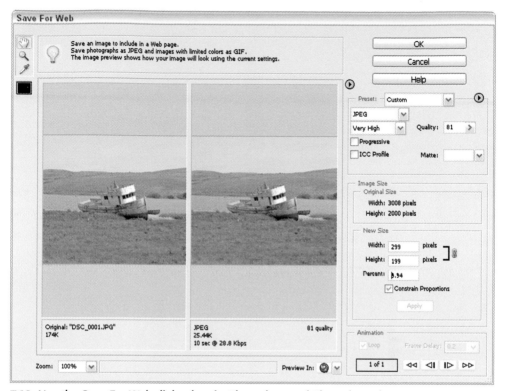

7.19 Use the Save For Web dialog box in Photoshop and Photoshop Elements to prepare photographs for display on the Web.

The size of the image and its approximate download time on a dial-up connection will now be displayed in the right-hand pane of the Save For Web dialog box, so that you can verify that the resulting file is small enough.

You can now move the Quality slider to change the resolution of the image. The higher the quality, the larger the file. As you move the slider, you can compare the original image (in the left-hand pane) with the image prepared for the Web (the right-hand pane).

When you are satisfied with your image's quality and size, click OK. You will next be prompted to provide a filename and location on your computer for the photograph you are saving for the Web.

Tip

If you are using a push-button Web publication system, like the one provided by Picasa that lets you publish your photos directly to a blog, the software automatically sizes and saves your images for you.

Publishing Photographs on the Web

There are many different issues involved in publishing photographs on the Web. If you are using a program like Dreamweaver or FrontPage to design and publish your Web pages, most of the details will be taken care of for you.

If you are managing your own Web site, then your Web host will likely provide a program for you to use to upload files to the Web server. If you prefer (and are using a Windows PC), you can use an FTP program

such as WS_FTP from Ipswitch Software, shown in figure 7.20, to manage uploading your photographs to your Web server.

If you are manually coding the addition of a photograph to a Web page, such as a blog entry that you create yourself, you will need to use an HTML `` tag to include the photograph. The `src` attribute of the `` tag provides the location of the photograph.

For example, the HTML tag

```
<img src="http://www.digitalfieldguide.
com/images/boats.jpg" alt="Pt. Reyes tug
boat">
```

includes the referenced photograph in the Movable Type blog shown in figure 7.21.

7.20 You can use an FTP program like WS_FTP to upload photographs to your Web server.

7.21 You can use HTML tags to include photographs in Web pages, such as the one shown by this blog.

Lossy versus Lossless File Formats

Image file formats are characterized as *lossy* or *lossless* depending upon how they use compression. In a lossy image file format, some information is lost when you edit the file using digital darkroom software, while lossless formats retain all information.

JPEG is a lossy file format, while TIFF — tagged image file — is a format often used for image editing that is lossless.

If you make and save enough changes to a JPEG file, eventually the image will degrade somewhat due to the lossy characteristics of the file format. It's worth noting that improvements to both the JPEG format and the way image editing programs handle this format make JPEG lossy deterioration much less of a problem than it used to be.

Even though the problems with editing directly using JPEG files have largely been solved, it is still probably best to plan to edit images in Photoshop or Photoshop Elements with the image saved in a .tif format, particularly if you will be making many changes to the file. You can also save as a Photoshop .pcx or Photoshop .psd file for lossless editing, and then convert to another format if needed.

Quite a few hosted blogging services provide an easy mechanism for including photographs in your blogs. You don't need to know any HTML to use them, and these services mostly are free (for basic service).

> **Note** *One way or another, if you sign up for a hosted blogging service that allows you to post photographs, or a photo-sharing service, you are likely to end up paying something: either a subscription fee for the service, or through purchasing upgrades to a standard (minimal) free service.*

For example, Google's Blogger service allows easy posting of photographs to the blogs created by members. You can even post your digital photographs directly from Picasa: with a photograph selected in the tray, click the Blogger button. Besides Google's Blogger, you may want to check out these hosted blogging services that allow you to easily publish your digital photos:

✦ LiveJournal (www.livejournal.com) is an online personal publishing service built on open source software that allows interaction between users.

✦ TypePad (www.typepad.com) is from Six Apart, the creators of Movable Type blog hosting software.

Services that allow you to easily post and share photographs include

✦ Flickr (www.flickr.com) posts to almost any blog and allows viewers to annotate and tag photographs. Flickr is free, and it is the best photo sharing service in my opinion.

✦ HeyPix (www.heypix.com) provides online photo sharing, organization, and retouching, with the ability to upload photos to most blogs.

> **Tip** *You can upload a photo directly to Kodak Gallery from Photoshop Elements on your Windows computer by choosing Share ➪ Share Online from the Photoshop Elements Organizer.*

E-mailing Photographs

Assuming you've saved your photograph for the Web, sending the photograph by attaching the JPEG file to an e-mail message is easy.

For example, in Outlook or Outlook Express, click Create Mail to compose a new e-mail message. In the New Message window, choose Insert ➪ File Attachment or click Attach. The Insert Attachment dialog box opens.

Next, from the Insert Attachment dialog box, locate and select the photographic file you want to attach to the e-mail. Click Attach to attach the file.

When you are through composing your new e-mail message, click Send. The photograph will be sent as an attachment. Depending upon how your recipient's e-mail program reads the e-mail, your photograph will either appear in the body of the e-mail, or will be marked as an attachment to be separately opened by the recipient.

Note *You can e-mail photographs directly out of Photoshop Elements by choosing Share ⇨ Email in the Organizer, and from Picasa by clicking the Email button.*

Printing Photographs

Arguably, it's less important to print photos than it used to be. Instead, they are attached to e-mail, published on the Web as part of a blog, or shared via a service such as Flickr.

That said, there's nothing like a photo print for immediacy. Somehow, having a picture of my beautiful wife in her wedding gown in a photo blog doesn't remind me of that special day — and my special wife — in the same way that a framed print does.

Turning digital photos into prints

If you want to turn your digital photographs into prints, you have three options:

✦ You can use an online service.

✦ You can take your photos to a processor (typically, this means using a digital kiosk).

✦ You can print your photograph at home using special paper intended for printing photographs.

In general, it's cheaper per print to use a commercial service, whether online or at a retailer such as Wal-Mart. However, printing in the privacy of your own home is more immediate and likely to be more convenient. Feedback from your printer is instantaneous: If the image didn't come out as well as you expected, you can take remedial action to correct the problem right away.

Using a home printer

If you use a printer at home, you can

✦ Upload your photographs to your computer, work on them using digital darkroom software, and then print them on a connected printer (usually by USB cable).

✦ Insert the memory card from your digital camera directly in the printer to make your prints.

Moving up to a better printer

If you have a printer that came bundled with your digital camera, it most likely makes prints no bigger than 4×6 inches and possibly even prints up to 8½×11 inches in bordered or borderless format. It also probably works using thermal dye technology.

Thermal dye printers transfer dye from a ribbon to a plastic coating on special paper. The dye ribbon has sections of cyan, yellow, magenta, and a clear overcoat. The printer applies each color in turn, moving the paper back and forth for each dye section and finishing with the overcoat, which protects the print.

There's nothing wrong with thermal dye technology. When you move up to a more advanced class of photo printer, it will probably also use this technology — and be able to make larger prints, up to 11×17 inches.

Many amateur photo printers allow you to print from a computer connected to the printer, or by inserting the memory card containing your photos into the printer.

Comparative Costs per Print

It's probably less expensive per print to use a commercial printing service than to print your photographs at home yourself. Roughly speaking, if you use a home photo printer, the paper for each 4×6-inch print will cost you a minimum of about 15 cents and the ink will cost you another 15 cents, for a total of 30 cents. The cost of ink cartridges and paper can go as high as 70 cents per 4×6-inch print depending on the printer, manufacturer, and where you buy your supplies.

Photo printer manufacturers such as Epson and HP work on the razorblade business model: They are prepared to subsidize the cost of the actual printer (which is why printers themselves are relatively cheap), and make it up on the supplies such as paper and ink cartridges (which is why cartridges cost so much).

The cost of a 4×6-inch print ordered from a commercial service varies widely, so you should shop around if you like to watch your pennies. You should be able to get a 4×6-inch print of a digital photograph from a commercial service for as little as 15–17 cents — obviously cheaper than printing it yourself. If the prints are mailed to you (rather than picked up), you should add the cost of shipping and handling to the cost of the print (you won't have to pay this if you pick up the prints).

Advanced amateurs don't want to print directly from memory cards because they want to be able to optimize their photos using digital darkroom software. They want to save the optimized photographs, and print from software like Photoshop or Photoshop Elements. So, when you move up to a better photo printer, do not expect to be able to print from your camera's memory card with great results.

> **Note** *Photo printers aimed at advanced amateurs or professional digital photographers likely do feature a wire line or wireless network connection. This makes it convenient to use the printer across your home network without having to cable the printer directly to an individual computer.*

Photo printing services

You can order prints online from a commercial service and have the prints mailed to you. Hybrid services let you order prints online and choose to have the prints mailed or pick them up from a bricks-and-mortar store. Finally, some commercial services don't have an online presence: You order your prints in person, and come back in an hour or so.

If you order prints through an online service, you should expect to register at the online service's site (join the service), and then upload your photos using the software provided by the service.

> **Tip** *You can upload photographs for printing directly from software like Picasa and Photoshop Elements from your Windows computer.*

If you bring your digital photos into a printing service, you will most likely interact with a kiosk rather than a person. You should expect to insert the memory card from your digital camera into the kiosk, and then follow the prompts to select which images to print and what sizes to make.

Prices for prints vary greatly, with a 4-x-6-inch print going for between $0.10 and $0.30 at the time of this writing. You should look for discounts for printing in quantity and check around for specials offered to new customers.

Here are some of the leading commercial photo printing services:

✦ Costco (www.costco.com): hybrid online and bricks-and-mortar service (paid Costco membership required)

✦ Kodak Easy Share Gallery (www.kodakgallery.com): formerly Ofoto, online service

✦ Photoworks (www.photoworks.com): formerly, Seattle Filmworks, online service

✦ Ritz/Wolf Camera (www.ritzpix.com): hybrid online and bricks-and-mortar service

✦ Shutterfly (www.shutterfly.com): online service

✦ Snapfish (www.snapfish.com): online service

✦ Wal-Mart (www.walmart.com): hybrid online and bricks-and-mortar service

> **Tip** *Most online services offer free prints to new members as an incentive to join. For example, Shutterfly offers readers of this book who sign up for the Shutterfly service 35 free prints.*

Creating a Slide Show

One fun way to share your digital photos is by creating a slide show. If you are used to creating business presentations in PowerPoint, you can easily create a slide show using PowerPoint software with your digital photographs. You can display this slide show the same way you would any other PowerPoint presentation.

Perhaps you are not interested in creating formal presentations based on your digital photographs. Windows XP provides a screen saver that automatically makes a show out of your digital photographs. You and your friends can sit in front of your computer monitor watching the slide show of your photographs — it's a lot more fun than working!

> **Note** *There's lots more fun to be had. Mac computer owners can use the built-in iPhoto application to produce slide shows. And, those with a DVD writer can use a program to produce DVD discs that will play slide shows on a television equipped with a DVD player.*

PowerPoint

To create a slide show using PowerPoint, follow these steps:

1. **Open a new presentation.**

2. **Choose a blank content layout (this will be a blank page that a slide goes on).**

3. **Choose Insert ⇨ Picture ⇨ From File to add a digital picture that is saved on your hard drive to the slide show.**

Tip *You can add effects—such as dissolves and fades—between slides in the show.*

4. **Choose Slide Show ➪ View Show once your show is created to view your creation.**

You can also use PowerPoint's Photo Album feature to better organize the digital images that will go into your slide show. To create a Photo Album in PowerPoint and use the Photo Album to create a slide show of digital photos, choose Insert ➪ Picture ➪ New Photo Album. The Photo Album window, shown in figure 7.22, opens, allowing you to create a Photo Album as the basis for your slide show.

Windows XP

It's easy to set up Windows XP to display a screen saver using your digital photos. Follow these steps:

1. **Right-click anywhere on your Windows XP desktop and choose Properties from the pop-up menu.** The Display Properties dialog box appears.

2. **Click the Screen Saver tab.** The Screen Saver tab of the Display Properties window appears (shown in figure 7.23).

7.22 You can use Photo Albums in PowerPoint to organize digital photographs into slide shows.

3. **In the Screen Saver drop-down list, choose My Pictures Slideshow.**

4. **Click Settings.** The Settings dialog box opens.

5. **In the Settings dialog box, provide a folder location for the digital photos you want included in the slide show.** The image files in the folder are used for the slide show.

6. **Click OK.** The dialog will close. The next time your computer is idle and the screen saver activates, your slide show will start.

7.23 You can use the Screen Saver tab to display a slide show as a screen saver.

Appendixes

Resources

Companion Web Site

Harold Davis, the author of *Digital Photography Digital Field Guide*, maintains a companion Web site for the book. The companion site provides photographs from the book, a slide show, updates, tools, tips, techniques, links, and resources. The address for the companion Web site is www.digital fieldguide.com. Harold also writes a photo blog at www.photoblog2.com.

Digital Camera Manufacturers

You find a great deal of information on the sites offered by the manufacturers of digital cameras. If you are considering buying a particular model, this is a good place to start investigating it. If you already own your camera, and your manual isn't handy, you can use the manufacturer's site to find product documentation. Here is Web site information for the leading digital camera vendors:

✦ **Canon** (http://consumer.usa.canon.com/)

✦ **Kodak** (www.kodak.com)

✦ **Konica Minolta** (http://konicaminolta.com/ products/consumer/digital_camera/ dimage/)

✦ **Nikon** (http://nikonimaging.com/global/ products/index.htm)

✦ **Olympus** (http://olympusamerica.com/ cpg_section/cpg_digital.asp)

✦ **Pentax** (www.digital.pentax.co.jp/en/ index.php)

✦ **Sony** (www.sony.com)

Accessories

Here are some suggestions for online resources that may help you find the right accessories to use with your digital camera.

Camera bags

Camera bags are important for protecting your camera from the elements in the field. The right camera bag, if it fits you comfortably, can help make your photography experience more comfortable and productive.

✦ **Lowepro** (www.lowepro.com)

✦ **Tamrac** (www.tamrac.com)

✦ **Tenba** (www.tenba.com/camera.htm)

Filters

Filters can be a great way to extend the creative range of your photography. You can find a great deal of information about filters on the sites of these filter manufacturers.

✦ **B&W** (www.schneideroptics.com/filters/filters_for_still_photography/)

✦ **Filterhouse.com** (www.filterhouse.com)

✦ **Hoya** (www.thkphoto.com/products/hoya/)

✦ **Tiffen** (www.tiffen.com)

Tripods

A good tripod is probably the most important accessory a field photographer can have. You can use these sites to investigate tripods that work well in the field.

✦ **Bogen** (www.bogenimaging.us)

Note *Bogen is the U.S. distributor of Gitzo and Manfrotto.*

✦ **Gitzo** (www.gitzo.com)

✦ **Manfrotto** (www.manfrotto.com)

✦ **Slik** (www.thkphoto.com/products/slik/)

Software

For more information about these software packages, see Chapter 7.

Paint Shop Pro (Corel) (www.corel.com) An inexpensive product with much of the functionality of the better-known Photoshop.

Picasa (Google) (www.picasa.com) Free program that let's you do a surprising amount of quick photo editing.

Photoshop Elements (www.adobe.com/products/photoshopelwin/main.html) Photoshop's less expensive younger brother; most of the Photoshop functionality you are likely to need.

Photoshop (www.adobe.com/products/photoshop/main.html) The one and only incomparable photo enhancement and manipulation program.

PictureProject (http://nikonimaging.com/global/products/software/pictureproject/) Created by Nikon specifically for use with Nikon cameras; also let's you do some photo manipulation.

Web sites

These are just a few of the many good resources for Photoshop.

Adobe Studio (http://studio.adobe.com/us/)
The Adobe Studio is a great resource for Photoshop users. Browse through the Studio to find tutorials and tips, download actions and plug-ins, and find out about online Photoshop courses.

Braintique Photoshop (www.braintique.com/barticles/photoshop/)
This handy site offers many articles about using Photoshop to retouch and manipulate digital photographs.

Planet Photoshop (www.planetphotoshop.com/)
Planet Photoshop includes weekly tutorials, discussion boards, and news about upcoming Photoshop conferences, seminars, and products.

PhotoshopCafe (www.photoshopcafe.com)
PhotoshopCafe includes many tips and techniques, actions and plug-ins ready for download, and forums. Also, check out the links to other Photoshop resources available on the Web.

Leading Commercial Photo-Printing Services

When you've taken your photographs, you will certainly want some prints to frame or share with friends. Here are some of the commercial printing services I'd suggest checking out.

Costco (www.costco.com)
Hybrid online and bricks-and-mortar service

Kodak Easy Share Gallery (www.kodakgallery.com)
Formerly Ofoto; online service

Ritz/Wolf Camera (www.ritzpix.com)
Hybrid online and bricks-and-mortar service

Shutterfly (www.shutterfly.com)
Online service

Snapfish (www.snapfish.com)
Online service

Wal-Mart (www.walmart.com)
Hybrid online and bricks-and-mortar service

Publishing Photos on the Web

These hosted blogging services are particularly friendly if you'd like to publish and share your digital photos as part of a blog:

✦ Blogger (www.blogger.com)
✦ LiveJournal (www.livejournal.com)
✦ Typepad (www.typepad.com)

These online services are designed for you to publish and share digital photographs:

✦ Flickr (www.flickr.com)
✦ Heypix (www.heypix.com)
✦ Kodak Gallery (www.kodakgallery.com)

About Photography

You can learn a great deal about photography online and from books. I am particularly partial to classic books about photography because basic principles apply just as much to digital photography as to film photography. Here are some of my favorite books about photography, and Web sites I find interesting.

Photography books

Ansel Adams, *The Camera* (Bulfinch, Reprint edition 1995, ISBN 0821221841): Classic book about photographic basics by the master.

Bryan Peterson, *Learning to See Creatively: Design, Color & Composition in Photography* (Amphoto, Revised edition 2003, ISBN 0817441816): Good, if basic, book about photographic design and composition.

John Shaw, *Nature Photography Field Guide* (Amphoto Books, 2000, ISBN 0-8174-4059-3): Excellent discussion of photography principles as applied to field photography and pre-digital cameras.

Susan Sontag, *On Photography* (Picador, 2001, ISBN 0312420099): Intelligent and intellectual (perhaps overly intellectual) discussion about the meaning of photography and how it fits into life and society.

John Szarkowski, *Looking at Photographs: 100 Pictures from the Collection of The Museum of Modern Art* (Bulfinch, Reprint edition 1999, ISBN 0821226231): 100 classic photos from the Modern's collection, with a discussion by curator and photographer Szarkowski about why they are important.

Web sites

Digital Camera Blog (www.livingroom.org.au/photolog/) Digital camera news, reviews, and tips.

Digital Photography Review (www.dpreview.com/) Digital photography equipment reviews and news.

Digital Photography Weblog (http://digitalphotography.weblogsinc.com/) State of the digital photography industry (motto: a picture is worth five megapixels).

George Eastman House (www.eastmanhouse.org/) The site for the George Eastman House — one of the world's leading photography museums — features an online searchable photography archive.

National Geographic Photography (www.nationalgeographic.com/photography/) Field photography at the best professional level.

Open Directory Project, Photography Techniques and Styles (http://dmoz.org/Arts/Photography/Techniques_and_Styles/) This category of the Open Directory provides links to sites with information about photography.

PixelPress (www.pixelpress.org/) Online magazine intended to "encourage documentary photographers, writers, filmmakers, artists, human rights workers, and students to explore the world in ways that take advantage of the new possibilities provided by digital media."

Glossary

ambient light General diffuse non-directional lighting. Term used in contrast to reflected light and added light sources.

aperture The lens opening used to create an exposure, indicated by f-stops.

Aperture-Preferred In Aperture-Preferred exposure mode, you set the camera's lens aperture, and the corresponding shutter speed is automatically selected. See also *Shutter-Preferred*.

autofocus When you use autofocus, the camera determines the correct way to focus the camera lens. See also *locking focus* and *focus tracking*.

automatic exposure When you use automatic exposure mode, the camera's computer determines all aspects of exposure settings.

available light Light that is naturally available in a photographic situation.

backlighting Lighting from behind. Backlighting comes from behind the subject and toward the camera. Backlighting can be used to create silhouettes or reveal the texture of illuminated subjects such as flowers.

bad pixels Pixels that are an erroneous representation of an image, usually white, cyan, magenta, or yellow. Too many bad pixels cause image degradation. See also *hot pixels* and *stuck pixels*.

bayonet mount The twist and screw mechanism used for changing lenses on interchangeable-lens SLRs.

blog A blog, also called a weblog, or Web log, is a diary posted on the Web, with entries listed in reverse chronological order (the most recent first).

bracketing The photographic technique of taking a variety of exposures, letting in less and more light around a given exposure, usually by varying the aperture (although you can bracket shutter speeds as well).

bulb exposure A time exposure of any length created by setting the camera on Bulb and depressing the shutter release. The shutter will stay open as long as the button is pressed.

chromatic aberration A persistent condition of purple fringing that can occur in strong backlit conditions. It can be partially improved or completed eliminated using an UV filter.

CompactFlash (CF) Kind of memory card used to store the images taken with a digital camera.

composition The art and craft of arranging the elements of a photograph.

dead pixels Caused by a camera defect, these are bad pixels that are always off and reoccur in exactly the same spot.

depth of field How much of a photograph is in focus. The smaller the camera aperture, the higher the depth of field. Conversely, the larger the camera aperture, the lower the depth of field. Note that depth of field is not the same thing as sharpness: You can have an image with high depth of field that is completely unsharp (because of camera shake), and an image with low depth of field that is very sharp (because there is only one focal plane).

diaphragm The mechanism that controls the aperture of the lens usually marked to indicate various openings called f-stops.

digital connector The female plug on a digital camera used to connect the camera via a USB cable to a computer.

digital darkroom See *image manipulation software.*

Digital Negative format (DNG) Adobe's answer to proprietary RAW formats advanced by different camera manufacturers (all the different formats can be easily converted to DNG).

digital raw capture See *RAW.*

digital retouching Fixing minor blemishes and defects in a digital photo.

equivalent exposures Different aperture and shutter speed combinations that effectively send the same amount of light to the image capture device.

EVF camera An electronic viewfinder — or EVF — camera has many features similar to an SLR (but is not a true SLR). That is, you view what you are photographing through the lens, but you are seeing an electronic image in the viewfinder. EVF cameras do not let you change lenses.

exposure mode An exposure mode is a camera setting that prepares for a specific type of photography. They may include Program, Automatic, Shutter- and Aperture-Priority, and Manual. Choice may also include settings for Sports, Portrait, Landscape, Close-up and Night conditions.

filter Secondary lens, usually a piece of optical glass, placed on the end of a camera lens; also, within photo manipulation software, a command that applies a filter-like effect to a digital image.

focal length The distance, usually expressed in millimeters (mm), between the outermost optical element and the image capture device (whether film or digital).

focal-length equivalent The equivalent focal length of a lens, expressed as the equivalent angle of view provided by a lens on a 35mm film camera. The focal length of a lens in and of itself provides you with no information about the angle of view the lens provides. This information is determined by the ratio of the focal length of the lens to the image capture device dimensions. Because digital camera brands and models each have differently sized image capture devices, there's no way to understand effective apples-to-apples focal length comparisons without expressing these as their 35mm equivalents.

focus tracking An autofocus mode in which focus is constantly recalculated as long as the shutter release is partially depressed.

formatting Prepares a Compact Flash memory card, or other digital storage device, to receive data, such as digital photographs.

front lighting Lighting on the front of the subject. Depending on the direction of the light, few shadows may be produced.

f-stop The logarithmic scale used to notate a lens aperture. The lower the f-stop number, the larger the lens opening. For example, the f-stop f/2.8 might be the maximum aperture for a given lens, and f/22 might be the minimum aperture for the same lens. The greater the f-stop, the smaller the opening in the lens, and the more depth of field there is.

FTP (File Transfer Protocol) A method used to transfer files, including digital image files, to the Web.

GIF (Graphics Interchange Format) File format for graphics used on the Web. While GIFs are fine for graphics, they are not as suitable for photographs as JPEGs.

Healing Brush Tool in Photoshop used to clean up minor imperfections in a photograph during postproduction.

History Brush Tool in Photoshop that works with the History palette. It is used to paint portions of a photograph's history—that is, from prior to its current, edited state—back into the photograph.

History palette Used in Photoshop to keep track of previous states of an image, and to revert to previous states if needed.

hot pixels Hot pixels are caused by a sensor defect where the pixel is always on and may produce various colors that are more visible during a long exposure. They may appear in different locations. Some cameras have built-in Noise Reduction software to ease the situation.

image capture device Sensor, or sensors, used to translate an optical image so that it can be saved using digital media.

image degradation Deteriorating digital image due to a variety of possible factors, including the engineering of a particular piece of digital equipment; the boosting of the ISO speed; and bad, hot, or stuck pixels.

image format The format used to store a digital image. Possible formats include JPEG, TIFF, GIF, or RAW.

image manipulation Creating new digital imagery based on existing digital photographs and/or other digital material.

image manipulation software Software such as Photoshop or Photoshop Elements used to change elements of an image after exposure. Sometimes referred to as the *digital darkroom*. The process of using image manipulation software is called *postproduction*.

image quality Image quality is partially subjective and affected by a number of factors including the amount of compression used, the image size, the quality of the lens used, and so on.

image size The size of a digital image, expressed in pixels. For example, a 6-megapixel camera creates a maximum image size of 3008×2000 pixels producing a print of 20×30 inches. Image size is adjustable on most cameras.

iris See *diaphragm*.

ISO (International Standards Organization) An organization that defines standards.

ISO speed A standard term for expressing the light sensitivity of a digital camera (sometimes called simply ISO for short). The higher the ISO speed, the greater the image degradation due to noise. Digital cameras typically provide a normal (or default) ISO setting of 100 or 200, and the possibility of setting ISO speed to 100, 200, 400, 800, or 1600. Each setting in this range provides twice the light sensitivity to the previous setting. ISO is comparable to film speed in traditional photography.

JPEG (Joint Photographic Experts Group) Compressed file format used with digital images, often used to display photos on the Web. JPEG is a lossy file type.

JPEG mode Tells the camera to compress the images in JPEG format. JPEG images are compressed, as opposed to RAW files, which are not. Also, depending on the camera, JPEG mode sets the amount of compression used to save an image file in the JPEG file format.

Kelvin scale The Kelvin scale is based in physics and used in photography to describe the color temperature of light. It ranges from temperatures of conditions such as tungsten lighting to temperatures such as blue sky at noon.

LCD viewfinder Liquid-crystal display viewfinder, or screen, is a technology that provides a simulation, like that used in video cameras, of what your final image will look like. Digital cameras have LCD viewfinders, optical viewfinders, or (in some cases) both.

light, character of How hard or soft the light appears.

light, intensity of How strong the light is.

locking focus An autofocus mode in which focus locks after you've partially depressed the shutter release or used a focus lock button.

macro filter Close-up lens that screws on the front of a camera's normal lens.

macro lens A lens with close-focusing capabilities specially designed for close-up photography.

Manual mode Mode in which you set the exposure manually.

mode setting Tells the camera what kind of picture you are taking, and therefore what mode should be used to set the exposure. For example, in Sports mode, the camera automatically uses the fastest shutter speed possible to stop motion.

model release See *release.*

noise Image degradation caused by the insertion of random pixels. Often appears in low light situations or when using high ISO camera settings.

optical viewfinder Uses optics (made of glass or plastic) to let you see what the image looks like. Digital cameras have LCD viewfinders, optical viewfinders, or (in some cases) both. An SLR uses a system of mirrors to provide an optical viewfinder that lets you actually view through the lens.

photo blog A blog consisting largely or completely of digital photographs.

pixel The smallest unit of digital imaging.

polarizer A polarizer is a filter that controls light reflections and the appearance of a subject by blocking certain light rays. Rotating the polarizer not only blocks reflections, but also it can add dramatic blue to the sky and change the appearance of water. The effect the polarizer has depends on light conditions.

postproduction See *image manipulation software.*

RAW Uncompressed format used by digital cameras. This format preserves all available image information. Also called *digital raw capture.* May also be called by a camera specific name such as Nikon's NEF, standing for Nikon Electronic Format.

red eye Red eye is caused by flash light bouncing off the subject's retina, which is full of blood vessels. It is more apparent when ambient lighting levels are low and the subject's pupils are dilated. It can usually be eliminated by using bounce flash or raising the ambient light level. In camera red-eye reduction methods seldom work completely. Postproduction correction can be extremely effective.

reflected light The light given off, or reflected, by an object in a scene. Term used in contrast to ambient light.

Reflex Short for Single Lens Reflex (SLR).

release Written permission to use a photograph. Also called a *model release.*

self timer Mechanism that allows exposure following a time delay.

sharpness The degree that a photograph appears crisp and defined. Note that sharp photographs can still have low depth of field.

Shutter-Preferred In shutter-preferred exposure mode, you set the camera's lens shutter speed and the corresponding aperture is automatically selected. See also *Aperture-Preferred.*

shutter release Button depressed to take an exposure.

shutter speed The length the camera shutter is open for an exposure.

side lighting Light striking the subject from the side, which creates shadows and highlights that can reveal significant amounts of detail.

Single Lens Reflex See *SLR.*

slot The place in which the memory card fits in a digital camera.

SLR (Single Lens Reflex) Generally a more expensive interchangeable-lens camera that allows viewing through the lens.

stuck pixels Caused by a camera defect, these are bad pixels that are always on and reoccur in exactly the same spot.

telephoto lens A lens of greater-than-normal focal length that brings faraway objects closer. Telephoto lenses have a narrower angle, or field, of view than lenses with a normal focal length. Telephoto lenses have lower depth of field than normal-focal-length lenses. Any lens of greater than about 85mm (measured in 35mm equivalent focal length) can be considered telephoto.

TIF, TIFF (Tag Image File format) This is a widely used format for storing high-resolution images. For example, if you open a NEF (or other RAW) image in Photoshop, you will probably want to save it as a TIF if you want to create a print from the image. TIF is a lossless file format.

time exposure Manually sets the length of the exposure, usually for durations greater than one second, by keeping the shutter open as long as the button is depressed.

tonality The consistency of the range from dark to light of the different areas of a photograph.

Unsharp Mask filter In digital darkroom programs such as Photoshop and Photoshop Elements, a tool for sharpening photographs, named after a pre-digital darkroom masking technique.

USB (Universal Serial Bus) A standard connection used between a computer and peripherals such as a digital camera and a printer.

weblog See *blog.*

white balance A setting that tells the digital camera or postproduction software the color temperature of the prevailing lighting conditions, so that the camera or software can normalize the image.

wide-angle lens A lens of less-than-normal focal length that provides a wider angle, or field, of view than lenses with a normal focal length. Wide-angle lenses have higher depth of field than normal-focal-length lenses. Any lens of less than 40mm (measured in 35mm equivalent focal length) can be considered wide angle.

zoom lens A lens capable of taking pictures over a continuous range of different focal lengths.

Index

Continued

Continued

Continued